Publisher's Acknowledgements
Special thanks to **Cornelia Providoli**, Zurich, **Rahel Sprecher**, Zurich, and **Galerie Hauser & Wirth**, Zurich. We would also like to thank the following publisher for their kind permission to reprint texts: **Sterling Lord Literistic, Ltd.**, New York, **Christoph Doswald**; and the following for lending reproductions: **Galerie Hauser & Wirth**, Zurich. Photographers: **Ellen Baily, Stefan Banz, Markus Bertschi, Ela Bialkowska, A. Burger, Davide Ciresa, Alex Colle, Thomas Cugini, Marc Domage, Jennifer Esperanza, Nicolas Faure, Robert Fischer, Kathrin Freisager, Daniel Gerber, Anders Guggisberg, Christian Herdeg, Mathias Herrmann, Christine Huck, Verena Isler, Johann Koinegg, Larry Lamay, Tobias Madörin, Bruno Mancia/ Franziska Bodmer, Martina Meier, B. Merrett, Arthur Miranda, Helge Mundt, Peter Muscato, Franz Noser, Rita Palanikumar, Public Art Fund New York, Andrea Rist, Anna Rist, Pipilotti Rist, Stefan Rohner, Michel Rubino, Martin Rütschi, Samir, T.omi Scheiderbauer, Lothar Schnepf, Daniel Spehr, Andrea Stappert, Niklaus Stauss, Irene Stehli, Martin Stollenwerk, Alexander Troehler, Pius Tschumi, Angel Tzvetanov, Uri Urech, Franz Wassmer, Dimitri Westermann, Jean-Marc Wipf, Sabine Wunderlin, Friedrich Zubler.**

Artist's Acknowledgements
I would like to thank my staff for the marvellous collaboration, their humour and their commitment: Cornelia Providoli, Pius Tschumi, Davide Ciresa, Remo Weber, Claudia Friedli, Rahel Sprecher, Sushma Banz, Nexhmie Shkodra; my former staff: Nadia Schneider, Anahita Krzyzanowski, Maria Monika Ender, Bettina Coaz, Arthur Miranda; also my freelance staff: Tamara Rist, Mich Hertig, Aufdi Aufdermauer, Karin Wegmüller, Trix Barmettler, Simon Lenz, Adrian Bauer, Dimitri Westermann, Roli Widmer, Beat Zgraggen and Irene Gattiker. I thank Thomas Rhyner for many print and gadget designs and Anders Guggisberg for the collaboration in sound.

I would like to thank Gilda Williams, commissioning editor, John Stack, Stuart Smith, Ian Farr, Clare Manchester and Veronica Price at Phaidon Press and all photographers, translators and writers in this book, specially Peggy Phelan, Elisabeth Bronfen and Hans Ulrich Obrist.
I would also like to thank all the people I have worked with and who are listed in the Production Credits at the end of this book.

I thank my teachers, my discussion partners Käthe Walser, Samir and Iwan Wirth. I thank my friends, influences and supporters: Balz Roth, Bice Curiger, Jacqueline Burckhardt, Emanuel Tschumi, Liliane Lerch, Bady Minck, Ruth Rothenberger, Anna Rist, Tom and Andrea Rist, Manuela Wirth, Ursula Hauser, Franz Wassmer, Trix Wetter, Ashiko Rupp, Kilian Dellers, Eric Franck, Ines Zurbuchen, Livia Hegner, Harm Lux, Friedrich Meschede, Sakiyo Yagi, Mick Flick, Hanna Widrig, Josef Felix Müller, Urs Staub @ Culture Department of the Swiss Confederation, Barbara Mosca, Peter Bläuer, Konrad Bitterli, Bernhard Mendes Bürgi, Andreas Balze, Sasha Haettenschweiler, Peter Fischli, Gaby Hächler, Tigi Fuhrimann, Eva Keller, Karl Friedrich, Stephan Schmidt Wulffen, Judith Nesbitt, Sabine Folie, James Rondeau, Louis Grachos, Rosa Martinez, Vicente Todoli, Paolo Colombo, Dominic Molon, Leontine Coelewij, Martjin van Nieuwenhujzen, Harald Szeemann, René Pulfer, Nancy Spector, Germano Celant, Jean-Christoph Ammann, Katerina Gregos, Ydessa Hendeles, Olga Viso, Sjarel Ex, Ranti Tjan, Akiko Miyake and Nobuo Nakamura, Walter Rist, Ursula Rist, Stefan Sagmeister, Nedko Solakov, Iara Boubnova, Pro Helvetia, Marc Payot, Kalle Gattinger, Emil Guggenbühl, Florian Berktold, Esther Flury, Roland Augustine, Lawrence Luhring, Michele Maccarone, Katy Schubert, Alexia Holt, Raphael Bosma, Tom Eccles.

I thank the curators, exhibition institutions, foundations and collectors who supported our work.

Remember Ansgar!

All works are in private collections unless otherwise stated.

cover, **Feuerwerk Televisione Lipsticky** (Firework Television Lipsticky)
1994/2000
Video still (detail)

page 4, **Sip My Ocean**
1996
Video still (detail)

page 6, **Me As a Human Being**
2000
120 photographs

page 32, **Himalaya Goldsteins Stube** (Himalaya Goldstein's Living Room)
1999
Video still (detail)

page 78, **(Entlastungen) Pipilottis Fehler** ([Absolutions] Pipilotti's Mistakes), from the 'Water Jump-up Series'
1988
Video still
12 min., colour, sound

page 92, **Hello Goodbye**
2000
Video installation, silent
Projector, 2 light boxes using natural light, Duratrans transparencies, cardboard tubes
Installation, Musée des Beaux-Arts, Montreal

page 144, **Yoghurt on Skin – Velvet on TV**
1994
Video installation, sound
8 video players, 3 shells, 3 handbags with built-in LCD monitors with sound, 1 LCD at the entrance, projection, 3 computer-controlled trade spotlights, paint on walls
Installation, Neue Galerie, Graz, 1995
Collection, Kunsthaus, Zurich

Peggy Phelan Hans Ulrich Obrist Elisabeth Bronfen

Pipilotti Rist

Contents

Interview I rist, you rist, she rists, he rists, we rist, you rist, they rist, tourist: **Hans Ulrich Obrist** in Conversation with **Pipilotti Rist, page 6**. **Survey** **Peggy Phelan** Opening Up Spaces within Spaces: The Expansive Art of Pipilotti Rist, **page 32**. **Focus** **Elisabeth Bronfen** *(Entlastungen) Pipilottis Fehler ([Absolutions] Pipilotti's Mistakes)*, **page 78**. **Artist's Choice** **Anne Sexton** Barefoot, 1969, **page 94**. **Richard Brautigan** The Irrevocable Sadness of Her Thank You, 1980, **page 98**. **Artist's Writings** **Pipilotti Rist** Innocent Collection, 1988–ongoing, **page 104**. Title, 1989, **page 106**. Preface to *Nam June Paik: Jardin Illuminé,* 1993, **page 110**. 'I Am Half-aware of the World': Interview with Christoph Doswald, 1994, **page 116**. Two Untitled Poems, 1996, **page 130**. Monologue in Car (Suburb Brain), 1999, **page 132**. A Dream, 1999, **page 136**. One Day – Friday, 6 August 2000, 2000, **page 138**. **Chronology** **page 144** & Production Credits, Bibliography, List of Illustrations, **page 158**.

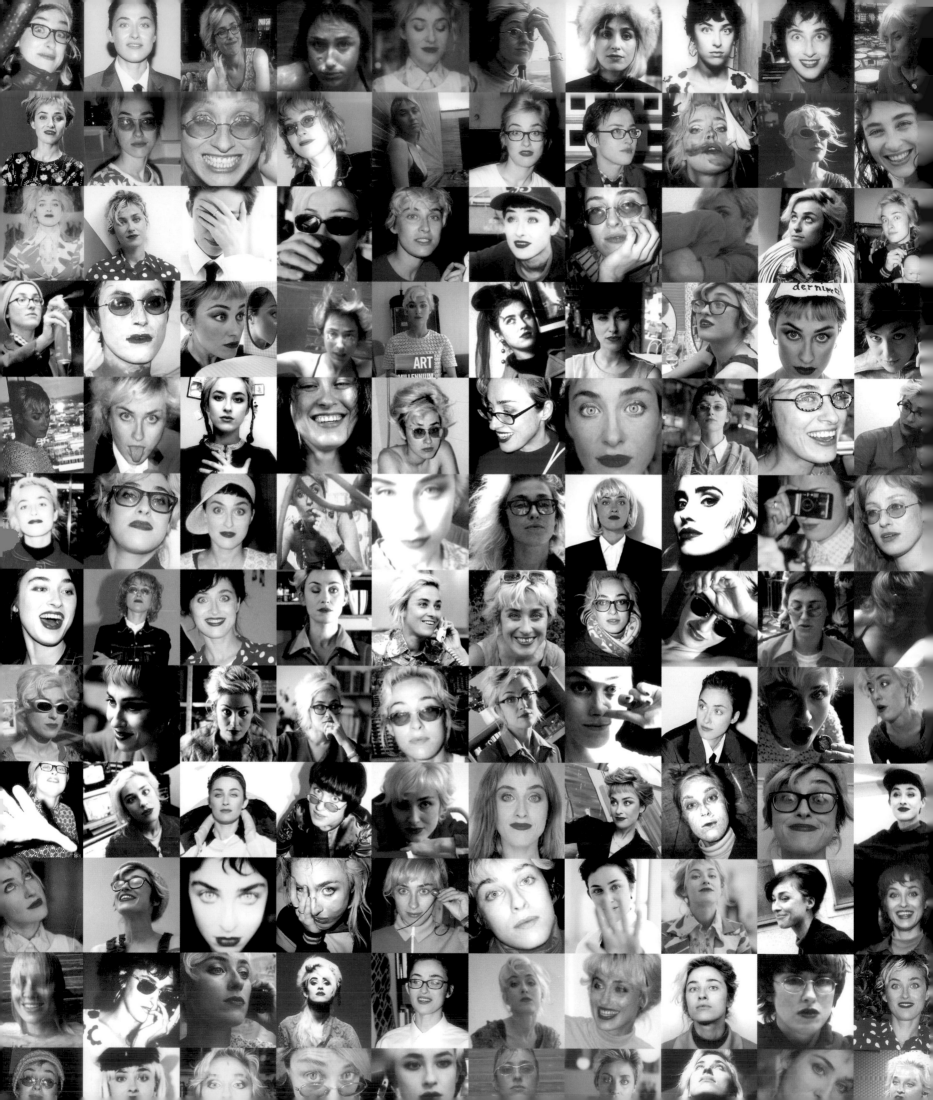

Contents

Interview

I rist, you rist, she rists, he rists, we rist, you rist, they rist, tourist: **Hans Ulrich Obrist** in

Conversation with **Pipilotti Rist, page 6**. Survey Peggy Phelan Opening Up Spaces within Spaces: The

Expansive Art of Pipilotti Rist, page 32. Focus Elisabeth Bronfen (Entlastungen) Piplottis Fehler ([Absolutions]

Pipilotti's Mistakes), page 78. Artist's Choice Anne Sexton Barefoot, 1969, page 94. Richard

Brautigan The Irrevocable Sadness of Her Thank You, 1980, page 98. Artist's Writings

Pipilotti Rist Innocent Collection, 1988 – ongoing, page 104. Title, 1989, page 106. Preface to Nam June Paik, Jardin Illuminé,

1993, page 110. 'I Am Half-aware of the World': Interview with Christoph Doswald, 1984, page 116 Two Untitled Poems, 1996,

page 130. Monologue in Car (Suburb Brain), 1999, page 132. A Dream, 1999, page 136. One Day – Friday, 6 August 2000, 2000,

page 138. Chronology page 144 & Production Credits, Bibliography, List of Illustrations, page 158.

I rist, you rist, she rists, he rists, we rist, you rist, they rist, tourist:
Hans Ulrich Obrist in Conversation with **Pipilotti Rist**

Hans Ulrich Obrist In architecture, it is customary to publish and discuss
unrealized projects; architects can make a whole career out of such work. But in
art, unrealized artworks strangely remain almost totally unknown.

I wonder if you could tell me about an unrealized 'dream' project that you
would like to see in the future? Do you have any projects which are too big or too
expensive to make, or which would not fit into the existing structures for
exhibiting work?

**Pipilotti Rist I'm not really that interested in unrealized work. I want people
to take part in my creation, and if they can't, I feel I have failed. I try not to feel
sorry for myself because of the impossibility of my unrealized projects; I don't
want to mythologize them. Unrealized projects can be infinitely big, but it's
hard to estimate their worth: would they even work, if they could be made?
Of course you are right to say that the existing structures for exhibiting art
often stand in the way of ideas. There are always obstacles presented by the
building conditions, laws and permits, restrictions, power struggles,
budgets, intrigues, incomprehension, laziness and divergent ideas of what a
project is meant to be. These days artists must devote their imagination not
only to the art itself, but to negotiating the given structures, which are often
very rigid. They can do this on their own or with the help of a curator, who
passionately and carefully arranges conditions on the artist's behalf. We need
art managers!**

**Going back to your question, some projects remain unrealized for per-
sonal reasons, or because the time isn't yet ripe – and maybe it never will be.
In many cases unrealized projects are not lost, but return in different guises.**

Obrist You made a proposal for a project with an airline, on board an areoplane,
that was not realized.

**Rist I was invited by Swissair to propose an art intervention. Most of the
entertainment offered in the air reproduces the usual, TV-based idea of the
banality of everyday life, or – even worse – represents an institutionalized,
infant stage in an incomplete womb. We proposed videos that, alongside the
existing information-oriented videos shown before landing, would also give
information about the approaching city but from the super-subjective point
of view of the artist. Private interviews with flight personnel about their
experiences in the city of destination would also be included. The flight
attendants and pilots would document their stop-overs in various cities with
a camera, and passengers would watch this uncut material.**

**We wanted to organize mini workshops on contemporary art during the
flight. Short animated films inspired by the aesthetics of the security
information videos would be screened to instruct the workshop participants.
Passengers could hear short 'radio plays' on an audio channel; for example
they could listen to the couple sitting in front, discussing their relationship, or
the flight attendants making fun of a passenger, or they could listen to the
pilot's latest dream, or even the internal monologue of a passenger suffering
from fear of flying. Meanwhile the flight attendants would recite poems.**

**We proposed to install a corner for yoga and meditation in first class,
accessible to all passengers. We wanted to stick prisms on the windows that
would break the sun's rays into spectral colours. There were to be outboard
cameras with telephoto lenses towards the landscape; the resulting images**

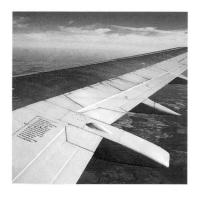

Nedko Solakov
On the Wing
1999
14 texts on the wings of
6 Boeing 737s
Commissioned by Luxair, with
Casino Luxembourg

Texts: 'Under this very wing there
is / a very small rain drop /
hanging on to the silver / metal …
somewhere close to / the wheel …
She is very / happy. Why? Because
later / on she intends to drop
down / on that (sometimes snowy)
/ mountain where her cousins live.
/ They are some of the best
snowflakes / in the World.'

'Dear passenger, / can you see that
little cloud / on the right … so
young / and relatively small. / He
wants so much to be / like the Big
Mighty Guys / (close to the
horizon) … / but, for the time
being, he can't and that is why /
he is a bit sad … but not / so sad
because his responsibility for / the
Atmosphere's image / is not so big
either … '

would be shown on the floor of the plane.

Swissair didn't want our proposals in the end. They got cold feet.

I must mention that one of the best projects with areoplanes I have ever seen was by Nedko Solakov with Luxair in collaboration with Casino Luxembourg. He wrote short poems on the areoplane wings, so that when you looked out at the wings, you could read poetry.

Obrist What are some of your other 'roads not taken'? And, what is your idea of a Utopian space where such unrealized works could exist?

Rist I would like to build a huge leisure park full of art, in collaboration with architects, musicians, designers and writers. I have already designed it in my mind on long forest walks with my friend, artist Käthe Walser, and with Iwan Wirth (who is more than just a gallerist) and with my staff.

Another project would be to establish a worldwide kindergarten chain. Also, I would like to create a skyscraper full of studios for Eastern European artists.

Another idea would be for people to sew labels into their clothes; on the labels they would write where the clothes had been worn, what happened when they wore them and so on. Every piece of clothing would carry with it the full record of everything it had experienced. I would also like to make an installation that would cure visitors of the pains of love.

My Utopia is working with the people with whom I already work. Utopia, I expect, is not an easy place to live, however.

One ideal place which really does exist is the Centraal Museum Utrecht in the Netherlands, not far from Amsterdam. It's set among a number of other buildings – a monastery, a psychiatric clinic, a church and a residential building. The museum has 45,000 pieces in its collection: works of fashion, painting, ceramics and more. You look the item up in a catalogue; each has a reference number, like the call number in a lending library. You can request the item and it's brought to you within an hour, so you can have a good look at any object in the collection. That's what I call service! The entry tickets are issued by machine, but each of the 100 employees, from the cleaning staff to the director, takes their place at the entrance for three days a year, offering their help to you. They wear uniforms, which consist of jeans and a denim jacket, with a green band around the torso with their name written on it.

Anyway, going back to your question, unrealized projects are created every day in billions of conversations and humorous dialogues. I would like to live in your nose.

Another unrealized project was my unsuccessful attempt to rob the Feldkirch stadium (in Feldkirch, Austria) during an ice hockey game.

Obrist You've mentioned in the past that one of your aims is to create unexpected partnerships between science, art, literature and physical recreation.

Rist That's exactly what I attempted in my one-and-a-half-year tenure as the artistic director of the Swiss National Exposition, in the three-lake area in western Switzerland in 2002. The project is a six-month event that draws together the cultural, economic and social forces of our small country. My team and I launched many interdisciplinary projects, such as a collaboration among scientists, insurance companies and artists who together explored

the phenomenon of pain. Other ideas we had included: building recycling machines as translucent sculptures; creating an institution where you could get married for twenty-four hours. A few of our projects are now actually being put into practice.

Appointing an artist as the Expo director was a sign. My way of working as director – as an art theorist who considers her acceptance of the job as a conceptual choice[1] – is pretty rare. But beware of being overly enthusiastic about the potential for contemporary art to filter into 'the real world'. The fact is that most people are not interested in art as an interdisciplinary field. Art has repeatedly opened itself to other disciplines, but most of these other disciplines have not responded by being open to art. Art's task is to contribute to evolution, to encourage the mind, to guarantee a detached view of social changes, to conjure up positive energies, to create sensuousness, to reconcile reason and instinct, to research possibilities, to destroy clichés and prejudices. Most people don't see it that way.

clockwise from top left,
Jeans
1984
Acrylic on paper
30 × 21 cm

Rahel kommt (Rachel Comes)
1984
Pencil, ink on paper
30 × 21 cm

Disco (with T.omi Scheiderbauer)
1985
Lightbox, X-rays
Installation, Club Opal, Lochau,
Austria

Tiroler Pickel (Tiroler Pimple)
1984
Collage
59.5 × 42 cm

Obrist One of the problems of the cross-disciplinary approach is the 'territorial anxiety' it can induce. How can we go beyond this anxiety of breaching the boundaries between disciplines?

Rist **Art still offers a protected field in which to experiment and work. But it becomes more and more essential for artists to have an unequivocal attitude about their usefulness to society. Artists' great wealth lies in their distance from the ways of the world and in the 'time-out' that they can take. Artists are abandoning the notion of a creative vision, becoming more like great inventors in their specialized fields. Artists are importing, changing, interpreting and positioning everything they find. The danger is that artists, kept busy learning and digging up information, can no longer get around to developing new media, raising funds, forming artists' groups and so on. If they want to improve the substance of their techniques, they lose the time and money necessary to go deeper into their subject matter.**

Also, I think technicians and scientists should make art too.

Obrist Have you always worked with video or did you begin with other practices, like painting, drawing or design? What was your first contact with video?

Rist **I studied graphic design in Vienna at the Hochschule für Angewandte Kunst (Institute of Applied Arts, 1982–86). I made Super-8 animation films, created stage sets for bands and did a lot of drawing there. When I finished school and returned to Switzerland I knew I wanted to work with moving images. I took the entrance exams for video classes – although really all I wanted was to use their equipment for free. I didn't care whether I worked on celluloid or analogue tape, I just wanted to learn and experiment in the audio-visual field. Film is a good, high-resolution medium, but production is too cumbersome and the division of labour absolutely necessary. I opted for video because I can perform all the steps myself, from the camera work to online editing, and that suits me. I can work all by myself or in a small team.**

Obrist Could you tell me more about the differences between video-making and film directing?

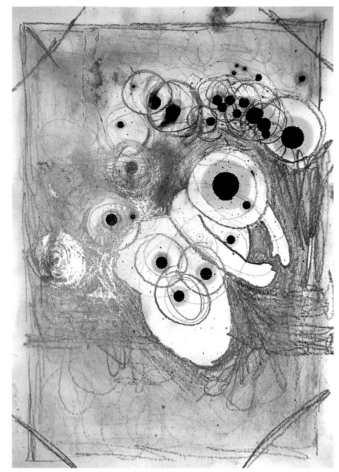

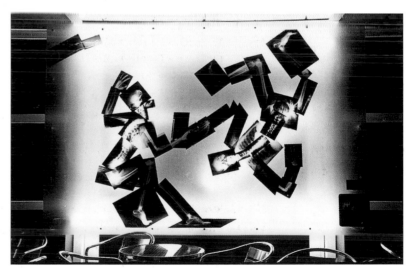

Rist If you're the director of a big feature film you know a little about everything, but you're not a specialist in anything in particular, so your knowledge is general. A low-budget video director still needs a filmmaker's general knowledge, but also has to be practical – you really have to know every single technical and artistic step. I often say that video is like a painting on glass that moves, because video also has a rough, imperfect quality that looks like painting. I do not want to copy reality in my work; 'reality' is always much sharper and more contrasted than anything that can ever be created with video. Video has its own particular qualities, its own lousy, nervous, inner world quality, and I work with that.

Obrist What were your influences at the beginning? Were pop music and culture as important to you as art?

Rist Like everyone else I've seen a lot of movies, especially on TV. I don't necessarily know the titles or the directors' names but they still influenced me. I started making Super-8 films in Vienna following the example of the girls in my animation film class, Bady Mink and Mara Matuschka. I began working with video and music in Basel around the same time MTV was developing in the mid 1980s and people later saw a connection there. At that time I was more influenced by experimental films, such as *Parallels* (1960) by Norman McLaren, or *Plötzlich diese Übersicht* (*Suddenly This Overview*, 1981) by Peter Fischli and David Weiss, and feature films, for instance the Czech film *Daisies* (1966) by Vera Chytilová, or *Pink Flamingos* (1972) by John Waters. There is a long history of films inspired by music and other experimental filmmaking that predates MTV. People saw my first video, *I'm Not the Girl Who Misses Much* (1986), as a critical reflection of MTV, but I hadn't even seen MTV at that point. That work was a reflection of contemporary pop culture in general.

In video class our teacher, René Pulfer, showed us a whole range of video art from the 1960s to the 1980s, from Ulrike Rosenbach to Joan Jonas to Peter Callas, and I admired that work a lot.

Obrist It's interesting that one of your first texts was a homage to Nam June Paik.[2] Was he another early influence?

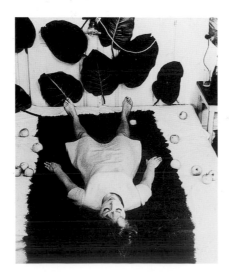
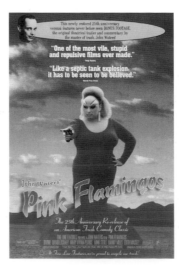

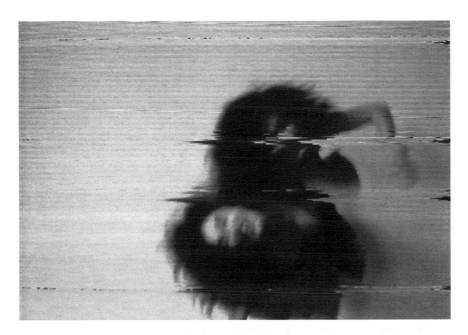

left and overleaf, **I'm Not the Girl Who Misses Much**
1986
Video stills
5 min., colour, sound

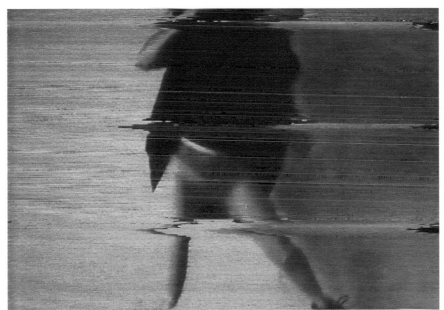

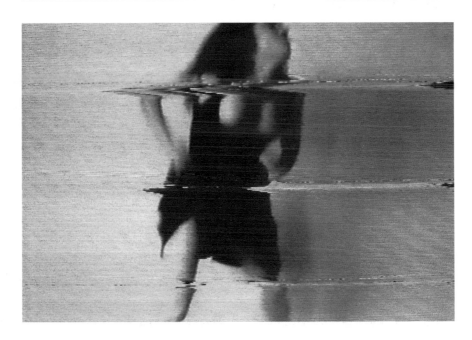

 Interview

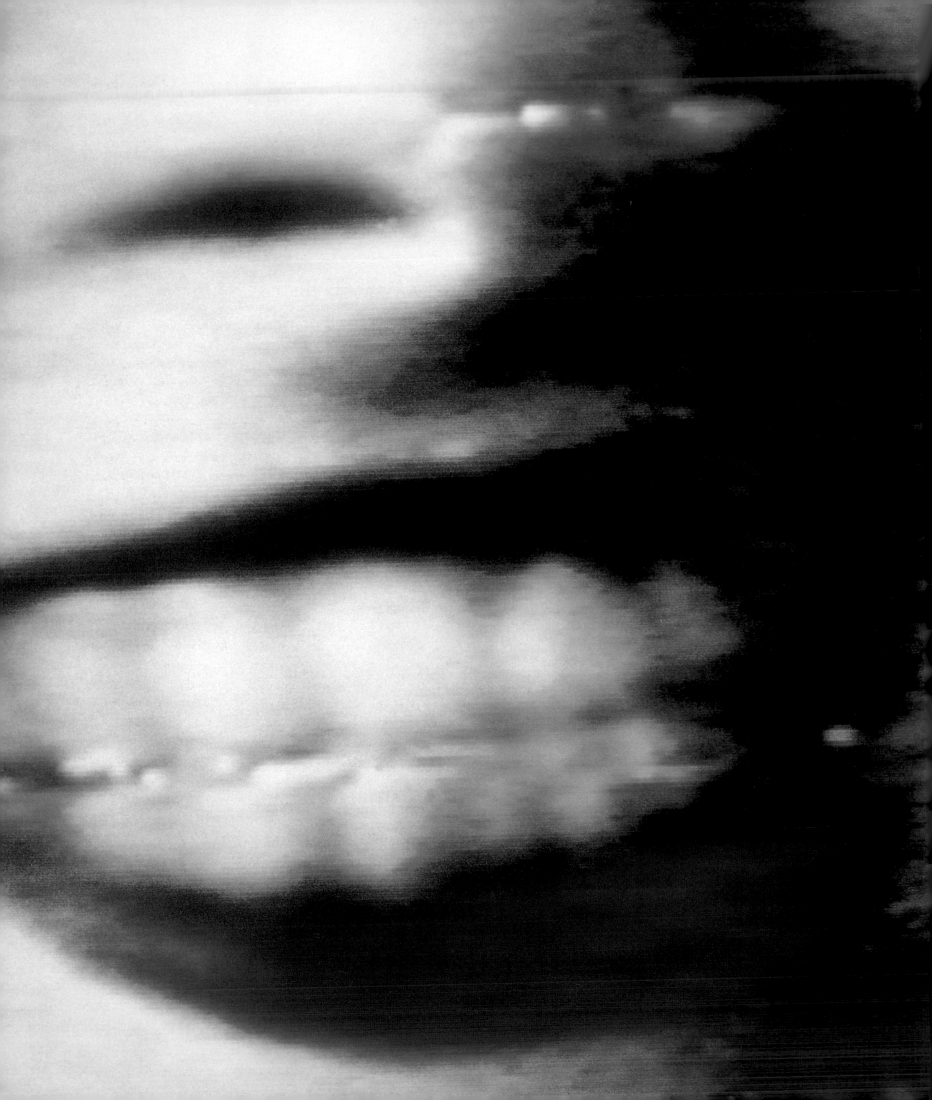

Rist Yes. Paik really set out to occupy the space that television had opened up, exploring the possibilities of the machine-cable-space connection. I like the way he treated technology, simply as another ingredient, without much respect for it. He arranged electronic cables so they'd seem like organic elements, like flower stems or veins. For Paik, technology could be adapted to any context.

Obrist Paik was a pioneer: he was using video when it was a new medium, which is very different from now, when it's so widely available it's as common as drawing with a pencil.

Rist We can no longer look at technology innocently and see it as miraculous; it's become too ordinary. Video art has been outdone – in both form and content – by music clips, TV advertising and film. The important thing in art is the quality behind the artist's basic motivation. Artists must be uncompromising. When they want to make trash, they must do it consciously. The 'I'm-doing-this-badly-so-that-I-can-distance-myself-from-commerce' style can't survive much longer. It's bad and it's kind of impertinent. It steals the viewers' time, in the sense that with a painting you can decide more quickly whether to stay and look, or walk away. With video you have to watch for at least a minute before you can decide, and that's too much time to give a bad video. Creative expression is a 'summing up of time' (*Zeitschöpfung*). With video you give the viewer fifty hours' work in one minute, so video is like concentrated time. Video-making must be precise; Paik, for example, was very precise in his work. It's not surprising that he was also a musician, working with sound and synchronization.

Obrist What connection do you see between your work and Paik's?

Rist Paik's work and mine have in common that we both try to draw the viewer inside it. At first you look at the box, at the screen or projection, but when you concentrate on the sequences you feel as if you're inside the box, behind the glass, within the wall. You forget everything around you and concentrate completely on the box: you're swallowed. This can be achieved in many different ways, for example, through the number of monitors or the size of the display, through the installation and its choreography. Paik managed to rid himself of this suspicious box in many different ways: he'd transform the TV monitor into a lamp or place it inside an aquarium. Reconquering the space inside the TV set: that's one of my aims as well.

Obrist What about Yoko Ono? She was among those artists who, from the 1960s onwards, promoted a strong idea of art for everyone, not confining her work only to the art audience but addressing a wider public.

Rist I was very interested in John Lennon when I was growing up, although I was born ten years too late to be a real fan. Through his music I became aware of Yoko Ono; I discovered that she made films and I started to learn about her marvellous work. Together with my first boyfriend, designer Thomas Rhyner (with whom I still collaborate), I collected everything I could about Ono. By the way, why is Yoko Ono always treated so badly?

Obrist She made amazingly pioneering work, such as her 'do-it-yourself' art pieces, like *Do It Yourself Dance Piece*, 1966, artworks created by viewers who follow her set of conceptual instructions.

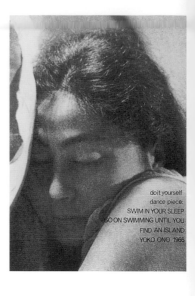

do it yourself
dance piece:
SWIM IN YOUR SLEEP
GO ON SWIMMING UNTIL YOU
FIND AN ISLAND
YOKO ONO 1966

Rist In my village in Switzerland I had a small window on the art world through the mass media; through John Lennon/Yoko Ono I moved from pop music to contemporary art. It was through my interest in mass media that I became involved in art. In return, I will always be grateful to popular culture. I've never had a snobbish attitude towards pop music or the applied arts. I've always had a great deal of respect for my colleagues who are doing great things in these different contexts.

Obrist Could you tell me about the importance of collaboration in your practice?

Rist My working structures have changed in the last fifteen years. They've become more professional, but the atmosphere has remained private.

I used to work at the editing suite of my school in Basel. Later I was a member of small film collectives (VIA, Basel; Dig it, Zurich), and now I have my own editing suite. At first, among friends, we used to pay each other with working time. Gradually, I began working with freelancers who have become regular collaborators, whose salaries are part of the production costs of a work. Cornelia Providoli, an art historian, handles the planning with curators and is responsible for the budget. You could say she's my manager; I'm her boss and her child at the same time. Pius Tschumi is responsible for development, production and installing shows.

Most of my working relationships are or turn into friendships. My gallery acts as more than my producer: gallerists Manuela and Iwan Wirth have become very dear friends. In the studio, in addition to Cornelia and Pius (with whom I've been working for eight years) are Davide Ciresa (interior decorator), Sushma Banz (video archives and technical files) and Remo Weber (workshop and storage). Working with and for Cornelia are Claudia

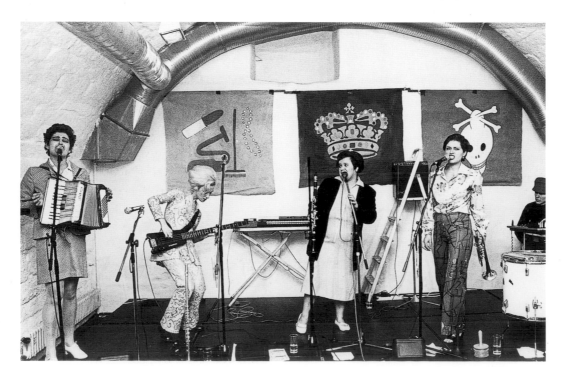

Les Reines Prochaines
1993
l. to.r., Fränzi Madörin, Pipilotti Rist, Muda Mathis, Gaby Streiff, Sus Zwick
Performance at Jazzkeller, Stuttgart

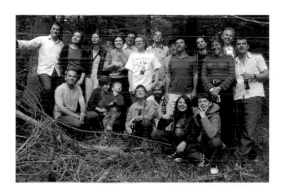

Friedli and Rahel Sprecher, who are in charge of photo archives and documentation. This group of close collaborators also includes artist and musician Anders Guggisberg, with whom I've developed the sound for my works for more than five years, since my band Les Reines Prochaines; Aufdi Aufdermauer and Karin Wegmüller, who service all the technical equipment, help install shows and produce the DVDs; designer Tamara Rist, who collaborates on all the installations and also installs individual works on her own; my mother, Anna Rist, as driver and best girl; and Dimitri Westermann, who develops and produces special equipment (like the redirecting mirrors of *Extremitäten (weich, weich)* (*Extremities [Smooth, Smooth]*, 1999) or the smoke bubble machine of *Nichts* (*Nothing*, 1999). Apart from my team, Käthe Walser, a video artist like me and my best friend, is an important person with whom I discuss my work. She taught me how to solder metal, and so many other things.

The actors are often people from my team – for example, Cornelia plays the woman in the snow in *Himalaya's Sister's Living Room* (2000) – or from my circle of friends – for instance, architect Gabrielle Hächler is the policewoman in *Ever Is Over All* (1997). In that same piece my mother Anna and my brother Tom are passers-by. Journalist and documentary filmmaker Silvana Ceschi, who plays the hit woman in that piece, turns up again in the forest of *I Couldn't Agree with You More* (1999), as does my co-musician Anders Guggisberg. Singer Saadet Türkös also turns up in several works. When I'm not acting myself, I'm behind the camera; sometimes I do both.

Obrist You have many roles: you shoot your own videos, produce them and often perform the central role, and for a long time you were responsible for their distribution. Then there's your work with your band Les Reines Prochaines, and the Rist Sisters Corporation, which functions a bit like a 'factory'.

Rist **Rist Sisters Corporation is a small, serious company, with development and production units for unique works in many disciplines. We are trying to blend the innocent mood of the 1960s with the ambivalence and differentiated perspectives of the 1990s. As I said earlier, at first we – my friends and sisters and I – just paid each other with our time. Now I work with a permanent, professional team. I run a small enterprise, like the carpentry shop around the corner – although perhaps with better, self-invented jobs. Artists plan big exhibitions the way directors must organize a large-scale film production. Rist Sisters Corp. functions like a self-sufficient spaceship: my team and I arrive at the exhibition space with all the necessary equipment, with the installation process organized in great detail in terms of logistics and personnel. We have already tested the installation process using models in the studio and can work quickly.**

Obrist The staff includes your sisters, like the traditional family enterprise, only all-female.

Rist **The name 'Rist Sisters Corp.' was simply a nod to names like 'Warner Brothers'. My sisters, twins Tamara (designer) and Andrea (photography student), often work with me. My older sister Ursula sometimes handles my private photos and brother Tom was the model for our T-shirts from 'Slept In, Had a Bath, Highly Motivated' (Chisenhale Gallery, London, 1996). I never**

want to sideline the basic operational aspect of art-making, it's really part of being an artist. A huge part of art-making is administrative and technical work, which involves hammering away and tinkering with everything, travelling, examining samples, changing, improving and making decisions. We often work closely with manufacturers and specialized technicians. These are very pragmatic, technical negotiations, and we try to create a positive atmosphere. We cook and have lunch together, so if tensions arise we can resolve them. I feel that if the process of creating hasn't been positive, then that negativity will come out in the final work.

Obrist What is the role of improvisation and self-organization?

Rist One of my goals is to avoid as many of the architectural, financial and structural constraints of the institutions where I show my work as possible, or to use the constraints in such a way that they become normal conditions of creation. My small team is phenomenal in this. In terms of software and modes of film production, we work on a low-budget level which leaves room for plenty of experimentation. I can afford to make a lot of mistakes in my laboratory. The result is a lot of unpublished material that ends up in my huge archives, and which I may come back to years later.

Obrist Has the Internet changed the way you work?

Rist It's become less complicated to foster long-distance friendships, as with my friend Liliane Lerch, a web designer in Los Angeles. *'Dear Lilchen, I'm wearing the red and red-pink plastic lace dress that we bought on our walk to the sea, the one you photographed me wearing, the one in the picture of me that you have hanging behind your desk. I'm wearing a pink long-sleeved shirt underneath and a 100% acrylic cashmere-like orange cardigan, but that's lying beside me now.*

'A lot has happened; I don't get those bottomless lows anymore. I'm calmer; I've gotten to know my mother, my nephews and my sisters a lot better, and the family is a bed of roses again. Officially I'm still in that half-year sabbatical I began when I was with you, and which was nice.

'Don't worry, Sophia Coppola's Virgin Suicides *hasn't weighed me down too much; I thought it was quite atmospheric. I didn't really understand the need for the wild turn at the end. I saw the suicides more as an emotional metaphor, an image of the power of feelings in teenage years.*

'After a few weeks in supermagnificent nature in an almost magical house near Basel, I'm now back in Zurich. A great plus is my new, larger studio. We have almost 100 m² more on the mezzanine now, and I have my own editing suite. From the kitchen we can go out and sit on the loading platform. Downstairs we're having a hardwood floor put in so we can take yoga lessons before meetings.'

Obrist How do you choose the subject matter of your films, inductively or deductively?

Rist The term 'subject matter' in relation to works of art is something I've never understood. People often ask me about subject matter and expect a one-word answer. Such questions miss the point. My subjects are amorphous

opposite, **Closet Circuit**
2000
Video installation
Built-in infrared camera under glass-bottomed toilet, plasma screen
Installation, toilet, Luhring Augustine Gallery, New York

below, **Nichts** (Nothing)
1999
Machine producing soap bubbles with white smoke
Installation, *l. to r.,* Gesellschaft für Moderne Kunst am Museum Ludwig, Cologne; Palazzo Remer, Venice; 'd'APERTutto', 48th Venice Biennale

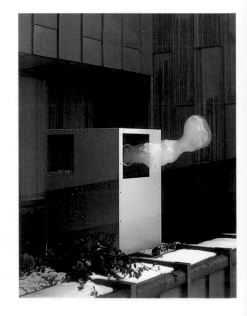

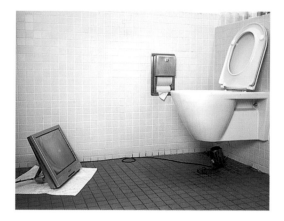

and overlapping. It's the subjects that choose me, not the other way round. We marry, the subject and I, and every now and then I'm being hurled out of the whirl of time and catapulted to my editing suite. This sponge made up of so many subjects from life comes over me and covers me up.

Subject matter can develop through conversations and desires. For example the work *Closet Circuit* (2000) came out of a discussion after lunch, when I expressed my desire to visualize what, where and how my body produces every day. I made a joke that we set a camera in the toilet and play the real time images back to the seated person on a screen in front of them. Pius took my idea seriously, and *Closet Circuit* is the result.

In other instances a work can come about by chance, or can manifest itself during the development of another body of work. With *Nichts* (*Nothing*), for example, we had been testing whether it was possible to project images on smoke. The resulting 'smoke bubble machine' worked surprisingly and wonderfully well as an independent work.

Blood, sweat and tears are usually required to create the subject/matter connection. I think I can arrive at something that's socially relevant with honesty and Protestant diligence.

I'm interested in universal feelings. However, there are certain images that never or hardly ever appear in my work: cigarette-smoking, urban architecture (at least not until I visited Kitakyushu, Japan), intrigues, hatred, weapons, carved wood, teacher-pupil situations, masks, moving cars shot from the outside and sports.

Obrist At the first show of yours that I saw, at the Kunsthalle St. Gallen in 1989 (with Muda Mathis), you made your famous statement comparing video installations to a handbag, because 'there is room in them for everything: painting, technology, language, music, movement, lousy flowing pictures, poetry, commotion, premonitions of death, sex and friendliness'. One could almost say that the handbag opens and spreads its contents out into the city in quite a subversive way.

Rist Yes, the holy, holy handbag. Video has all these different levels in

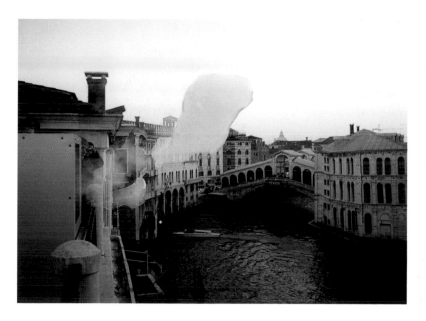

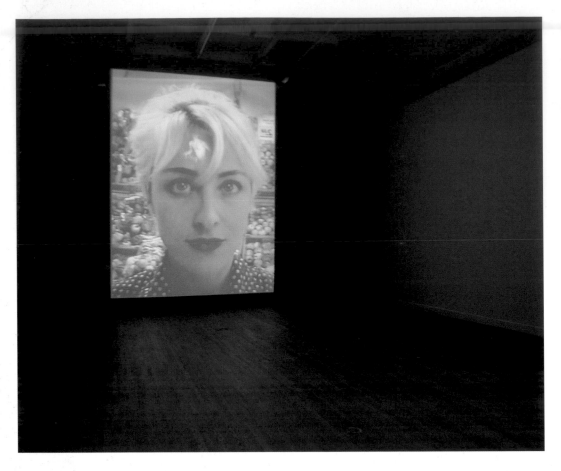

I Couldn't Agree with You More
1999
Video installation, sound with
Anders Guggisberg
2 overlapping video projections,
audio system
Collection, Museum of
Contemporary Art, Los Angeles
left, Installation, Musée des
Beaux-Arts, Montreal, 2000
above and opposite, video stills
(details)

below, **Maureen Connor**
The Sixth Sense
1992–93
Velvet curtains, two-way mirrors,
video monitors

form and content, as well as in its technical possibilities and its potential to combine visual and audio media. What has really changed in the last decade is that video equipment has become much cheaper and smaller. Mass-market cameras now are as good as professional ones were just a few years ago. Cameras have become much lighter, so I can move them around easily, even with my thin, rather weak body. For example, in my work *I Couldn't Agree with You More* (1999), a woman is filming herself, the camera rotated 90 degrees, as she walks around a supermarket and an apartment in a skyscraper. Her gaze is hypnotic. The image has been enlarged to fill the entire wall, so it's grainy. Another image is projected at closer range on her forehead and it's clearer, brighter. It looks like a tiara, or like liquid thoughts shining through her mind, onto her forehead. In this 'tiara' image, naked people in a forest are disturbed by car headlights. The people are shy, yet curious, like wild animals. The atmosphere is one of both fear and fascination – which is exactly how I feel when I'm in a city. We are like wild animals in the city. We watch each other; we are interested in those around us, yet we don't want them to come too close.

Obrist The handbag is also a kind of urban survival kit, isn't it? A survival kit for urban street guerrillas.

Rist It contains the basics, but its contents are always a portrait of the owner. I love looking into other people's handbags; they reveal their secrets and tell me a lot about their owners' characters, about their wishes and fears. Exhibiting my art is like letting people take a look into my bag.

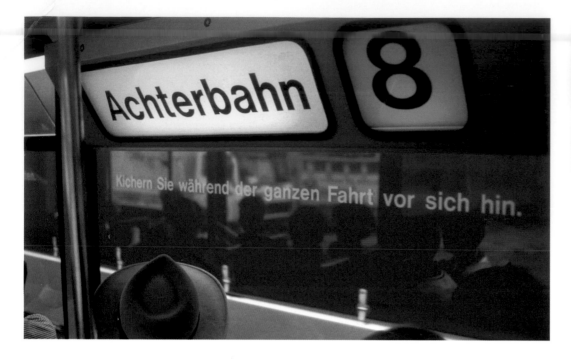

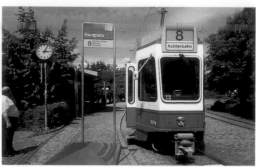

Obrist I wanted to ask you about a non-video work, your tramway project in Zurich *Achterbahn/das Tram ist noch nicht voll* (*Tram Route 8/The Tram Is Not Crowded Yet*, with Thomas Rhyner and Jan Krohn, 1998) where you inserted your art into the urban flux.

Rist **In *Achterbahn* we changed the list of regulations on the Zurich trams to read:**

Count all light blue cars.
Push the button so my heart will explode.
See luck lying in the road.
Remain on tram for one week.
Whisper to somebody through the window.

We also changed the names of all the stops of the map inside the tram, so Paradeplatz became Paradoxplatz, for example. Through the speakers the passengers heard sounds which varied according to the context – when the tram went by a bank you could hear the sound of jangling coins, when it passed the lion's cage at the zoo you'd hear a roar. One seat was marked as reserved for fare dodgers. On the front, tram number eight (*Achter*) was named *Achterbahn* ('helter-skelter' in German); on the rear was a sign which read 'You wanted to finish first, didn't you?'

Obrist Was *Achterbahn* a performative space?

Rist **Yes, but the performer was the passenger. The basic idea was to change the information in the tram only slightly – using the same font, same size, same colour as the original – so that if you jumped on in the morning, at first you didn't notice any difference. This piece was influenced by the Living Theater in Brazil in the 1960s, who used to intervene in ordinary, everyday social situations without anyone knowing they were performers. It was also influenced by the work of Yoko Ono, of course.**

Obrist There is an ever-increasing proliferation of video work. Writer Siegfried Zielinski, in his important reflections on 'advanced audiovision', discusses how the hegemonic role of cinema and television, both of which can be considered as interludes in the history of the moving image, are coming to an end due to their sheer ubiquity. Now that film has broken free of the specialized viewing space of a cinema or television, it has become a part of the network of moving images within the visual environment.

You used a large electronic billboard for *Open My Glade* (2000) in Times Square in New York; this was a way of injecting video into the urban flux.

Rist **I see Times Square as an overwhelming space full of electric blossoms and electronic twinkle that hit visitors like a slap in the face. I use the energy of this 'slap' to fuel my video segments. The video was broadcast for 60 seconds every hour, sixteen times each day. Viewers saw a woman flattening her face against the screen as if she wanted to break out and come down into the Square. The flattened face looks very deformed and needy. You want to set her free, and with her all the ghosts on the surrounding screens.**

Obrist These large-scale electronic billboards do not seem to be conceived as public space, but as private (rental) space for the advertising industry, and they are therefore normally used in a very homogeneous way.

When artist Felix Gonzalez-Torres (1957–96) produced his billboard projects in the early 1990s (such as the unmade bed in *Untitled*, 1991) he spoke of infiltration rather than confrontation: 'I want to … look like something else in order to infiltrate, in order to function as a virus. The virus is our worst enemy but should also be our model in terms of not being the opposition anymore.'[3]

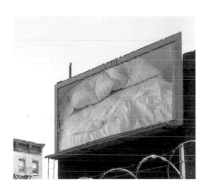

Felix Gonzalez-Torres
Untitled
1991
Billboard installation, 31–33
Second Avenue at East Second
Street, New York
Installation, 'Projects 34: Felix
Gonzalez-Torres', The Museum of
Modern Art, New York

following pages, **Open My Glade**
2000
Video installation
9 1-min. videos for Panasonic
Screen, running every quarter
past the hour from 6 April to 20
May, 2000
Panasonic Screen, Times Square,
New York
Commissioned by the Public Art
Fund, New York
page 25, Video stills

Rist **Yes. I think that 'trying to be different' is exactly the system already at work in Times Square, where thousands of advertisers are all trying to attract your attention at once. Advertising exists to grab our attention, and teams of advertising executives sit around tables asking, how can we be different? And of course they end up neutralizing each other. So, how can we really break with the resulting homogeneity?**

The screens on Times Square blink and flash and have their own unco-ordinated rhythm. The only genuinely 'different' image would be one in which the viewer can see and feel that there is no commercial intention behind it: this would truly be a shock. I don't pretend you can really knock TV out of its habitual hectic rhythm or provoke much reflection among viewers, even if this, of course, is what most artists would like to provoke – a distanced reflection on society, to shift the viewers just outside themselves and experience a flash of identification.

Pure subversion is no longer possible because our reality is too complex and disparate: it is already subversive in itself. I think mass media production, without the pressure of gaining a large audience (although I usually aim for that as well) is probably where the rupture occurs. The fact that an artist – who has nothing to sell but ideas, who has no direct commercial impetus, and no powerful company behind her – is given precious advertising time on Times Square is quite good. Art protects me even in this deeply commercialized site; it is my bodyguard.

Times Square, with all the big corporations, networks and advertising companies in the neighbourhood, is the symbol of the pseudo-democratic

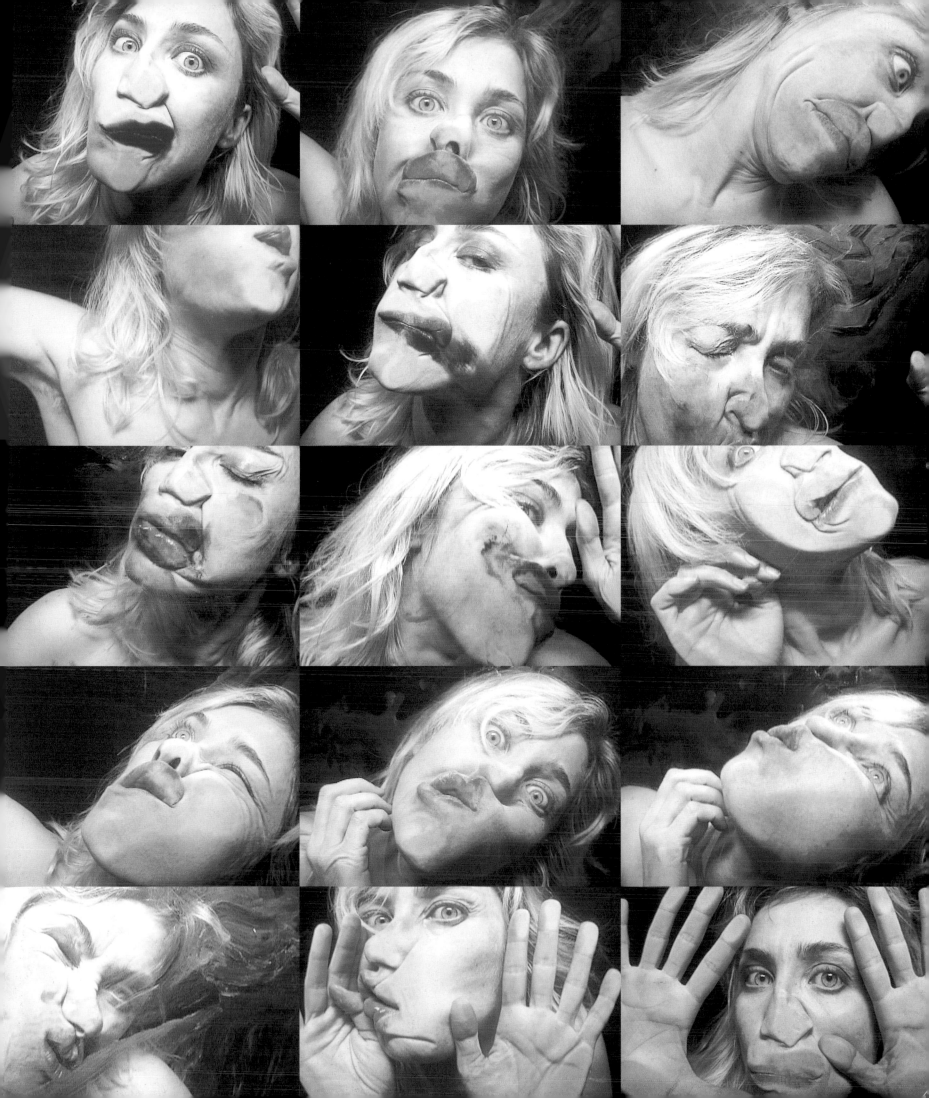

idea that your message can be heard by the whole world, all at once. New media does have some real democratic possibilities, but for the moment this idea still seems an illusion to me. In Times Square physical space melts into virtual space. Remember the New Year's Eve 2000 celebrations there, where you could watch 100,000 people watch themselves watching themselves on huge screens? It was wild.

I want people to pay attention to technology, to register its limits and its potential for deceit. Technology is so important in our lives! In the spirit of Paik, people should be more aware of the distinction between technological devices themselves and their virtual content. They should be aware of technology as a simple 'object', as the furniture of everyday life.

Obrist An interesting example of a use of technique in connection with subject matter can be seen on Colombian television. There, whenever there's news of another victim of terrorism, the image changes from colour to black and white.

Rist **Black and white pretends to represent documentary-like truth and credibility, which is what's most wanted and needed today. But the meaning of black and white is always changing. If you look at TV adverts now, a lot of them are reverting to black and white precisely because they want to be different. In 1991 black and white made an impact, but perhaps Gonzalez-Torres would have chosen a different strategy today. I made some technical tests in both colour and black and white on the screens in Times Square, and the black and white looked too fashionable. This opens up a whole issue for me: is it always necessary to react to trends or a current mood, or can I find an genuinely independent language?**

Obrist Often your videos and installations lead us into rooms within rooms, which reminds me of the writings of Georges Perec (1936–82). In *Espèces d'éspaces* (*Species of Spaces*, 1974), Perec describes how we never really know 'where a room stops, where it bends, where it separates and where it joins up again'. He wrote of rooms within rooms, and the magic charm of smaller and smaller repetitions of space, a complexity of convoluted spaces and images.

Rist **This kind of non-hierarchical space also acts as a remedy; it helps to open up your principal space: your mind and body. You may wish to imagine as many 'real' spaces as you can, but you can also open up your own primary space and expand it, so that you no longer return to a closed personal space. This is the main reason why I'm interested in these spaces within spaces.**

Obrist This view into a room 'behind the screen' transforms so-called public space into a more private space, creating as it were a room within a room. This idea often appears in your work: one space always hides another.

Rist **The moving picture itself is always a room within another room. When you project an image, the wall dissolves and the image becomes the architecture. I've been collecting pictures of rooms from interior decoration magazines for twenty years now. Once, in 1997, I wallpapered my living room with all these pictures of other living rooms. I never really had a theory about it; it was just a way to survive, a mind-opener, a way of enlarging horizons. Afterwards, for the installation *Himalaya Goldsteins Stube* (*Himalaya***

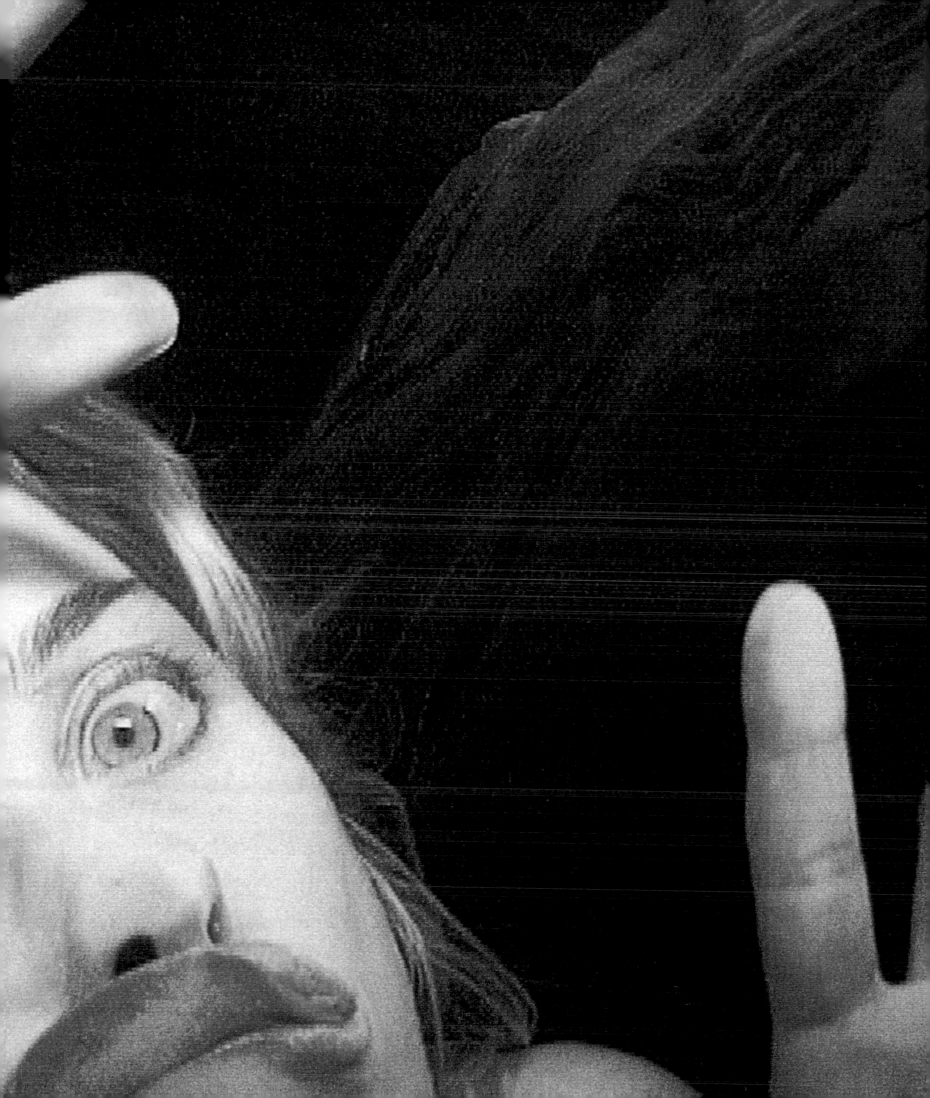

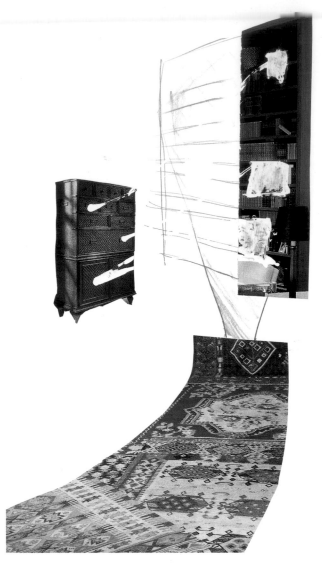

left, **Himalaya Goldsteins Stube**
(Himalaya Goldstein's Living Room)
1999
Acrylic, pencil, collage on paper
30 × 21 cm

opposite and following pages, **Himalaya
Goldsteins Stube** (Himalaya Goldstein's
Living Room)
1999
Video installation, sound with Anders
Guggisberg
13 video projections, 11 players, orange
seat, red sofa, desk lamp, high
sideboard, low sideboard, chair, table
and bar (all with built-in players), lamps,
wallpaper mounted on wood, audio
system, 4 speakers
Installation, Kunsthalle, Zurich
Collection, Bayerische
Staatsgemäldesammlungen, Munich

Goldstein's Living Room, **1999), I made digital scans of these living room
images, printed them out in different sizes and made computer collages from
them.**

**The artist Thomas Huber has said that today, now that we have explored
the whole geographical world, pictures or films are the new, unexplored
spaces into which we can escape. They are the new rooms in our physical
reality. I'm interested in the way levels of memory affect our view of the
present moment. What happened yesterday, and how does that change my
view of this moment, sitting at this table, overlooking the river Thames,
talking to you?**

Obrist This leads to the ideas of Israel Rosenfield, mathematician, doctor and
philosopher, who writes of memory as something dynamic.

Rist **Yes, but now I must go; my husband Maurizio calls me every evening at
the same time, after his spaghetti and I must be home.**

German parts of this interview translated by Simon Lenz.

1 See also 'Hans Ulrich Obrist Talks with Pipilotti Rist', *Artforum*, New York, April, 1998, p. 45

2 Preface to *Nam June Paik: Jardin Illuminé*, Galerie Hauser & Wirth, Zurich, 1993. See in this volume, pp.110–13

3 Felix Gonzalez-Torres interviewed by Hans Ulrich Obrist, Museum in Progress, Vienna, 1994

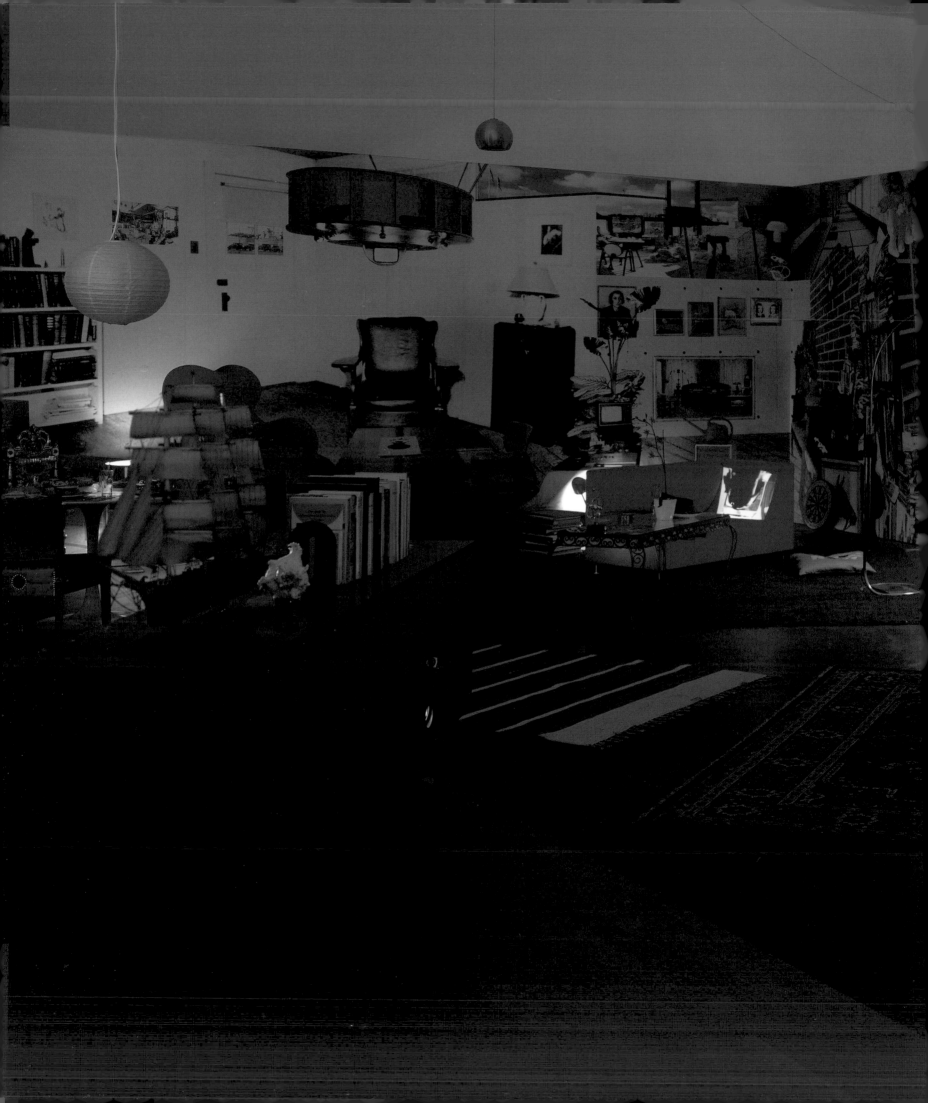

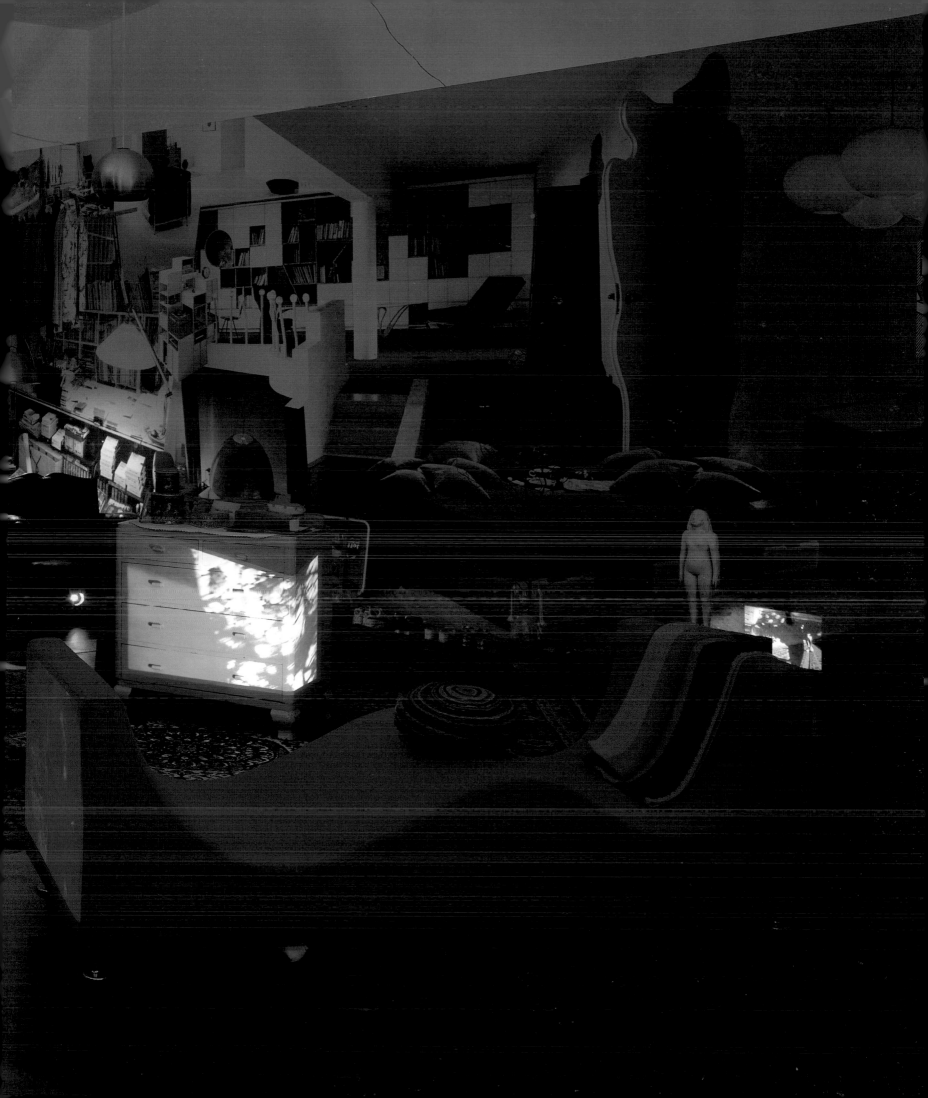

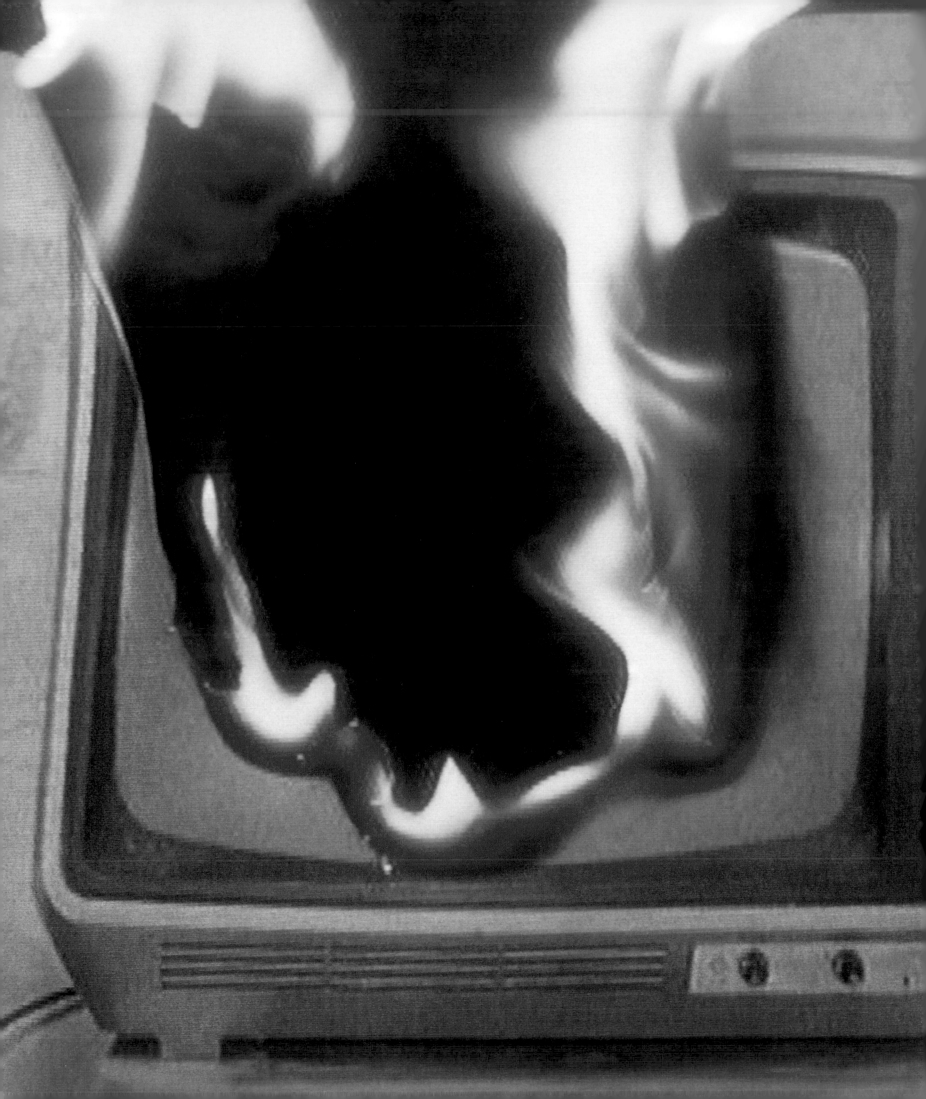

Contents

Interview I rist, you rist, she rists, he rists, we rist, you rist, they rist, tourist: **Hans Ulrich Obrist** in Conversation with **Pipilotti Rist, page 6.** **Survey** **Peggy Phelan** Opening Up Spaces within Spaces: The Expansive Art of Pipilotti Rist, **page 32.** **Focus** Elisabeth Bronfen *(Entlastungen) Piplottis Fehler ([Absolutions] Pipilotti's Mistakes)*, page 78. **Artist's Choice** Anne Sexton Barefoot, 1969, **page 94.** **Richard** Brautigan The Irrevocable Sadness of Her Thank You, 1980, **page 98.** **Artist's Writings** Pipilotti Rist Innocent Collection, 1988 - ongoing, **page 104.** Title, 1989, **page 106.** Preface to *Nam June Paik, Jardin Illuminé*, 1993, page 110. 'I Am Half-aware of the World': Interview with Christoph Doswald, 1984, **page 116.** Two Untitled Poems, 1996, page 130. Monologue in Car (Suburb Brain), 1999, **page 132.** A Dream, 1999, **page 136.** One Day – Friday, 6 August 2000, 2000, page 138. **Chronology** page 144 & Production Credits, Bibliography, List of Illustrations, **page 158.**

opposite, clockwise from top l.,
Rachel Whiteread
Ghost
1990
Plaster on steel frame
270 × 318 × 365 cm

Tony Oursler
Angerotic
1994
Cloth, wood, video projection
Doll, 20 × 10 × 10 cm

Matthew Barney
Drawing Restraint 7
1993
Video still
13 min., colour, silent

Stan Douglas
Hors-champs
1992
Video installation
13 min. 40 sec. each rotation,
black and white, sound
Installation, Institute of
Contemporary Arts, London

Douglas Gordon
Twenty-four Hour Psycho
1993
Video
24 hours, black and white, silent
Installation, 'Spellbound',
Hayward Gallery, London, 1996

Susan Hiller
Belshazzar's Feast
1983–84
Video installation

A winner of the Premio 2000 award at the Venice Biennial in 1997, and a finalist for the Hugo Boss Prize in 1998 at the SoHo Guggenheim Museum in New York, Pipilotti Rist is one of the most internationally acclaimed artists of her generation.[1] Her video installations, which combine elements of performance art, poetry, music and sculpture, envelop the viewer in a total environment, sometimes mesmerizing and enchanting, sometimes arch and witty. Beginning in 1986 with her brilliant single-channel video, *I'm Not the Girl Who Misses Much,* up to her one-minute projections *Open My Glade* (2000) on NBC's Panasonic videotron in the centre of New York's Times Square, Rist has demonstrated an impressive technological fluency while pursuing a remarkably consistent emotional and aesthetic investigation of space.

To put it succinctly, Rist has been devoted to exploring how to extend and enlarge spatial limits. Her work makes room for interior images, emotions, dreams and all that is usually edited out of external images on the stage of postmodern art. Video is at the centre of these investigations. Concentrating primarily on the ways in which the language and rhythm of video alters, surmounts, enriches and displaces our relationship to physical space and, therefore, to material reality, Rist's work to date offers an unusual opportunity to assess more richly what it means to live 'inside the box' of the ubiquitous external image.

While it has become a cliché of Postmodernism to say that reality is nothing but thick layers of representation, the consequences of this world-view still require careful sorting out. If reality is what we come to know through and in the screened image, how exactly should we view that screen? Is it the transparent frame that makes boundaries such as inside and outside, reality and fantasy, life and death, obsolete? These questions are at the heart of contemporary art, as witnessed in some of the most potent work made by Rachel Whiteread, Janine Antoni, Mariko Mori, Douglas Gordon, Cindy Sherman, Mona Hatoum, Susan Hiller, Stan Douglas, Tony Oursler, Matthew Barney and Glenn Ligon. Their work has been devoted to an illumination of the steady erosion of these lines. Whiteread's casts, for example, often turn sculptural objects inside out, like a child intent on wearing socks the wrong way around. Whiteread has been devoted to creating works that provoke public architecture and monuments to reflect on their private, usually hidden interiors. Similarly, Rist has been dedicated to making an intervention in the two most powerful, and contradictory, allures of video technologies. On the one hand, video is seen as a surveillance technology that eliminates the concept of a private act (at least in dominant capitalist cultures intent on maintaining property), and, on the other, video is seen as a way to value, through preservation and ownership, 'private' events – from birthday parties to sex acts. Politically, video has been a significant tool in enlarging access to the public sphere. Citizens' video-recording of police brutality, for example, has served as a powerful deterrent to sometimes licensed assault. On the other hand, video technology lends itself all too easily to the more noxious consequences of capitalist ideology: nothing that cannot be possessed, preserved and seen has any value. While the axiom 'what you see

is what you get' has enjoyed a full life, 'what you see is who you are' is becoming, for better or for worse, ever more accurate.

Surprisingly perhaps, despite its centrality to contemporary culture, video is still viewed with some scepticism in large portions of the art world. After a century of breathtaking achievement in cinema, an achievement often less celebrated than it might be because of the compromises it has often made with an industry devoted to producing largely mediocre and absurdly expensive entertainment, video often plays the role of the not yet blessed bastard. It's slick, it's cheap, it's fast and, above all, it's common. The same is true of still photography, although in recent years it has gained more status and respect in the art world; in fact, video has taken up the role still photography formerly held. More than the consequence of knee-jerk elitism still rife in large portions of the art world, the hesitation about video's claim to artistic merit comes from its 'once removed' relation to light. Cinema and still photography are both developed and projected in relation to the physics and chemistry of light. Video and digital photography are electronic interpretations of the effect of light.[2] Rist accentuates video's distance from 'natural' light by accenting the colours of her images to emphasize their artifice. Fuchsia-haired women, psychedelic washes, low-tech gimmicks and underwater shots edited to within an inch of their life conspire to create a visual surface in which 'interpretation' of everything – including light – is a necessity, a compulsion, a responsibility, an inevitability. Shooting over ten hours of footage for a three-

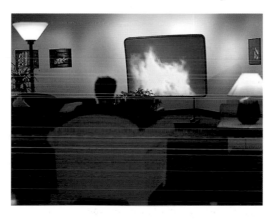

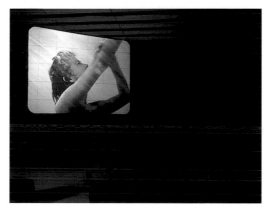

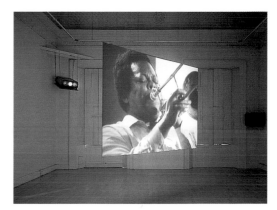

minute video, Rist's editing process is more than a search for match-line cuts. Her writing in sound and image takes on a sort of hypnotic and dream-like feel; it is aural and visual emotion melodically montaged.

Working against the tendency, indeed the desire, to view video as a transparent record of the real, Rist's art proposes a more complex relation between her dense visual surfaces and truth's elusive realities. In a 1994 interview, Rist compared her technological manipulation of video images to painting, suggesting that her 'technique is similar to painting, where expressiveness or tackiness comes closer to the truth than a perfectly sharp, slick representation'.[3] Willing to risk tackiness, in her early work Rist frequently employed a low-art look, crossing the conventions of Pop art and pornography in an extremely disciplined and technically accomplished manner. 'I work with trash', Rist admitted, 'But I want to control the trash with no technical compromises. I hate technically lousy things.'[4] As her work has progressed, however, her art has almost incarnated trash, becoming more explicitly lush and beautiful.

Becoming Pipi

Born Elisabeth Charlotte in 1962 in Rheintal, Switzerland, Rist studied at the Hochschule für Angewandte Kunst (Institute of Applied Arts) in Vienna from 1982 to 1986. On the eve of her entry into art school, Rist blended her love for Astrid Lindgren's great girl-hero of 1945, Pippi Longstocking, with her own affectionate pet name 'Lotti'. Becoming Pipilotti, the young artist

claimed the power of psychic and linguistic montage that would hold her in good stead for the next two decades. 'Pipilotti' declares Rist's allegiance to the realm of fantastic power and indomitable optimism in which children dwell. The enduring appeal of Lindgren's Pippi, who was raised on pirate ships and had magical physical strength and great generosity, comes from the girl's fidelity to her own enigmatic desire. Unable to do as she is told with sufficient conformity to attend school, nor able to live in peace with her father and the ghost of her dead mother, Pippi Longstocking pledges allegiance only to her own heart – making her a rare feminist heroine in children's literature. Rist, Pippi's contemporary incarnation, pirates pop culture and avant-garde art history as she travels the world channelling and re-channelling her video and sculptural installations. Evoking Pippi in innumerable interviews and public statements, Rist keeps Longstocking's story front and centre in framing the sly spirit of her own art: to keep faith with the enigmatic desire of the machine and with the equally enigmatic desire of those enthralled with the machine.

In Vienna, Rist studied illustration, photography and, notably, commercial art. She also 'made Super-8 animation films, created stage sets for bands and did a lot of drawing'.[5] After four years in Austria, Rist returned to Switzerland and, between 1986 and 1988, studied video and animation at the Fachhochschule für Gestaltung (School of Design) in Basel. The steady patience of an animator combined with the exuberant irreverence of a rock star inform Rist's best art.

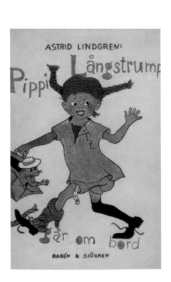

Pippi Långstrump (Pippi
Longstocking)
c. 1946
Created by Astrid Lindgren
Illustrated by Ingrid Vang-Nyman

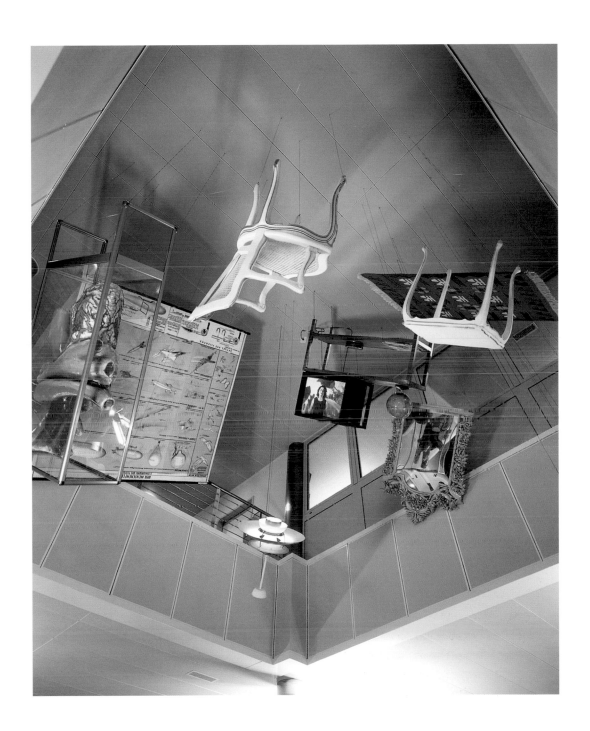

Fliegendes Zimmer (Flying Room)
1995
Video installation, silent
Monitor, furniture illusionistically
hung on ropes, oil painting
(*Fernsehturm Buchs* by Anders
Guggisberg)
Permanent installation, lobby of
UBS, Buchs, Switzerland

Selbstlos im Lavabad (Selfless in
the Bath of Lava)
1994
Video stills

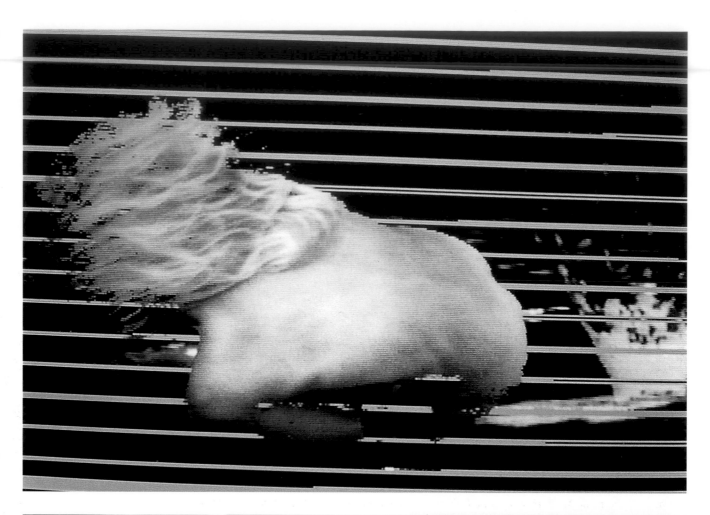

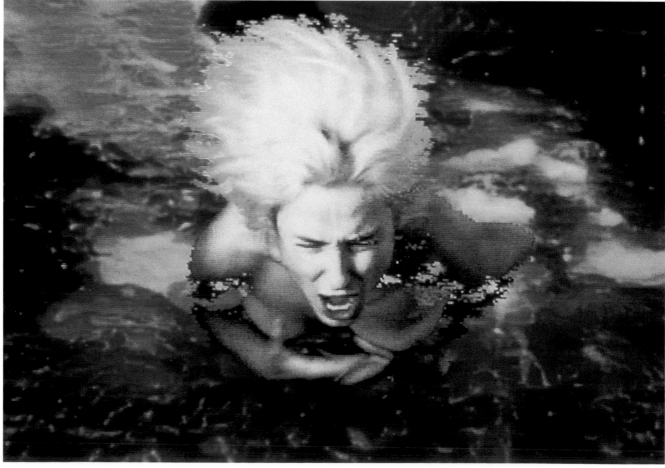

Traversing spaces as diverse as the tiny flap of a single wooden floor panel (*Selbstlos im Lavabad* [*Selfless in the Bath of Lava*, 1994]), to the large lobby of the Swiss Banking Corporation in Buchs, Switzerland (*Fliegendes Zimmer* [*Flying Room*], 1995), to New York's Times Square videotron (*Open My Glade*, 2000), Rist's installations expose both the steaming heat of erotic desire and the mindless wash of a million advertisements. Underneath all of her work is a continual examination of the technological and ideological effects of our screened lives. Light, colour, opening, closing, zooming, fading: the technical language of the camera's motion also, for Rist, contains a language of emotion. 'I love you relentless colour, overexposed.'[6]

In her 1989 essay, 'Title', Rist notes: '*Making videos ... means doing family therapy; the television is a family member, so to speak. If my work is intense, honest and good, then its therapeutic function is also my social relevance.*'[7] Written when she was twenty-seven, Rist's statement provides a useful point of entry into her early work. The idea that the television is not merely a functional appliance but rather an animate character in the family romance informed the spirit of Rist's work from 1986 to 1996.

Secrets and Dreams

One of video's attractions for Rist was that she could do most of the work herself. 'I opted for video because I can perform all the steps myself, from the camera work to online editing, and that suits me. I can work all by myself or in a small team', she stated in 2000. 'I do not want to copy

reality in my work; "reality" is always much sharper and more contrasted than anything that can ever be created with video. Video has its own particular qualities, it's own lousy, nervous, innerworld quality, and I work with that.'[8] Motivated by the possibility that the inner world of video paralleled her own unconscious, Rist attempted to capture machine dreams, to trace the secrets often edited out of the television, film and video images that flood our consciousness.

In other words, Rist has been interested in video's relationship to the secret; like a good psychoanalyst, she proposes that the secret has at least two registers. First, there is the secret code within the technological transmission that allows the secret to be read; then there is the secret that the transmission reveals. Borrowing the language of Sigmund Freud's *The Interpretation of Dreams*, we can call the first level of the secret the latent content, and the second, its manifest content.[9] Subjecting both the code and the content to psychoanalytic interpretation, Rist insists that if we are to come to terms with the screen central to Postmodernism, we must look very carefully at both the content on the visual surface of that screen and at the out-takes edited from that screen. Rist, like many of her peers, sees the screen as itself an object – indeed perhaps as 'the' object *par excellence* – that serves as the threshold between Modernism and Postmodernism.

It is not so much that generations of artists prior to Rist's were somehow immune from the effects, both good and ill, of Postmodernity, but that prior to this generation the line between reality and representation was recognized as a

Laurie Anderson
Stories from the Nerve Bible
1992–93
Multimedia performance

Andy Warhol
The Chelsea Girls
1966
Film still
16 mm film
3 hours, 15 min., two-screen,
colour and black and white, sound

force, even if one whose clarity and strength were diminishing. While older artists such as Nam June Paik and Laurie Anderson have been inspired by video and sound technologies, much of their work has been addressed to an audience which sees these forms as almost 'avant-garde' in and of themselves. Rist addresses an audience which views these technologies as a given. Her generation came of age when the distinction between reality and representation had already been lost. Thinking 'outside the box' or 'beyond the market', as earlier generations of artists aspired to do, are no longer compelling notions for those who accept that there is no way to evade the box, no way to imagine a space 'beyond' the market. With typical forthrightness, Rist claims, 'I don't see why it [art] shouldn't be commercial. It's absurd. Even if the art world keeps denying it, the art market exists and functions according to the same laws as any other business.'[10] Rist is one of the few women in the art world blunt enough to admit that her art is a business.

In this, and in much else, Rist makes a plausible claim for being counted as one of the most compelling heirs of Andy Warhol. Describing

her series of nine one-minute video projections for the Times Square project as 'advertisements for feelings', Rist echoes Warhol's conviction that commercial and high art are not mutually exclusive genres. Warhol, of course, liked to pretend he had no feelings, but his performance stemmed from a capitalist conviction that he only wanted to be associated with things that sold. Rist knows that, for better or for worse, at the dawn of the twenty-first century everything is for sale. And she also knows that women's power in the market still derives from their emotional expertise.[11] While Rist's characteristic performance in interviews and press statements is a kind of cheery exuberance, and Warhol's was a kind of passive acceptance of anything the interviewer said, the profundity of their best work lies in darker insights.

What distinguishes Rist's work from other influential artists working with video and new technologies, such as Matthew Barney, Tony Oursler, Stan Douglas and Douglas Gordon, is her wit, her brevity, her accessibility and, above all, her fascination with emotions in and of themselves. Her 'advertisements for feelings' projected in Times Square often seemed to be ads for not

having too many. Rist's videos astutely point to the acquisitive structure of the media screen: from ads to news, public screen projections participate in an economy of having, possessing, knowing and owning. Her more enigmatic projections suggest that emotions are not things to be acquired or owned, but rather are things that circulate and gain value only when they are given to others. This economy upsets the system of capital, including image capital, that holds us ever more captive. Eloquently reflecting the claustrophobia and insularity of our screened reality, many of the videos in *Open My Glade* displayed a woman's face (Rist's own) pressed hard up against a window/screen. Projected in the sea of screens that now compromise the architectural centre of the 'new' Times Square, Rist's project exposed all too well the violent limit of capitalism's sharply edged screen.

Retakes and Mistakes

Rist's work exposes the elisions and omissions within 'the given-to-be-seen' that video's very ubiquity seems to erase. Unwilling to ignore the failures and mistakes that the photographic arts often repress as 'bad takes', between 1986 and 1989 Rist pursued the glitches and mis-cues of video transmissions, proposing that they might offer clues to a kind of technological unconscious that can illuminate our own. Just as Freud focused on the symptoms that produced bodily 'failures' – paralysis and aphonia chief among them – Rist has focused on the gurgling burps of video sound tracks, the bleeds of colour bands, the melody of feedback static and the dripping ooze of loose vertical hold that all produce so-called 'bad pictures'. For Rist, these symptomatic knots in transmission suggest the charged crossing of the human and technological unconscious. Rist wagers that the technological unconscious might be able to 'free associate' lucidly enough to illuminate our own unconscious desires and fears.

Walter Benjamin, the prescient cultural theorist, was the first to articulate the unique role of the camera in exposing an 'unconscious optics'. Suggesting that 'a different nature opens itself to the camera than to the open eye', Benjamin equates the revelations of the camera to those of

opposite, **Japsen** (with Muda Mathis)
1988
Video stills
12 min., colour, sound

below, **Die Tempodrosslerin saust**
(The Tempo-throttler's Rushing)
(with Muda Mathis)
1989
Video stills
15 min., colour, sound with Les Reines Prochaines

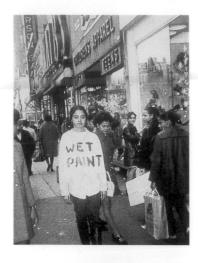

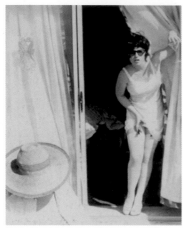

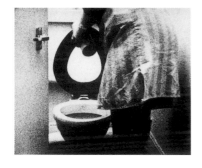

Adrian Piper
Catalysis III
1970–71
Action document

Cindy Sherman
Untitled Film Still 7
1978
Gelatin silver print
25 × 20 cm

Berwick Street Film Collective,
including **Mary Kelly**
Nightcleaners
1975
Film still
90 min., 16 mm film, black and
white

psychoanalysis: '*The act of reaching for a lighter or a spoon is familiar routine, yet we hardly know what really goes on between hand and metal, not to mention how this fluctuates with our moods. Here the camera intervenes with the resources of its lowerings and liftings, its interruptions and isolations, its extensions and accelerations, its enlargements and reductions. The camera introduces us to unconscious optics as does psychoanalysis to unconscious impulses.*'[12]

Benjamin wrote at a time that was full of the foreboding of a catastrophic loss, when much more than the 'aura of the original' was likely to be lost. Rist works in the buzzing static of the catastrophe's incompleteness. While officially over and off the air, World War II continues to haunt history. For Rist, the technological unconscious exists in the elusive space between the machine's expressions and the viewer's encounter with them. That space is full of multiple histories that may or may not overlap. Her transmissions reside neither on the side of the suffering patient/machine, nor on the side of the all-seeing doctor/spectator, but rather in the liminal space between them. Her art is the very provocation – sometimes erotic, sometimes traumatic, sometimes melancholic, sometimes hilarious – that keeps their meetings necessary.

I'm Not the Girl

From the start, Rist's work has been described either as feminist art and/or as sophisticated music video. Both terms are accurate, although somewhat limiting. The reason the critical terminology has been so persistent, however, stems both from the power of her first significant

piece, *I'm Not the Girl Who Misses Much*, and from Rist's own struggle to articulate her evolving work in a vocabulary that crosses multiple languages and two significantly different moments in art history. In 1986, feminist art was central to contemporary art theory; in 2000 it is often hurriedly, and mistakenly, dismissed as a movement that has been superseded by more complicated ideological positions. While theorists have been rushing to the newest fashionable critical paradigm, many contemporary artists have been returning to the work of 1970s feminism.[13]

Rist's single-channel video, created while she was still in art school, condenses John Lennon's lyrics to *Happiness Is a Warm Gun* (1968)[14] to one line. Significantly, the condensation also transposes the third-person of his lyric, 'She's not a girl', to first-person, 'I'm not the girl'. In an interview, Rist admitted: 'As a girl I dreamed that I was the reincarnation of John Lennon.'[15] While the video does not literalize her dream, it employs the jump-cuts and dissolves central to dreaming.

The political, kinetic and psychic drama of the linguistic pronoun shift from 'she' to 'I' is registered through the disjuncture between the image and soundtracks in Rist's video. Manipulating the speed of the soundtrack, sometimes as fast as The Chipmunks, sometimes as slow as a funeral dirge, Rist creates a different rhythm and pulse between sound and image. Rist's technological manipulations become even more absorbing as the video continues. The image loses both vertical and horizontal hold. The video surface is scissored in zig-zag lines, suggesting that video editing is a form of paper-cutting as grand as Matisse's paper

cut-outs. The spectator must scramble to make sense of the scrambled tracks: putting the pieces together exposes the work of interpretation at the heart of art viewing. And what a view she gives us! The sped-up frenzy of Rist's dancing, a hilarious, breast-popping, animated bob around a room that seems precipitously small, is at once melancholic and joyous.

The buzzing static of the electrical transmission serves as the objective correlative for the linguistic, psychic and political transposition from Lennon's 'she' to Rist's 'I'. In Lennon's version, the line only occurs once; it's the first line of the lyric. In Rist's, the line serves as the whole song. While pop music has a long and vibrant relation to 'doing covers', re-recording great but often neglected songs, Rist inverts that tradition by taking a neglected line from Lennon's song and covering it. Her 'cover', then, is also a recovery. At one point in the video her maniacally accelerated dancing leads her to slide down a wall and almost disappear from the frame.

While many feminist artists and theorists have worried about what it might take for women under patriarchy to move from being the objects of men's sentences to the subjects of their own, Rist amplifies the static in the way the proposition is stated. By the mid 1980s, feminist artists and theorists had clearly articulated the trap for women within the representational codes of patriarchy: to enter the frame of representation is already to approve of that frame; however, to reject that frame allows patriarchy to continue its traditional obliviousness to women as anything other than 'objects' of masculine power.

Influential feminist artists of the 1980s, such as Mary Kelly, Adrian Piper, Cindy Sherman, Jenny Holzer and many others, had dedicated themselves to exposing the impoverishment of that frame. Rist's *I'm Not the Girl Who Misses Much* consolidates those theoretical and aesthetic convictions and extends them to music video, a genre in which women had quickly become codified once again as only sexual objects. Energetically refusing the passivity of that position, Rist introduces a bittersweet comic edge to the feminist project. Her jerky dancing, sartorial disarray, messy make-up and jiggling naked breasts coyly mocked the implicit puritanism in some of feminism's renunciation of visual pleasure. Moreover, the difficulty of joining the lyric and the image deftly enacts the difficulty of women's attempts to become 'fully-embodied subjects under patriarchy'. The whole enterprise feels dauntingly out-of-sync, yet somehow extremely compelling.

Technically, visually, aurally and emotionally, it's an audacious performance. Drawing on her six-year stint (1988–94) playing percussion, bass and flute in the all-women rock band Les Reines Prochaines (The Next Queens), two years creating stage sets for rock bands and that wide repertoire of femininity-in-everyday-life common to attractive young women, Rist's performance registers first as a technological triumph. The editing is an unabashed declaration of disloyalty to high production values, to smooth sync, to the lie of 'the look'. Aesthetic tyranny, from high fashion to high art, has edited out the vibrant bleed of the mistake necessary to the vitality of art

I'm Not the Girl Who Misses Much
1986
Video still
5 min., colour, sound

John Lennon
c. 1970

and life. Rock 'n' roll, one of the few places where one might hope to find rebellious resistance, was beginning to surrender, all too meekly, to that tyranny. MTV had begun airing a twenty-four hour cable broadcast of video-clips, and music video was quickly becoming rigidly generic. Although Rist has repeatedly maintained that she had not seen any music videos until after 1986, her piece was widely seen as a kind of send-up of the genre. Music clips had quickly become a sophisticated form of marketing; the perfectly reproduced commodity was celebrated, rather than the miscued entries, the breaking voice, the wandering figures, the elusive magic of ephemeral mistakes. (MTV, recognizing the problem, tried to address it by making a new genre of the non-generic. They named their recordings of 'live' sessions the 'unplugged' series and advertised the broadcast times, which were, paradoxically, regularly repeated.) Lennon himself was a hero of the mistake and, in the 1968 Esher recording of *Happiness Is a Warm Gun*, he gets the chord wrong, stops, and does it again. This model of mistake and return has been a central one for Rist.

Critic Peter Schjeldahl has astutely observed that: '*Music videos dwarf museum art. Their economic base in the global entertainment industry and their social site is the universal cyberair. Rist opts to function as a museum artist, but don't be misled. She exploits the museum for music video's sake, not vice versa.*'[16] One of probably only a handful of great music video artists working independently of the music-advertising business, Rist's work can be seen as a critique of the form. But in considering Rist's work in this way one risks

reifying music video rather than looking carefully at Rist's art, both of which are more complicated than this argument suggests. Moreover, Rist herself often praises her 'colleagues' in music video and advertising, thwarting attempts to see her as a kind of feminist scold.

Unencumbered by the marketing pressure to sell a song, Rist's single-channel works often caress the glitches in colour and sync as a way to embrace the larger losses with which we must contend in our screened world. Her insistence on exposing 'bad pictures' removes her from the aesthetic orthodoxies of most music video; moreover, it lends her work an evocative gravity. Rist explained it this way in 1989: '*The faulty images reveal what is otherwise concealed. These are the pictures that the industry technicians are so horrified by, or that they simply ignore. But there are lots of other people working with botched material. By doing so we pay homage […] to the dead inventors who created these tools.*'[17]

It's a very complicated homage, however. By recalling those who are dead and therefore beyond 'the given to be seen', Rist invites her spectator to look beyond the surface of her work to what is usually kept off-screen. Moreover, by paying homage to the dead by remembering their now-superseded, if not quite obsolete inventions, we necessarily place ourselves in a space that extends beyond theirs. Their displacement is not necessarily violent; it might indeed be necessary for us to take up our own work, our own lives. Thinking of video as a kind of living anthology still pulsing with the history of its earlier forms, Rist encourages her viewers to reconsider the

traditional conception of the past and the dead as somehow over, gone, vanished. Re/covering a line from Lennon's song, Rist also makes an intervention into the ongoing historicity of his death. Shot by a gun held by Mark Chapman in 1980, Lennon's death transforms the 'original' version of *Happiness Is a Warm Gun*. The song's lyrics both anticipate and recollect the event that lies beyond the moment they were recorded. The recording, which is re-encountered over and over by new listeners, becomes a different song after Lennon's death in 1980. More than saying that 'new meanings' are added to the song after the shooting, I am suggesting, more fundamentally, that a new song is heard. When Benjamin considered the loss of originality in the work of art in the age of mechanical reproduction, he did not fully anticipate the role of temporality at the heart of the living performative encounter with art. After Lennon's shooting, the record itself gains a different impression and it becomes impossible to hear: 'When I hold you in my arms /And I feel my finger on your trigger/ I know no one can do me harm / Because happiness is a warm gun' in an exclusively sexual register. Precisely what was missed the first time (the time before the shooting) was the possibility of missing the overdetermined meanings of 'no one can do me harm/ Because happiness is a warm gun'. Thus, Rist's *I'm Not the Girl Who Misses Much* is a kind of posthumous bearing witness to that which was missed in the 'first' impression of the LP. This witnessing re-covers the song precisely by uncovering what we missed in its meaning the first time.

More profoundly, *I'm Not the Girl Who Misses Much* is itself canny about its own propensity towards forgetting. Unable to deliver more than a promise to remember – and a promise, precisely because it promises – defers rather than delivers that which is promised. Rist's 'homage' here to another dead inventor oscillates between her desire to remember and her knowledge that she'll forget. Wavering between an urgent, sped-up, intense memory and a murkier droning, *I'm Not the Girl Who Misses Much* promises only to try not to miss everything again. Each attempt and each promise is less innocent than the previous one, for the accumulating repetitions produce a knowing that erodes innocence. 'It takes a lot of skill to make up for every iota of innocence we lose. On top of that, we work to recover unabashed innocence and blend it with the know-how we've acquired', writes Rist.[18]

The flowering of the central insights of *I'm Not the Girl Who Misses Much* can be seen in Rist's remarkable 1988 piece, *(Entlastungen) Pipilottis Fehler* (*[Absolutions] Pipilotti's Mistakes*). Elisabeth Bronfen, in her essay in this volume, reads the video as a complex feminist response to psychoanalytic notions of hysteria. She argues that in this video, 'Rather than representing feminine malaise as a loss of language (with its corresponding loss of power), by performing difference Pipilotti Rist celebrates the malfunction of a language regulated by normative laws.'[19] The difference that Rist's work 'performs' is quite difficult to elucidate, in part because it involves falling into falling. Birgit Kempker has written an evocative response to the twelve-minute video

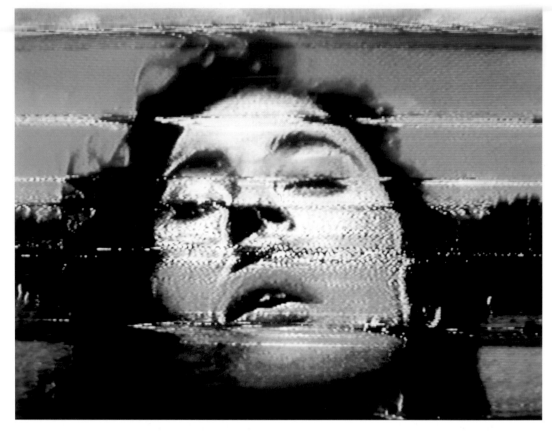

(Entlastungen) Piplottis Fehler
([Absolutions] Pipilotti's
Mistakes), from the 'Heads Series'
1988
Video still
12 min., colour, sound

which, following Rist's example, tries to expose rather than to hide the difficulty of describing the piece: '*It is a matter of transformation rather than contrasts, of transitions rather than objects, though that, too, is too awkward a way of expressing what takes place between the forms, figures, sounds, and eyes and ears, what takes place between thinking and bodies, which is also a way of saying: easy as the figures seem to fall, it is difficult to capture them into words, to clothe them in concepts, to incorporate them into the concept, to drum them into service.*'[20]

Beginning with the title, a rhetorical figure that bespeaks the difficulty of speaking across languages – be they verbal, physical, visual or aural – Rist indicates the value in the blurry impression, as opposed to the clarity of the factual act. *Entlastungen* is often translated as 'absolutions', and that term helps register the ethical challenge of the work. But 'unburdenings'

conveys the sense of work involved in the labour of assessing and interpreting what can be put down and what must be taken up, repeatedly. In French *Entlastungen* is rendered as 'desculpations' and the Latin *culpa* nestled within that word rings with the echo of the theology of regret (*Mea culpa, mea culpa, mea maxima culpa*).

To the soundtrack's percussive rhythm, two different women repeatedly fall down, stand up and fall again. Another woman tries unsuccessfully to scale the walls that constrain her and is also unable to quit trying; remarkably, the work forgives both failures. An extraordinarily compassionate piece, the video heroically pursues the labour of living with one's mistakes. The sheer effort of this task, the apparently infinite possible ways of seeing and hearing one's own failures, might also be seen in terms of the larger political preoccupation with absolution that remains one of the central dilemmas for contemporary politics.

When is forgiveness possible? Switzerland, like Sweden, was officially neutral during World War II. Unlike Sweden, however, Switzerland is not part of the European Union. It seems ever clearer that confronting the war will be one of the most important challenges the European Union faces and its future may well depend on finding a way to make 'absolution' fall into alignment with 'justice'. Can the effort to extend absolution contribute to the enormity of the pain of the catastrophe itself? What would it mean to try to withhold it, or to extend it? Rist insists that both options will require an extraordinary tolerance for errors and an immense capacity for re-imagining how the surface images of the present come to us as carefully edited compositions.

Incorporating home movies of her younger self swimming and being dunked in a pool, the video also suggests the impossibility of precise memory. As Bronfen puts it, 'by bracketing the word Entlastungen, *Pipilotti Rist immediately draws our attention to the seminal, rhetorical idea of her video – namely, that exoneration is possible only to a degree; that a trace of guilt, a mark of imperfection will always remain, marring any drive towards a perfect, flawless and unblemished state of being in the world.'[21] Thus, the idea of absolution comes to us already idealized, thereby making it impossible to realize it psychically or to actualize it historically. At the end of the video, this impossibility is stated this way: 'I want to say that life is beautiful. Look at these colours, look at the amusing television programme. Look at the cosmos. But my pain has blinded me. The sun is setting. Soon I will no longer be cheerful. I hate all ideas of the ideal, which doesn't exist.'[22] The logic of the statement is: 'I hate all ideas of the ideal because the ideal does not exist.' In leaving the 'because' out, Rist also leaves out the logic of causality more generally. Instead of, 'I got up because I fell down', the video seems to suggest another possibility for action. Almost Beckettian in its oscillation between 'I can't go on / I go on', Rist's argument with the ideal is that it refuses both to appear and to vanish. In that refusal, we are consigned to repeat our wish for its return and our acknowledgement of that impossibility.

Discussing how she went about creating the dense visual errors that bleed across the surface of *(Absolutions) Pipilotti's Mistakes,* Rist said, *'I subjected the images to all kinds of interference: I played them too quickly for two simultaneously activated recorders, then put the pictures through a time-base corrector that evens out irregularities. That was only one of twenty-five kinds of disturbance that I experimented with on the tape. Asking too much or too little of the machines resulted in pictures that I was thoroughly familiar with, my inner pictures – my psychosomatic symptoms.'[23]* So too will asking too much or too little of those who come after the catastrophe risk merely repeating the same narratives of excess or inadequacy. But getting it 'just right' only happens in fairy tales. Thus the challenge may well be to learn to incorporate 'all kinds of interference' in all images dedicated to envisioning an ethics of the future. An ethics too blindly enthralled to an ideal, like an ethics too defeated to pursue restitution, might leave us falling away from the justice we most want to realize.

Sexy Sad 1
1987
Video still
4 min., 30 sec., colour, sound

Embodied Machines

Alert both to the affective and philosophical consequences of Western culture's romance with the camera, Rist has suggested that the human body is itself a metaphor for the camera's technology: 'Our eyes are blood-operated cameras.'[24] The camera's fatigue and bleed are illuminations of our own. This radically anthropomorphic view of the camera propels the intimacy of Rist's art and has led her to reclaim some of the terrain seceded to pornography. While pornography has long celebrated the alluring visual echo between the dilating eye of the camera and the dilation of the anus, an echo that underscores one aspect of the erotics of the visual, Rist channels that echo into music of her own. In some of her works made in the late 1980s and early 1990s, with wry titles such as *Pickelporno* (*Pimple Porno)* and *Blauer Leibesbrief* (*Blue Bodily Letter*) (both 1992), Rist employs the conventions of pornography to celebrate narcissism rather than to replay the familiar loop of objectification, voyeurism and fetishism of the naked white woman caught under the male gaze. Posing for her own camera, Rist's auto-eroticism is oddly alluring. Unlike other artists who have raided the apparatus and allure of pornography for high art, from Jeff Koons' and Ilona Staller's sexually explicit works and titles (for example, *Jeff Eating Ilona*, 1991), to the soft porn allusions strewn throughout contemporary photography and fashion, Rist maintains a curious innocence. She is not naïve. But, remarkably, she seems to have escaped the oppressive weight of sexual guilt, an unusual achievement for any adult, but almost unheard of for an attractive Western white woman.

In her 1992 *Pickelporno* (*Pimple Porno*), Rist attached a tiny surveillance camera to the end of a stick and filmed an Asian man and a European woman pursuing a carnal passion. The extreme close-ups of bodily orifices are intercut with brightly coloured images of fruit and flowers, giving the proceedings a hilarious edge. He wears a kind of astro-turf bikini and she spins across the sky clutching a globe between her thighs. Attempting to capture the floating feeling of great sex, *Pimple Porno* creates a riotous videoscape that scrambles space and time and collects their slow drip through skin the way carnal passion can.

In her subtly provocative short video, *Mutaflor* (1996), the camera, in a long overhead shot, observes a naked woman wearing bright red lipstick, sitting in an empty room surrounded by croissants and oranges. The camera slowly moves in towards her face as she opens her mouth and then the screen goes dark. A second later the screen fills again with the same colour and, one assumes, the same image. But as the camera moves back to its original position, the viewer realizes one is observing the opening and closing not of the woman's mouth but of her dilating anus.

With works like these, not surprisingly, Rist's relationship to feminism is complicated. On the one hand, her work celebrates women's bodies. *Blutclip* (*Bloodclip*, 1993), a two-minute music video that played on Swiss television, is an exuberant ode to menstruation. 'I would be happy if young girls who have their first period see it as an occasion for loud rejoicing. Bring the blood out into the open, show this red fluid, this wonderful

Blauer Leibesbrief (Blue Bodily
Letter)
1992/98
Video stills
Installation video projected
sharply angled on a coloured wall,
with white paint bubble, sound

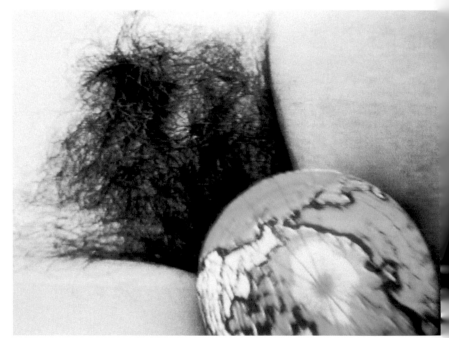

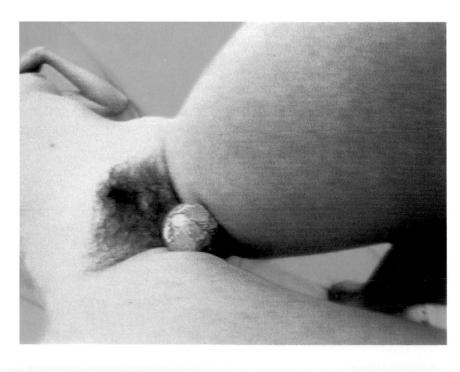

Pickelporno (Pimple Porno)
1992
Video stills
12 min., colour, sound

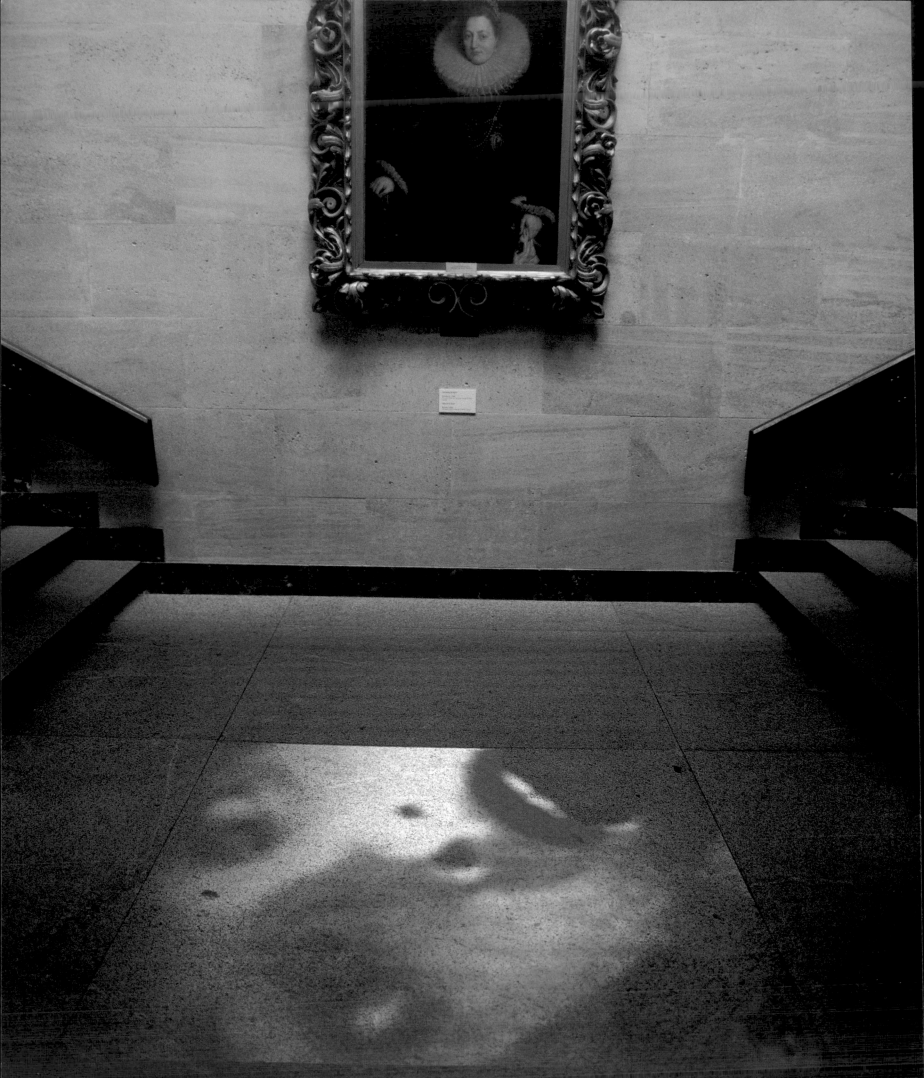

sap.'[25] On the other hand, Rist has a *realpolitik*
about her, in common with other successful artists
of her generation, but still a bit tricky to reconcile
with mainstream notions of feminism. In a blunt
mood, Rist observed: '*Of course I am a feminist
because every normal person is a feminist. I am a
feminist in a political way in that I am for the same
salaries and the same jobs. But in my private life I
don't have to be because the people I am dealing
with are not assholes. I am grateful for feminism.
But women did it once so I don't have to go back
and do what they did.*'[26] Rist seems to share the
widely accepted idea that feminism has largely
succeeded and that now there are other issues that
are more central to the politics and aesthetics of
contemporary art. Some might disagree with Rist's
optimistic assumption that since 'women did it
once' there's no need to do it again. Arguments
could easily be made pointing out the difficulty in
separating the political and the personal as neatly
as Rist does here. But in the end, it is in the work,
rather than in statements about the work, that
Rist's ideological positions emerge most clearly.

Towards Flowering

As she continued to work with video, her interest
in the spatial possibilities of the screen increased.
In *Yoghurt on Skin – Velvet on TV* (1994) and
Eindrücke verdauen (*Digesting Impressions,* 1993),
Rist tried to complicate the viewing experience by
eliminating the large square box of the monitor as
the primary frame for viewing. In *Yoghurt,* she
placed tiny monitors inside handbags and seashells
and placed them on pedestals. If one opened a
purse or peered into a seashell, one might see a

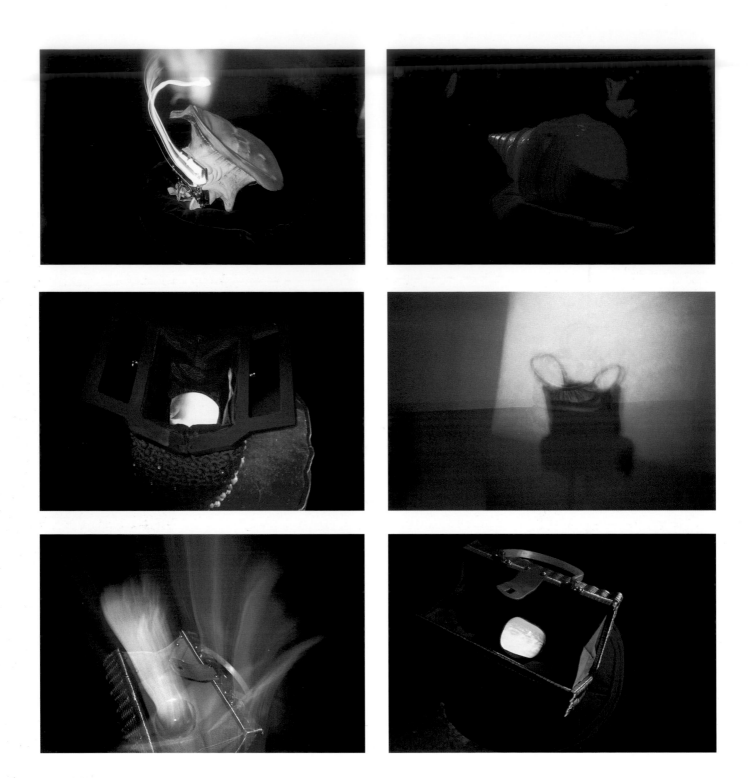

Yoghurt on Skin – Velvet on TV
1994
Video installation, sound
8 players, 3 shells and 3 handbags
with built-in LCD monitors with
sound, 1 LCD at the entrance,
projection, 3 computer-controlled
track-spots, orange and pink
paint on walls
Installation, Neue Galerie Graz,
1995
Collection, Kunsthaus Zurich
opposite, installation details

Eindrücke Verdauen (Digesting
Impressions)
1993
Video installation, silent
Black and white spherical
monitor, swim suit, bows
Installation, Galerie Stampa,
Basel

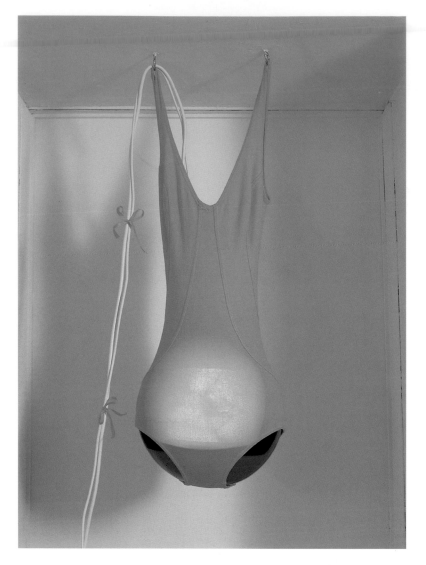

intestines, suggesting perhaps a limit to the
appeal of an ever-closer look.

These works culminated in a large-scale piece
entitled *Eine Spitze in den Westen – ein Blick in den
Osten* (*A Peak into the West – A Look into the East*,
1992/99). Three oddly shaped structures, best
described as horizontal pyramids, abutted the wall
at eye level; each contained four head-level
openings. In order to see the videos inside, the
spectator had to enter the 'peep-hole' to look. In
all three of these works, Rist was attempting to
combine video with installation, looking for a way
to interfere with the architectural and spatial
orientation of the fixed screen emanating from the
square box of the monitor. But the installations
also risked overwhelming the video images; the
viewer was sometimes more entranced by picking
up the seashell or opening the purse than by
looking at the video.

In 1996, with *Sip My Ocean,* and again in 1997
with *Ever Is Over All,* Rist solved her problem by
enlarging her screen, eliminating the monitor and
working more intimately with the architecture of
the exhibition space itself. 'When you project an
image, the wall dissolves and the image becomes
the architecture.'[27] *Sip My Ocean*, a mirrored
projection, dilates and expands in the crease of
the room where two walls join. Having created
these two pieces (discussed in detail below) Rist
returned to installation again and this time found
ways to make her videos appear utterly necessary
to the space itself. No longer an 'accessory' in a
handbag, Rist's latest videos are full architectures
that serve to frame the external projection of her
inner pictures.

video of a brightly coloured sea scene, or a garish
toe spotted with red blood. Inverting the
prohibition against touching the art object
common to most museums and galleries, *Yoghurt*
also brought a haptic dimension to Rist's work,
which had been primarily visual and aural before.
In *Digesting Impressions*, Rist placed a circular
monitor inside a woman's yellow bathing suit and
suspended it from the ceiling. A kind of bobbing
buoy, the slightly transparent swimsuit served as
both a skin that veiled and a skin that beckoned
the eye. Looking closely, one could glimpse an
endoscopic camera's progress through human

left, **Eine Spitze in den Westen – ein Blick in den Osten** (A Peak into the West – A Look into the East) (detail)
1992/99
Video installation, sound
Video projection, audio system, wood, aluminium construction in pyramid form, head-holes, paint
Installation, Gesellschaft für Moderne Kunst, Museum Ludwig, Cologne, 1999
Collection, Museum Ludwig, Cologne

below, l. to r., **Als der Bruder meiner Mutter geboren wurde, duftete es nach wilden Birnenblüten vor dem braungebrannten Sims** (When my mother's brother was born there was a fragrance of wild pear blossom outside the brown-burnt sill)
1992
Video still
4 min., colour, sound

You Called Me Jacky
1990
Video still
4 min., sound by Kevin Coyne

I'm a Victim of this Song
1995
Video still
5 min., sound after Chris Isaac

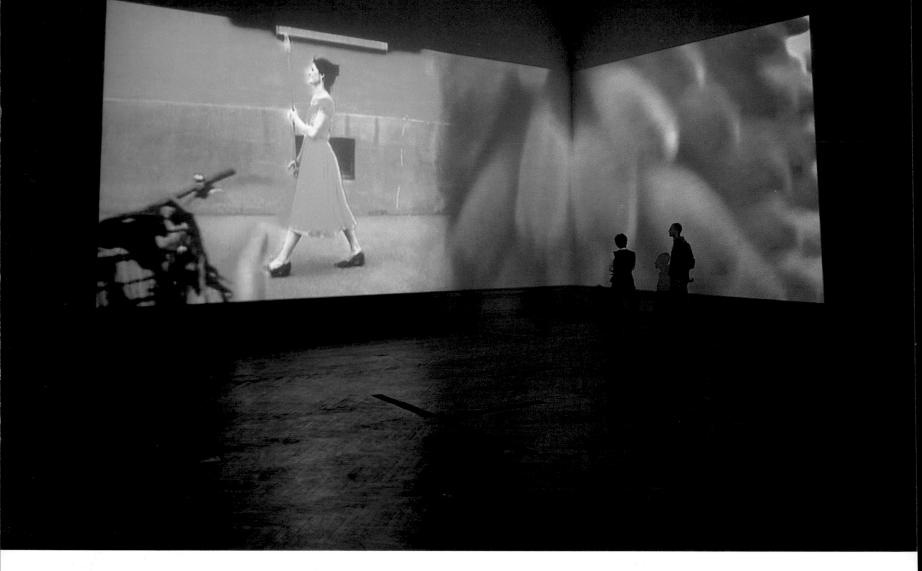

Ever Is Over All
1997
Video installation, sound with
Anders Guggisberg
2 overlapping video projections,
audio system
Installation, National Museum for
Foreign Art, Sofia, 1999
Collection, The Museum of Modern
Art, New York
opposite, bottom, video stills

The Blooms

Rist contributed the witty and enigmatic *Ever Is Over All* (1997) to the 47th Venice Biennale. A slow-motion video diptych, *Ever Is Over All* combines narrative and abstraction, suggesting a concise insight into the connection between painting and video. On one screen a woman walks down a street carrying what appears to be a long stemmed flower, an appearance that is encouraged by the accompanying projection of a field of fecund blooms. The woman is wearing big red shoes, like Dorothy's in *The Wizard of Oz*. The music meanders beneath a soft, lilting 'la, la, la' as the slow-moving woman skips closer to an empty parked car and thrusts the flower across the passenger side window. The glass shatters as one realizes that the flower is metal. The soundtrack is almost fetishistic in the precision of its symphonic shattering. The woman continues to smash more car windows, in an unfrenzied, lyrical movement. Her face is ecstatic as her smile muscles, in majestic slow motion, raise her lips. A woman police officer, who has been walking behind the woman, passes and salutes her, smiling. Two male passers-by also observe the woman, but at a

worried distance. An older woman in a bright red coat walks by without fear. The video of the field of the same bright flowers (known as 'red hot pokers') is like an animated painting. The viewer registers the breeze, the way the light moves in the wind, and the vibrations of colour, recalling Monet's paintings of poppies and Van Gogh's wheat fields. This side of Rist's diptych, in other words, seems to animate the history of art. Taken together, the two sides of the diptych work to refigure the opposition between motion and stillness. Landscape painting has a curious vitality in Rist's view and the slow motion repetitions of violence contain a curious stasis.

Many read the video as a kind of feminist revenge fantasy. The phallic flower is wielded by a woman in a conservative dress; her counterpart, the woman police officer wearing the clothes of the state and representing 'the law of the father', applauds the power of the phallic woman. Unlike other feminist 'revenge' texts, however, *Ever Is Over All* is matter-of-fact, hypnotically beautiful in its slow motion effects and fade to flowers. The video is clearly a feminist work, but that is not the most interesting thing about it. Insufficient

Victor Fleming
The Wizard of Oz
1939
Film still
102 min., colour, sound

Claude Monet
Poppies, near Argenteuil
1873
Oil on canvas
50 × 65 cm

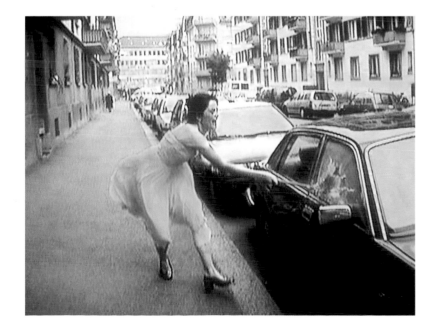

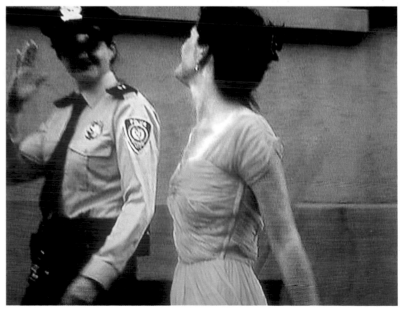

Ever Is Over All
1997
Video stills

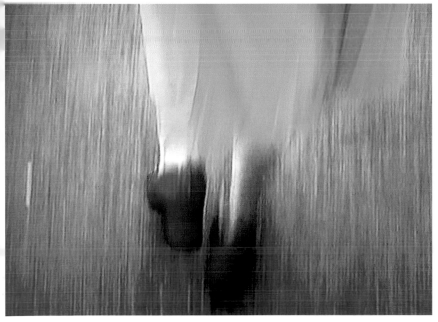
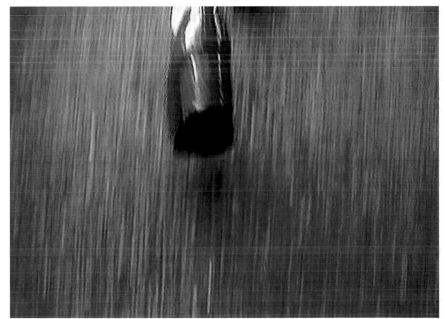

Sip My Ocean
1996
Video still

attention is paid to the diptych in critical commentary on the work; most read only the narrative plot. But the narrative works in the space between the two video projections as well. In that blank but fecund space, the associative links between nature, women, violence and beauty are all rearranged. The usual loop goes: '*Women are close to nature and they are beautiful. Violence is ugly and crime is bad and it happens quickly. Ugly men do it late at night or when no one is looking.*' Rist proposes a more startling way of linking these terms: '*Women might be most beautiful when most focused on shattering windows and mirrors; flowers might be metal or they might be soft; light is beautiful and painters and video artists are connected in their attempts to make it grow and illuminate their works. Slow motion is our deepest music and both flowers and women dance to it knowingly.*' The daring exuberance of thinking outside the law, imagining a different relationship to property, to movement, to the criminal power of beauty itself, is the video's truest achievement.

Rist noted: '*The holy-unholy subject of gender has taken hold of the unconscious in a particularly powerful manner. For this reason I am convinced that we will be able to approach the wounds, the festering kernels that have been stored there, only with the force of the visual, the figurative, and sounds. "Different" images can help bring about resilient change far more readily than verbal pamphlets. The language of images finds a more direct access to the unconscious, where prejudices slumber; it coins us far more strongly than words.*'[28]

For Rist, then, art's power stems primarily from its access to the unconscious. Her best work

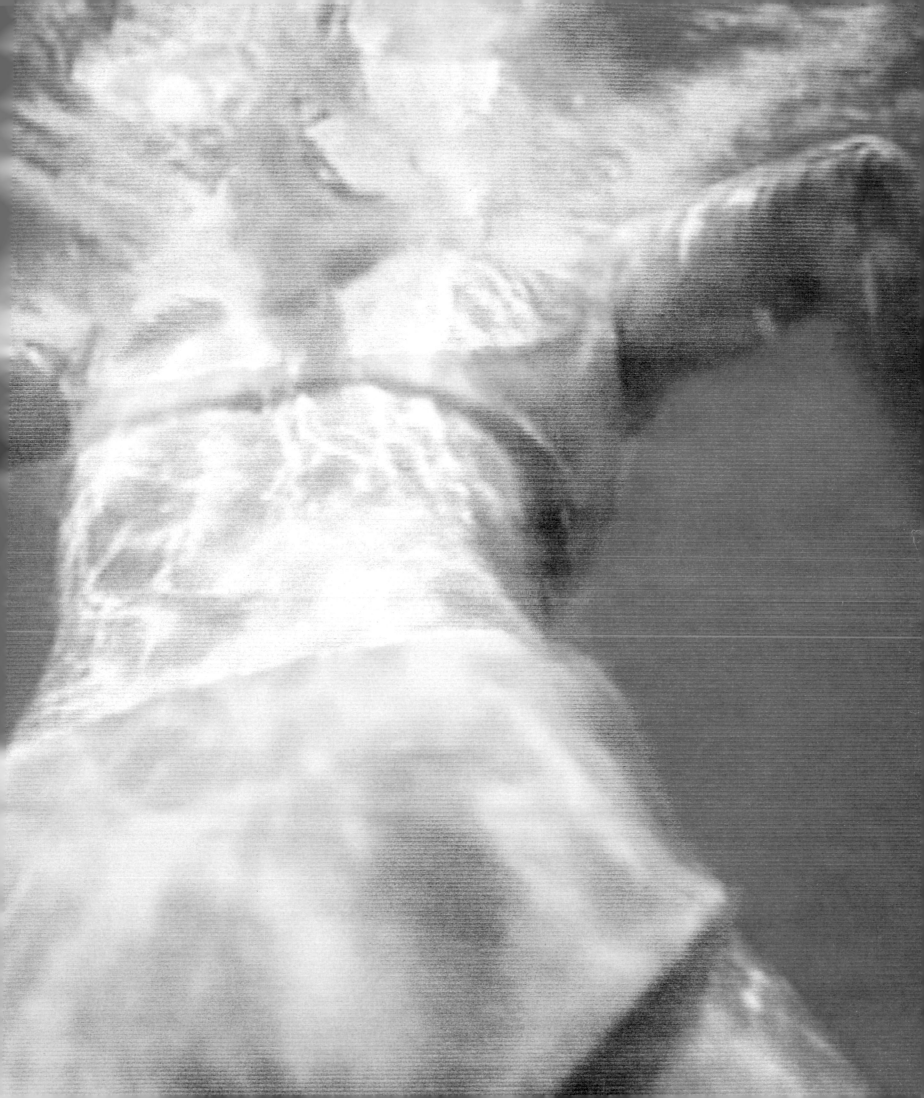

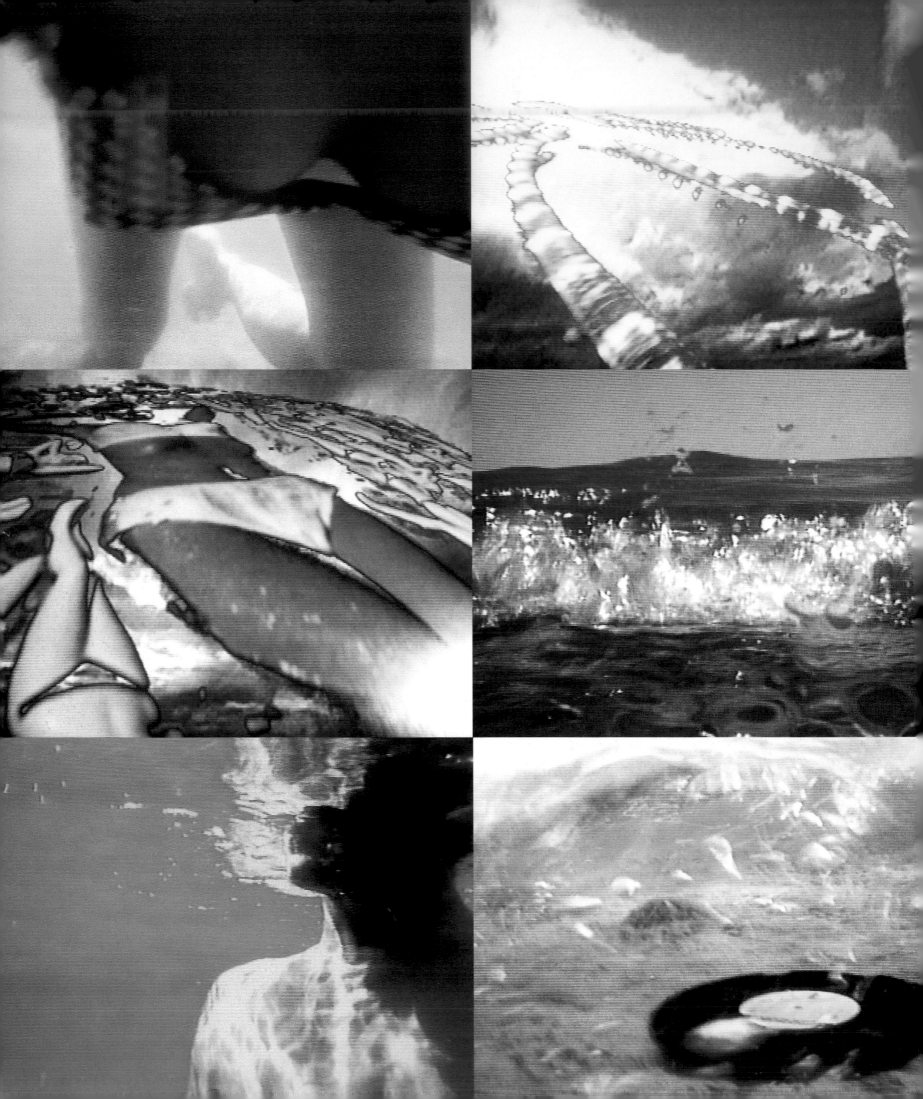

o My Ocean
96
deo installation, sound
video projections reflected in
e corner of a room, audio
stem
posite, video stills
low, installation, Musée des
eaux-Arts de Montréal, 2000
llections, Louisiana Museum,
umlebaek, Denmark; Museum of
ontemporary Art, Chicago;
olomon R. Guggenheim Museum,
ew York

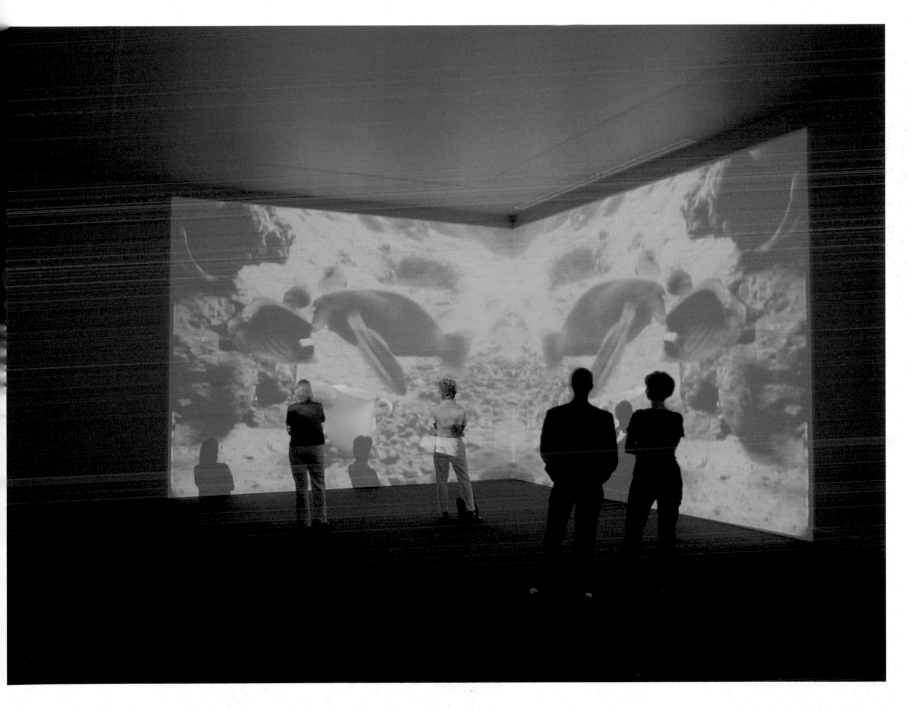

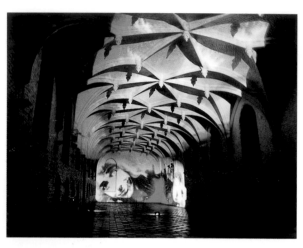

Grossmut begatte mich/Search Wolken (Magnanimity Mate with Me/Search Clouds), preliminary version of **Sip My Ocean**
1995
Video installation, sound
2 video projections reflected in the corner of a room, audio system
Installation, De Vleeshal, Middleburgh, the Netherlands, 2000
Collection, De Vleeshal, Middleburgh, the Netherlands

has the quality of a dream. The strongest of these dream-like pieces is *Sip My Ocean* (1996), which is composed almost entirely of footage shot underwater. A mirror projection folded into the corner pleat of a room, *Sip My Ocean* captures with poetic precision the kaleidoscopic double-view of falling in love and surviving it. Covering Chris Isaac's *Wicked Game*, Rist's version of the song moves from the whispered adolescent longing of 'I never thought I'd fall in love with someone like you', to the emotional devastation of the adult recognition, 'I never thought I'd lose someone like you'. The most affecting moment in the song occurs when Rist, who performs the vocals with Anders Guggisberg, intones, 'I never want to fall in love', and his background vocals agree, 'No, it's only gonna break your heart', before she finishes the line, 'with you, with you'. The duality of emotional desire is doubled both by the mirrored projection and by the 'double take' the viewer does upon seeing the accoutrements of domestic life turned into sinking children's toys – a caravan, a plate, a cup, all float to the bottom of the sea.

Critic and curator Nancy Spector, writing in the issue of *Parkett* devoted to Rist, helpfully suggests that the theoretical sources for Rist's feminism '*lie in the lyrical writings of Hélène Cixous and Luce Irigaray, who each espouse pure female embodiment as the vehicle for psychological and sexual emancipation from the inequities inherent to heterosexual gender difference.*' Spector suggests that *Sip My Ocean* is an 'invitation to participate in this game of [sexual] desire and fulfilment; yet it is also a dare to survive its perilous undertow'.[29] This two step, the double call of the invitation, has

sometimes been overlooked in critical assessments of Rist's work. Most focus on the optimism and celebratory tone of Rist's art – much of which is very witty – while overlooking the more foreboding stance of her work. Love, like beauty, often has a destructive power. It can turn one into a criminal; it can turn one into a fish. Sometimes it's hard to know if one should seek deeper currents or just let go.

Interior Architecture

In moving from single-channel videos to more elaborate video installations, Rist has begun to investigate a new architecture for both the body and the screen. '*The body is full of concentration, like a picture machine with an endless reservoir of images, feelings and sounds. It is full of inner pictures that are wilder than we will ever be able to show.*'[30] In a series of large works, *Himalaya's Sister's Living Room* (2000) and *Das Zimmer* (*The Room,* 1994/2000), Rist has used video sculpture as a way to re-imagine domestic space. Her aspiration in all of these works is to peel back wallpaper, open up skin, spill the contents of handbags and otherwise transform the static physicality of sculpture into a kind of animate, emotionally vivid screen. To put it simply, she wants to put the 'living' back into the living room, and she understands the paradoxical gesture of registering that flickering animation in mechanical mini-monitors.

Projecting images onto glass table tops strewn with Chinese takeaway boxes, or 'tossing' pictures, ice-like, into the glass bottles of a well-stocked liquor cabinet, Rist's 'camera as an agent

of family therapy' from 1987 has been transformed into an agent provocateur. Daring gallery goers who had the temerity to use the bathroom in her May 2000 exhibition at the Luhring Augustine Gallery, New York, were greeted by a piece called *Closet Circuit*. An infrared camera 'secreted' in the toilet and attached to a flat-panel display on the floor re-frames the usually private acts of elimination; when the toilet is flushed, the image dissolves in a pink froth and the image is eliminated from the camera's memory as well.

Rist's most recent work resembles a kind of sprawling archive, a collection of images potentially large enough to rethink how history and memory will be transformed by the technologies of the present. As early as 1985 artist Shigeko Kubota, whose work is an important predecessor of Rist's, noted that after the invention of video 'so much of collective memory got recorded. Jung and Freud must rewrite their theories in this video century'.[31] Rist might counter that artists are as capable as theorists of rewriting, re-imaging these memories. Treating video cables as branches that can sprout vine, and the monitor as an intoxicating glass frame for an animated painting – 'I see video as paintings behind glass that move'[32] – Rist composes an architecture that illuminates the blurry lines between interiority and exteriority, private and public, life and death, with a vivid exuberance and rigorous gravity.

Regenfrau (Rainwoman) (I Am Called a Plant) (1999) is a large video projection against a set of kitchen cabinets. In it, a naked white woman (Rist herself) wearing only a fuchsia-coloured wig lies face up in a large garden puddle. Somewhat

reminiscent of Cindy Sherman's photographic portraits of herself looking dazed, damaged and dead under her lens, *Rainwoman*, with its rhythmic dripping water on the soundtrack, slowly surveys the surface of the woman's skin. Wet and exposed, the woman's erect nipple is covered by a perfectly poised raindrop; as the camera zooms in closer to the water droplet, it takes on the quality of a teardrop. But the erect nipple also functions as the signifier here of life itself: we know this is not a corpse because her nipple registers cold water. At the end of the video, Rist rises and disappears from the frame, leaving the coffin-like rectangles of the kitchen cabinets briefly bathed in white light. The melancholic projection of the woman's white naked skin against the white kitchen cabinets deftly points to the ways in which kitchens grow women – literally framing their lives – and the ways in which they still, too often, plant women in spaces that kill, rather than kindle, life.

In *Das Zimmer (The Room)* (1994/2000) an oversized couch and two large chairs made of hot pink Naugahyde are arranged in the centre of a large room. In her solo show at the Montreal Museum of Fine Arts, 2000, the installation included digitized photographs of other living rooms, many of which also contained images of computer screens and televisions. Recalling art critic Harold Rosenberg's evocative phrase, 'apocalyptic wallpaper', Rist's digitized photomontage, *I Never Taught in Buffalo* (2000), slyly suggests the necessity of rethinking notions of abstraction and figuration in the electronic age.[33] Rosenberg was worried that Abstract Expressionism risked degenerating into chaotic

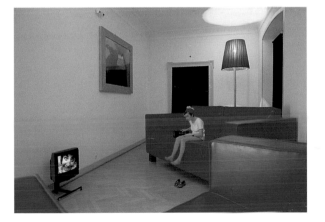

Das Zimmer (The Room)
1994/2000
Video installation
Television monitor, 10 Pipi-channels, crossbar, sofa, armchair, lamp, pictures, remote control (all larger than lifesize, except television)
Installation, Kunstmuseum St. Gallen
Collection, Kunstsammlungen zu Weimar, Neues Museum Weimar

overstuffed flung paint; but one man's apocalypse, Rist's work seems to suggest, might be another woman's reality. Surrounded by images of screens, the viewer is invited to sit in the oversized furniture, grab hold of the enormous remote control and watch Rist's single-channel videos from a monitor on the floor. Reflecting the point of view of children in a large room, *The Room* has something of an *Alice in Wonderland* feel. Controlling the remote seems to provide a secret, albeit limited, power. At the heart of that power is the transformation of the museum into a kind of fantasy house.

The through-the-looking-glass quality of Rist's domestic installations often seems to embody the lyrical speculations of the French philosopher Gaston Bachelard. In his 1964 book, *La poétique de l'espace* (*The Poetics of Space*, 1958), Bachelard brilliantly illuminated the ways in which domestic architecture responded to the human desire for pockets, hideaways and unseen interiors by creating elaborate closets, trap doors, secret attics and trick doorknobs. Rist is interested in how electronic and virtual space are themselves architectural. What unites Bachelard and the artist, however, is their shared obsession with secrets. For Bachelard, '*Wardrobes with their shelves, desks with their drawers and chests with their false bottoms are veritable organs of the secret psychological life. Indeed, without these ... our intimate life would lack a model of intimacy.*'[34] While Rist admits, '*I love looking into other people's*

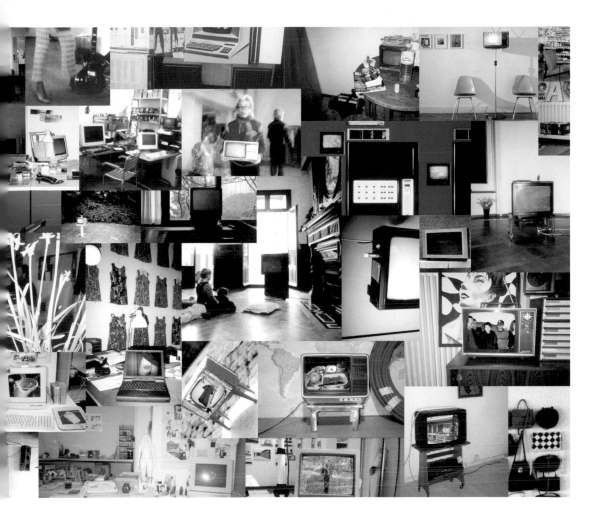

I Never Taught in Buffalo
2000
Digital photomontage plotted on
wallpaper
Dimensions variable

*handbags; they reveal their secrets and tell me a lot
about their owners' characters, about their wishes
and fears. Exhibiting art is like letting people take a
look into my bag.'*[35]

I Couldn't Agree with You More (2000) is a two-
projector piece that was shown in the Luhring
Augustine exhibition of Rist's work in May 2000 in
New York. One screen shows Rist riding the
tramway, going to the food market; on a smaller,
second projection shown on her forehead where
the third eye might be, naked men and women
frolic at the edge of a forest. Like artist Maureen
Connor's *The Sixth Sense* (1992–93; see page 20), *I
Couldn't Agree with You More* playfully captures the
pervasiveness of fantasy in everyday life. While
shopping or doing other mundane chores, the

unconscious never quits.

The vast unexplored terrain of human
sexuality is also the subject of *Extremitäten (weich,
weich) (Extremities [Smooth, Smooth])*, a 1999
four-projector, three-monitor work. Shown in the
back room of the Luhring Augustine exhibition,
and accompanied by a white circular bed in
Montreal, *Extremities (Smooth, Smooth)* shows
detailed close-up images of the human
extremities: breasts, ears, feet, penises, mouths.
These images fly across a black and white
projection of circular white dots that take on the
cast of a thousand galaxies. On the soundtrack Rist
chants: *Ich bin ein Säugetier, Ich bin nix, Ich bin
der König* (I am a mammal; I am nothing; I am the
king). The swirling lights and the soft chanting

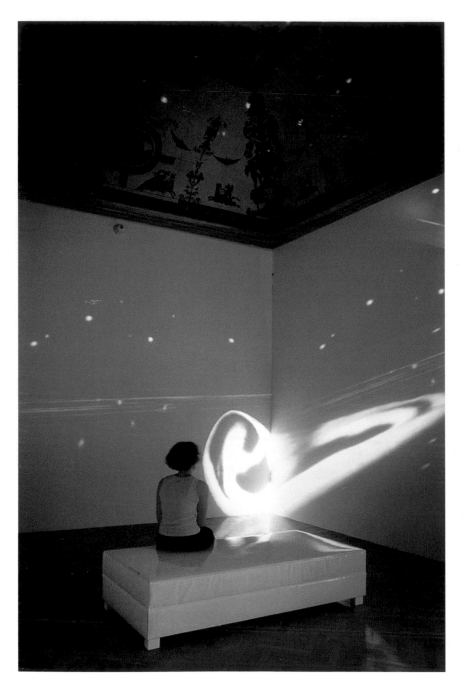 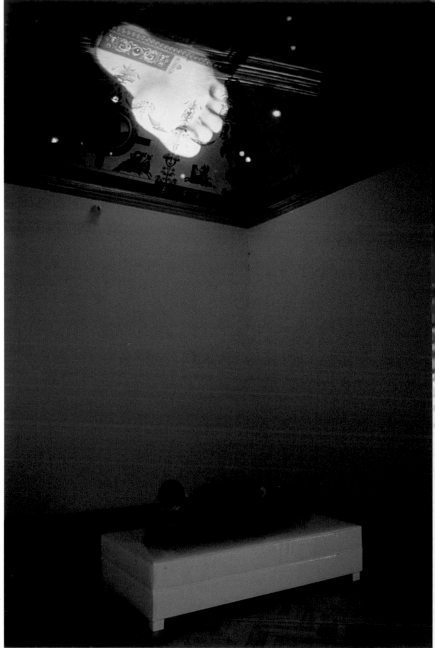

give *Extremities (Smooth, Smooth)* a gentle intimacy; while the dismembered body parts swirling within such a vast cosmological (and ingeniously simple) reach wryly mock such intimacy.

But perhaps the culminating attempt to transform the relationship between the museum and the house occurs in her 1999 piece *Vorstadthirn (Suburb Brain)*. Using a small architectural model of a typical suburban house complete with grass lawn and driveway, Rist inserts a screen in the main wall of the house itself. She recites a long text about childhood in suburbia, 'We lived in a flat-roofed house ... could hear the cars especially at night', it begins. As she drives across a suburban landscape, the text moves between personal references to family and relationships, to a theoretical speculation about 'redirect[ing] poetry back to metaphysics, physics and ethics', a consideration of the family as 'the ideal nuclear constellation for economic desire' in which all members sleep and eat at the same time, and a poetic self-definition: 'I am a birch tree.'[36] The final image of *Suburb Brain* is of a sky shot through with orange that looks like lava eating clouds of fire.

Theory and Image, One More Time

Immanuel Kant was the first philosopher to argue that art deserved philosophical contemplation. In the *Critique of Pure Reason* (1781), defining art as a disciplined pursuit of 'purposiveness', he claimed that art merited philosophical elucidation. Rist herself has been more ambivalent about the relationship between art-making and theoretical elucidation. '*I should say that for a long time I'd*

been seeking a theoretical or philosophical basis for explaining my work, but I haven't yet found any theory that doesn't put limitations on my work. I treat artworks as philosophical statements themselves, expressed in a tool other than language.'[37] For Kant, art's 'purposiveness' expressed itself most forcefully in its capacity to summon thought beyond its own habits. Rist's work can help enlarge the habits of mind that keep us submissive to the logic of an often dull rationalism. For Rist, expanding metaphysical limitations has led her to extend space itself – to bring the interior architecture of the body to the surface of her work, and to erode the divisions between private and public, him and her, dreamer and dream. '*This kind of non-hierarchical space also acts as a remedy; it helps to open up your principal space: your mind and body. You may wish to imagine as many "real" spaces as you can, but you can also open up your own primary space and expand it, so that you no longer return to a closed personal space. This the main reason I'm interested in these spaces within spaces.*'[38]

Within postmodernity, when one opens up spaces within spaces one often finds more images, more sounds. Commenting on her tendency to place pictures within pictures, rooms within rooms, computer windows within computer windows, screens within screens, Rist observed: '*Once in 1997, I wallpapered my living room with all these pictures of other living rooms. I never really had a theory about it; it was just a way to survive, a mind-opener, a way of enlarging horizons.*'[39] Rist's willingness to admit she needs to make an effort to survive is an acknowledgement of the darker

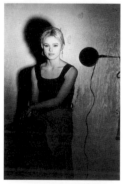

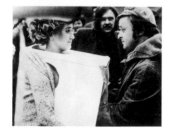

Vito Acconci
Adaptation Study (Blindfolded
Catching)
1970
Super-8 film
3 min., black and white, silent

Andy Warhol
Edie Screen Test
1965
Film still

Valie Export (with Peter Weibel)
Tapp und Tastkino (Touch Cinema)
1968
Vienna, action document

dimensions to her work, art that often tends to be treated as exuberantly optimistic.

Determined to find utopic visions in Rist's work, commentators have been less eager to trace the use of her predecessor's work in her own. While Nam June Paik and Laurie Anderson are often cited, the more subtle influences of Joan Jonas, Vito Acconci, Martha Rosler, Maureen Connor, Valie Export and others remain insufficiently documented. But perhaps even more challenging for critics is Rist's own self-appropriation and recycling. Electronic art in general tends to complicate the boundaries of discrete work, and both sound and image samples frequently recur across putatively 'new' works. The critical discussion of recycling in electronic art remains surprisingly thin: it is as if the often brilliant theoretical work prompted by 'appropriationists' such as Sherrie Levine and Richard Prince has ended the conversation. But some of the most profound implications of electronic mechanical art derive from the challenges they pose to the frame, the spatial limit of the artwork itself.

Rist sometimes recycles the same footage in different videos; that's common enough and easy enough to document. But more challenging for art critics and historians is the fact that from time to time different titles refer to the same work, and that more than one version of the same-titled work exists. (Preliminary versions of *Sip My Ocean* are called *Pearls of Time* or *Grossemut begatte mich/ Search Wolken* [*Magnanimity Mate with Me/Search Clouds*].) This makes it almost impossible to establish the boundaries, or limits, of the artwork itself. Ironically, in a medium known for its endless

ability to be perfectly reproduced, the video art of Pipilotti Rist remains fundamentally variable. In this, she retains her allegiance to the radical, ephemeral nature of performance.

Her most explicit performance project is *Shooting Divas*, a 1996 work in which she made ten different music videos, a work that resembles Warhol's Screen Tests. But here I would like to discuss a more subtle use of performance in and across Rist's work.[40] Rist often places the same work in multiple, and often in markedly different, locations. Just as live performance cannot be repeated exactly, so too do Rist's works re-invent themselves as they take up new spaces. Take, for example, a brief itinerary of *Selfless in the Bath of Lava* (1994). Originally shown in a group exhibition at the Kunsthalle Basel entitled 'Welt-Moral' ('World Morality') in 1994, it then moved to Zurich where it was installed beneath a medieval sculpture of the Madonna and Child.[41] In these two locations, the ethical and religious implications of Rist's supplications above a bath of fire can easily be read as an ironic comment on Christianity's versions of sin and hell. On the soundtrack, Rist's voice moves from German, to French, to Italian, to English as she repeats, 'I am a worm and you are a flower. You would have done everything better. Help me. Excuse me.' The 'you' in the context of European examinations of 'world morality' and Christian iconography seems to be addressed to a god, while the speaker takes on the role of the guilty, albeit not terribly contrite, sinner. But when it was installed in the floorboards of P.S. 1 in New York or in the Montreal Museum of Fine Arts, the 'you' became a kind of (male) art viewer, and

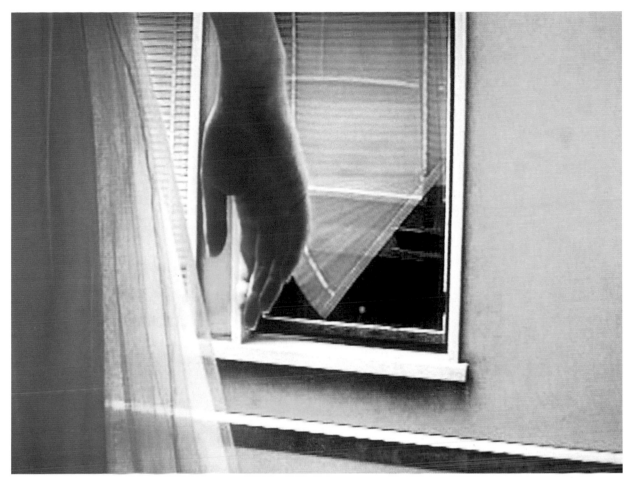

Shooting Divas
1996
Video stills
Work-in-progress with 10 singers,
1 editing system, 12 monitors, 1
projection, 13 players, crossbar
and remote control for sound
system; 2 songs with Anders
Guggisberg

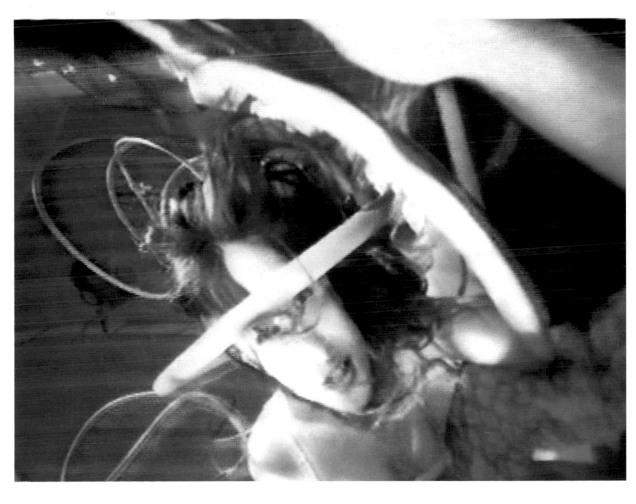

Selbstlos im Lavabad (Selfless in
the Bath of Lava)
1994
Video still
Video installation, sound
LCD monitor installed under the
floor
Collections, Musée d'art et
d'histoire, Geneva; Kunsthaus,
Zurich

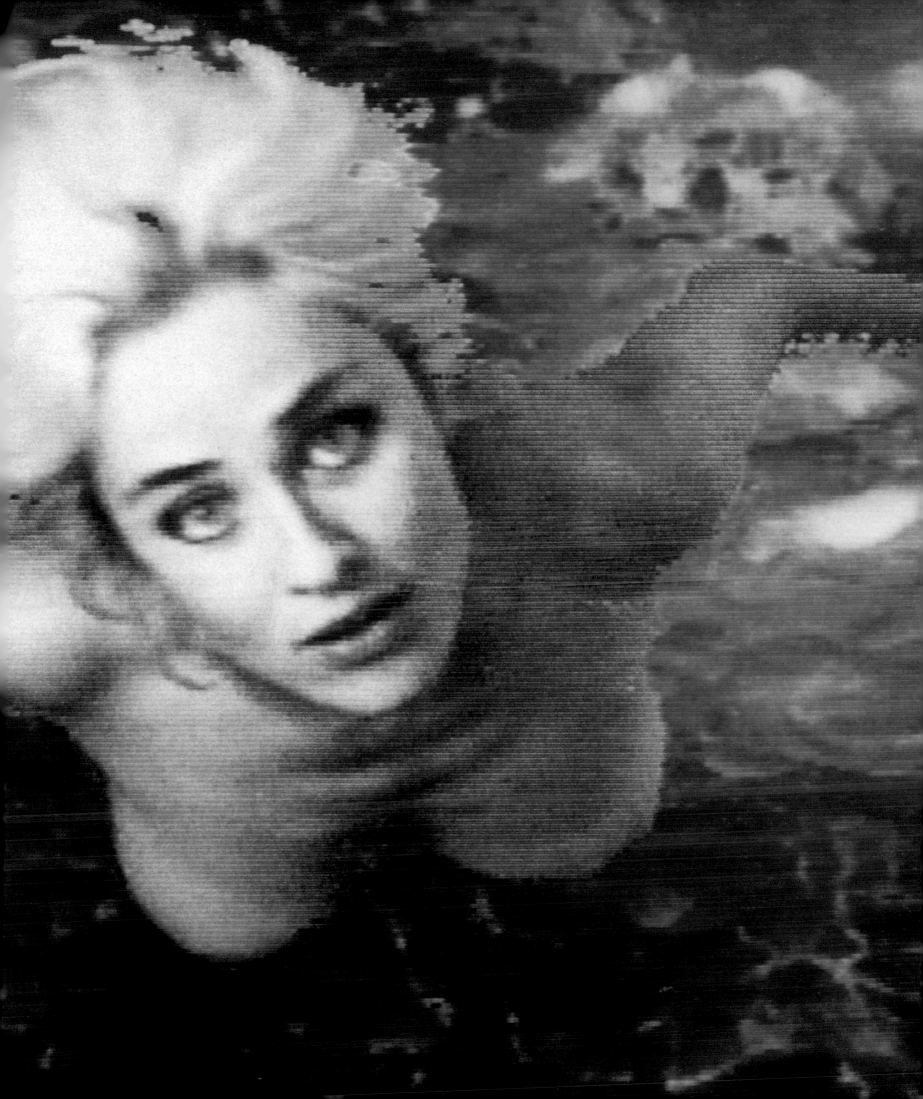

Selbstlos im Lavabad (Selfless in
the Bath of Lava)
1994
Video installation, sound
LCD monitor installed under the
floor
Installation EV+A, 'Friends and
Neighbours', Limerick
Collections, Musée d'art et
d'histoire, Geneva; Kunsthaus,
Zurich

Rist's supplications took on the air of a teasing
send up of the operations of visual power operative
in all exhibitions. As critic Dominic Molon has
argued, Rist appears to be '*flattering the (male)
spectator by appearing naked, crying for help, and
acknowledging the viewer's superiority, while using
her irrepressible humour to up-end the desiring gaze
into the lava-bath*'.[42] These divergent
interpretations suggest a kind of literal enactment
of the 'selfless' in the title, suggesting indeed that
Rist's tiny monitor exposes the viewer's
orientation to the work more precisely than it
exhibits what appears in the display. At the very
end of *Selfless*, the image of the naked Rist is
manipulated by Rist-the-animator. Like a
scrunched-up piece of paper, the image folds into
itself and disappears, leaving the viewer like one of
Plato's friends, staring at disappearing shadows in
a cave of fire.

1 The Premio 2000 award honours three artists under the age of forty.
 Rachel Whiteread and Douglas Gordon were the other recipients
 in1997. Rist's entry, *Ever Is Over All*, discussed below, led to this
 citation: 'For her masterful use of audiovisual material in expressing
 a brand new sensitivity that combines the power of the image with
 irony and a great emotional insight.'

2 I am grateful to the filmmaker Stacey Foiles for this formulation.

3 The artist in Christoph Doswald, 'Ich halbiere bewusst die Welt,
 Pipilotti Rist im Gespräch mit Christoph Doswald', *Be Magazin*, No. 1,
 Berlin, 1994, trans. Catherine Schelbert; see in this volume pp.
 116–29.

4 In Joanne Latimer, 'She's Not the Girl Who Misses Much', *Globe and
 Mail*, Montreal, 6 March, 2000.

5 The artist in 'I rist, you rist, she rists, he rists, we rist, you rist, they
 rist, tourist: Hans Ulrich Obrist in Conversation with Pipilotti Rist',
 see in this volume, pp. 6–31.

6 Pipilotti Rist, *I'm Not the Girl Who Misses Much*, Oktagon, Stuttgart
 1994/96.

7 'Title', *Cinema: Film und die Kunste*, Vol. 35, Verlag Stroemfeld/ Roter
 Stern, Basel/Frankfurt, 1989, pp. 121–27, see in this volume, p. 108.

8 The artist in 'I rist, you rist, she rists, he rists, we rist, you rist, they
 rist, tourist: Hans Ulrich Obrist in Conversation with Pipilotti Rist',
 op. cit., pp. 10, 12.

9 Sigmund Freud, 'The Interpretation of Dreams', *The Standard Edition
 of the Complete Psychological Works of Sigmund Freud*, ed. J. Strachey
 with Anna Freud, 24 Vols., Hogarth Press, London, 1953–64.

10 The artist in Christoph Doswald, 'Ich halbiere bewusst die Welt,
 Pipilotti Rist im Gespräch mit Christoph Doswald', op. cit.

11 Oprah Winfrey, for example, is one of the richest women in the world.
 She has made her fortune by understanding that emotion sells.

12 Walter Benjamin, 'The Work of Art in the Age of Mechanical
 Reproduction' (1936), reprinted in *Illuminations: Walter Benjamin,
 Essays and Reflections*, ed. Hannah Arendt, trans. Harry Zohn,
 Schocken Books, New York, 1968, pp. 217–52, 237.

13 For a more extended discussion of the complicated history of

feminist art see my 'Survey' in *Art and Feminism*, Phaidon Press, London, 2001.

14 *Happiness Is a Warm Gun* (Lennon/McCartney) from the LP *The White Album*, Apple Records, 1968.

15 The artist in Ulf Erdmann Ziegler, 'Rist Factor', *Art in America*, New York, June, 1998, p. 81.

16 Peter Schjeldahl, 'Bonjour Ristesse: The Hugo Boss Prize', *Village Voice*, New York, 11 August, 1998.

17 Pipilotti Rist, 'Title' (1989), op. cit., see in this volume, p. 108.

18 Pipilotti Rist, *I'm Not the Girl Who Misses Much*, op. cit.

19 Elisabeth Bronfen, '(Entlastungen) Pipilottis Fehler ([Absolutions] Pipilotti's Mistakes)', see in this volume p. 90.

20 Birgit Kempker, 'Also', in *I'm Not the Girl Who Misses Much*, op. cit. Kempker's essay is a remarkable piece of performative writing and comes close to finding a prose equivalent to Rist's oscillating visual style. Much of the early, and often most illuminating, writing about Rist's work was itself experimental and poetic. In her 1998 catalogue, *Himalaya* (Oktagon, Cologne) Rist included a CD recording of her music (made with Anders Guggisberg) entitled *We Can't* Working across the boundaries of the visual and the aural, Rist's work also complicates issues of transmission and translation. The latter has been, and will continue to be, an important issue in the critical discussion and in the titles of Rist's own work. See below for further discussion.

21 Elisabeth Bronfen, '(Entlastungen) Pipilottis Fehler ([Absolutions] Pipilotti's Mistakes)', see in this volume p. 84.

22 The artist in Elisabeth Bronfen, '(Entlastungen) Pipilottis Fehler ([Absolutions] Pipilotti's Mistakes)', see in this volume p. 91.

23 The artist in conversation with Christoph Doswald, op. cit., see in this volume p. 124.

24 Pipilotti Rist, *I'm Not the Girl Who Misses Much*, op. cit.

25 The artist in Ulf Erdmann Ziegler, 'Rist Factor', *Art in America*, op. cit.

26 The artist quoted in Kaelen Wilson-Goldie, 'Peep Show Video', *Black Book Magazine*, New York, Spring, 2000, pp. 52–54.

27 The artist in 'I rist, you rist, she rists, he rists, we rist, you rist, they rist, tourist: Hans Ulrich Obrist in Conversation with Pipilotti Rist', see in this volume, p. 26.

28 The artist in Elisabeth Bronfen, '(Entlastungen) Pipilottis Fehler ([Absolutions] Pipilotti's Mistakes)', see in this volume, p. 90.

29 Nancy Spector, 'The Mechanics of Fluids', *Parkett*, No. 48, Zurich, 1996, p. 84.

30 The artist quoted in Kaelen Wilson-Goldie, 'Peep Show Video' *Black Book Magazine*, New York, Spring 2000, p. 54.

31 Shigeko Kubota, in *Shigeko Kubota: Video Sculpture*, ed. Mary Jane Jacob, American Museum of the Moving Image, New York, 1991, p. 81.

32 The artist in Christoph Doswald, op. cit., pp. 91–96, see in this volume p. 124.

33 Harold Rosenberg, 'The American Action Painters', *ARTnews*, Vol. 51, No. 8, New York, December, 1952.

34 Gaston Bachelard, *The Poetics of Space*, Beacon Press, Boston, 1969, p. 78.

35 The artist in 'I rist, you rist, she rists, he rists, we rist, you rist, they rist, tourist: Hans Ulrich Obrist in Conversation with Pipilotti Rist', see in this volume, p. 20.

36 *Monologue in Car (Suburb Brain)* 1999, spoken text for *Vorstadthirn (Suburb Brain)*, see in this volume pp. 132–33.

37 The artist in unpublished transcript for 'I rist, you rist, she rists, he rists, we rist, you rist, they rist, tourist: Hans Ulrich Obrist in Conversation with Pipilotti Rist', op. cit.

38 The artist in 'I rist, you rist, she rists, he rists, we rist, you rist, they rist, tourist: Hans Ulrich Obrist in Conversation with Pipilotti Rist', see in this volume, p. 26.

39 Ibid.

40 The best discussion of this complex piece can be found in Paolo Colombo, 'Shooting Divas', *Parkett*, No. 48, Zurich, 1996, pp. 109–13.

41 For a full description of these spaces, see Elizabeth Janus, 'Pipilotti Rist', *Artforum*, New York, Summer, 1990, pp. 100–1.

42 Dominic Molon, 'Last Splash', in *Pipilotti Rist, Sip My Ocean*, Museum of Contemporary Art, Chicago, 1996, p. 4.

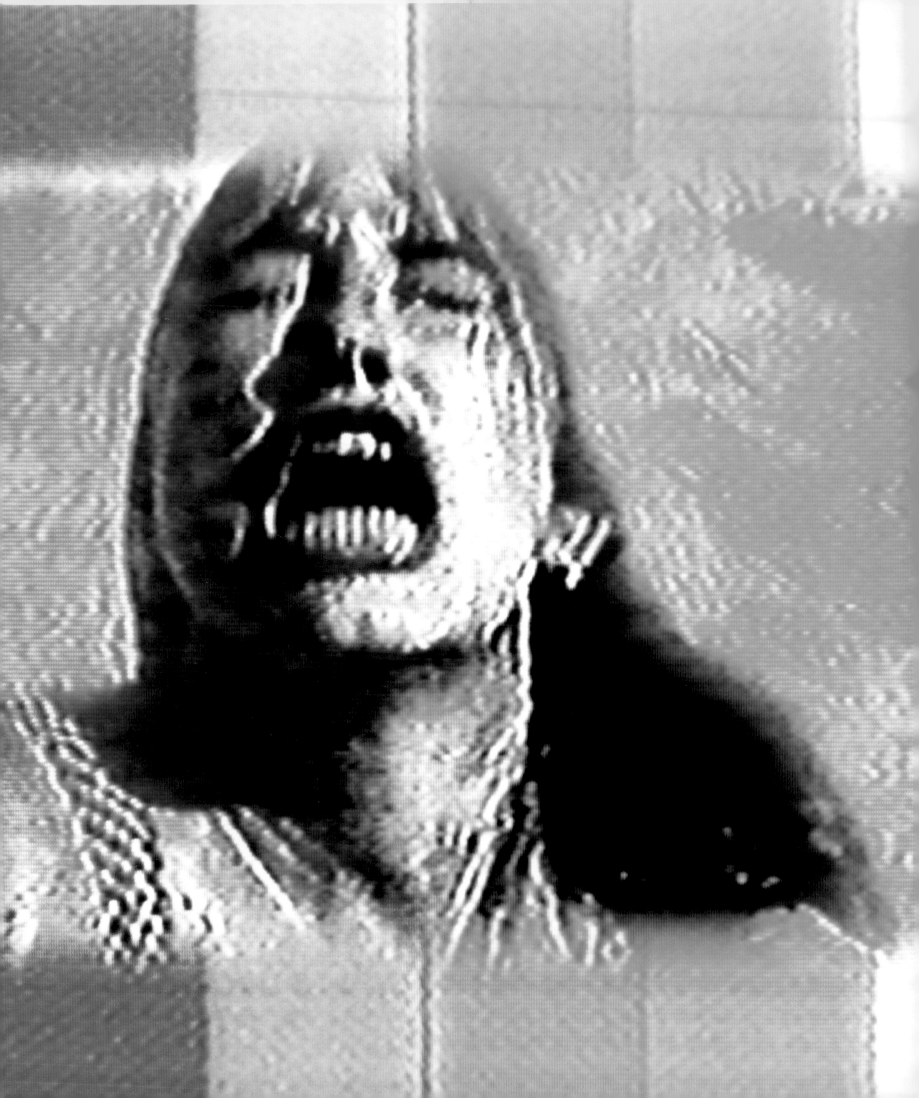

Contents

Interview I rist, you rist, she rists, he rists, we rist, you rist, they rist, tourist: **Hans Ulrich Obrist** in Conversation with **Pipilotti Rist, page 6.** **Survey** **Peggy Phelan** Opening Up Spaces within Spaces: The Expansive Art of Pipilotti Rist, **page 32.** **Focus** **Elisabeth Bronfen** *(Entlastungen) Pipilottis Fehler ([Absolutions] Pipilotti's Mistakes)*, **page 78.** **Artist's Choice** Anne Sexton Barefoot, 1969, page 94. Richard Brautigan The Irrevocable Sadness of Her Thank You, 1980, page 98. **Artist's Writings** Pipilotti Rist Innocent Collection, 1988–ongoing, page 104. Title, 1989, page 106. Preface to *Nam June Paik: Jardin Illumine*, 1993, page 110. 'I Am Half-aware of the World': Interview with Christoph Doswald, 1994, page 116. Two Untitled Poems, 1996, page 130. Monologue in Car (Suburb Brain), 1999, page 132. A Dream, 1999, page 136. One Day – Friday, 6 August 2000, 2000, page 138. **Chronology** page 144 & Production Credits, Bibliography, List of Illustrations, page 158.

The woman in the red dress keeps fainting. She lets herself fall onto the asphalt of the street, on top of the streetcar tracks, into the grass behind a car park. She collapses in the middle of a cornfield or on a green lawn next to a patch of bright red roses, matching her dress. Then we see her repeatedly jumping into a swimming pool, struggling to move forward. A hand, whose owner remains cut out of the frame, has taken hold of her hair and tries to submerge her in the water. She has only a few seconds to take in air before this ominously disembodied hand forces her again beneath the water's surface. Is this the same hand that stretches out towards her, as she is about to reach one side of the pool, only to withdraw at the last minute, forcing the swimmer back into the water? We also see her twice trying in vain to climb over a fence, almost scaling this wooden barrier, but then drawn down by the force of gravity: her strength has failed her. All three scenarios mark situations of strife sustained, of a struggle to escape thwarted, of a desire to move elsewhere left unsatisfied. All three consist of performing an attempt at contending with externally imposed constructions, at resisting constraints, at exerting oneself against a hostile situation, against all odds.

Indeed all three scenarios celebrate a risky moment, a turning point, a scene of utmost tension. In actively seeking a release from clearly unbearable situations, the woman's body is propelled forwards in anticipation of a situation presumably less distressing than the one she so desperately seeks to escape; yet something disappoints this desire. By fainting the woman may lose consciousness, but nevertheless she does not budge an inch. In fact, twice we find her immediately getting back into an upright position. Restitution significantly occurs in reverse motion, as though underscoring the way even as drastic a gesture as fainting is always recuperated back into the very order that produced this psychosomatic expression of discontent. In a similar manner the body that struggles to reach the end of the pool is repeatedly thrown back in or forced under water, while the body climbing the wooden fence is arrested precisely when transgression seems almost at hand. The antagonism staged, then, is one where a utopic desire for improvement (or simply change) is counterbalanced by the law of stasis that, although seeking to maintain a given situation at all costs, is instead forced back onto a preordained route. However, by being forced repeatedly to return to her point of departure, the woman enacts not only her failure to emerge but also the resolution of her intent. The forceful curtailment of progress is itself

(Entlastungen) Pipilottis Fehler ([Absolutions] Pipilotti's Mistakes), from the 'Water Jump-up Series'
1988
Video stills
12 min., sound, in part with Hans Feigenwinter and Les Reines Prochaines

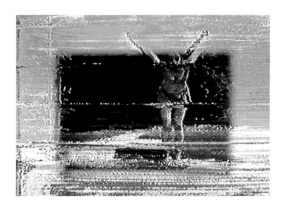

counterbalanced by her resilient insistence on transformation.

The title for this video-work – *(Entlastungen) Pipilottis Fehler* (*[Absolutions] Pipilotti's Mistakes*, 1988) – which artist Pipilotti Rist produced at the end of her studies at the School of Design in Basel, and which, though she considers it among her favourite pieces, has to this date never re-emerged in any of her installations – is significant not least of all because it festers with contradictions. The word *Entlastungen*, which Pipilotti Rist herself translates as 'absolution', is placed in brackets, as though to indicate an imbalance between, on the one hand, the gesture of exoneration and exculpation this video performs and, on the other, the act of recording physical flaws, bad habits and emotional defects, albeit in highly poetic refigurations; this staging is moreover undertaken to clear herself. Indeed the force behind these scenes of implenitude consists in the fact that the artist seems to enjoy the act of blaming herself, as though seeking to learn from and perhaps even capitalize on the act of representing her faults, her imperfections, along with situations that trouble her or place her at a disadvantage.

At the same time the bracketed concept *Entlastungen* is itself fraught with ambivalent meanings. For although in all cases 'absolution' describes a situation of relief, of unloading a burden off one's back and thus represents a gesture of stabilization, its discursive meaning varies. The religious and psychoanalytic encodings reference the idea of unburdening one's soul, while the judicial encoding is instead concerned with the idea of clearing someone of a charge brought against them. The economic encoding, in turn, refers to the discharging of a debtor, the formal approval of someone or the settling of accounts by a figure of symbolic authority, while a medical encoding points to the act of regurgitating undigested material rejected by the body. Cultural theorist Judith Butler has rightly identified the poignant intersection between these discourses of exculpation in a manner

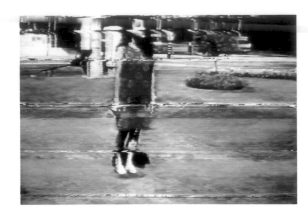 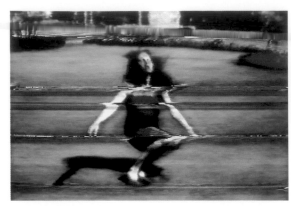 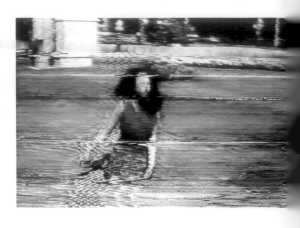

 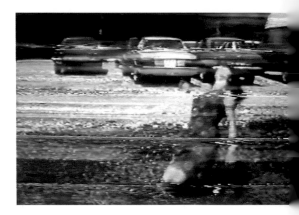

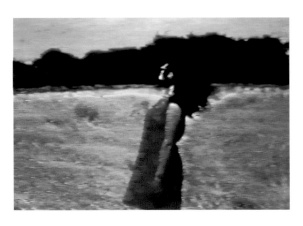 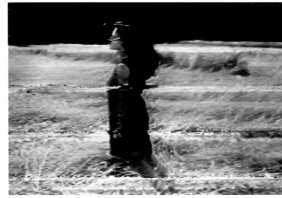 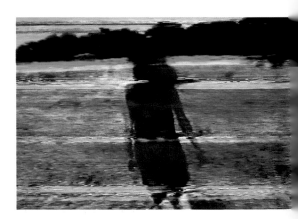

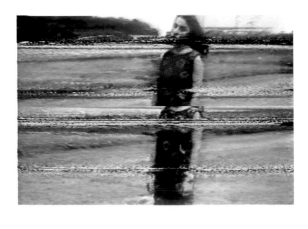 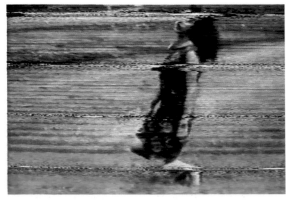 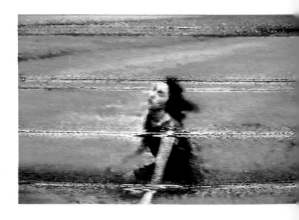

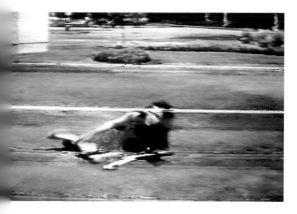
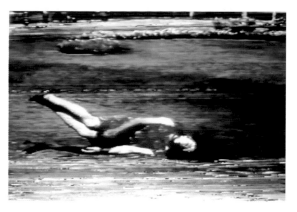

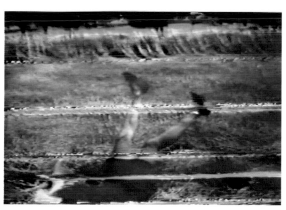

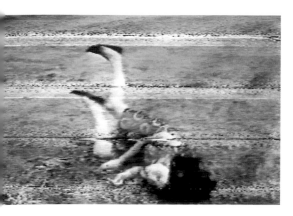
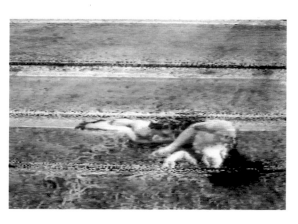

(Entlastungen) Pipilottis Fehler
([Absolutions] Pipilotti's
Mistakes)
1988
Video stills
12 min., colour, sound
from, *top to bottom*, the 'Station
Square Series'; the 'American
Series'; the 'Van Gogh Series'; the
'Football Field Series'

Pipilotti Rist picks up on self-consciously. To record one's flaws and fallibilities, to relieve oneself of oppressive material (regardless whether this refers to psychic frailties, psychosomatic disorders or actual transgressions), means presenting a narrative in one's defence that presupposes guilt before proven innocence. The pleasure of redressing a grievance is bought at the price of naming one's grief and one's shortcoming in advance.[1] Furthermore, by bracketing the word *Entlastungen*, Rist immediately draws our attention to the seminal, rhetorical idea of her video – namely, that exoneration is possible only to a degree; that a trace of guilt, a mark of imperfection will always remain, marring any drive

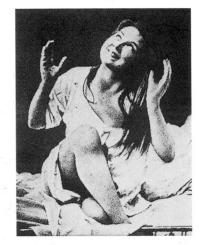

towards a perfect, flawless and unblemished state of being in the world.

With the first images of this video – close-up shots of a woman's face, her eyes and mouth opened wide, as if in ecstasy, or covered dramatically with her hands – Rist invokes the language of hysteria, as invented in the late nineteenth century by Jean-Martin Charcot in his clinic, the Salpêtrière, on the outskirts of Paris. The images have been reworked not only by the surrealists but also by contemporary women artists such as Annette Messager and Louise Bourgeois.[2] As

was the case in the photographs Charcot used to illustrate his case histories, the passionate poses here stage a disturbance of the body meant to express psychic anguish in an exaggerated and highly histrionic mode, though it is unclear whether the body fragments we see express pleasure, pain, laughter or fear. As the voice-over (which

alternates with the sound of percussive instruments, punctuating the statements) indicates, the passionate exaltation enacted here is fundamentally concerned with sight. It addresses not only the manner in which the feminine body has traditionally been turned into an object of the gaze, but more crucially the manner in which, once self-reflexivity is brought into play, any clearly delineated siting of this body is troubled. The 'I' that speaks in the voice-over invokes the situation of being aware of being seen, even while revealing this awareness to the implied spectator. The relay of gazes thus produced, along with the disturbance of an untroubled subject-object distinction, is, furthermore, duplicated when

(Entlastungen) Pipilottis Fehler
([Absolutions] Pipilotti's Mistakes), from the 'Individual Series'
1988
Video still
12 min., colour, sound

Jean-Martin Charcot
Attitudes Passionelles, Extase
1878
Illustrations from *Nouvelle Iconographie Photographie de la Salpêtrière*

Annette Messager
Voluntary Tortures (detail)
1972
Framed black and white photographs
approx. 200 × 400 cm overall

Louise Bourgeois
Arch of Hysteria
1993
Bronze
84 × 101.5 × 58.5 cm

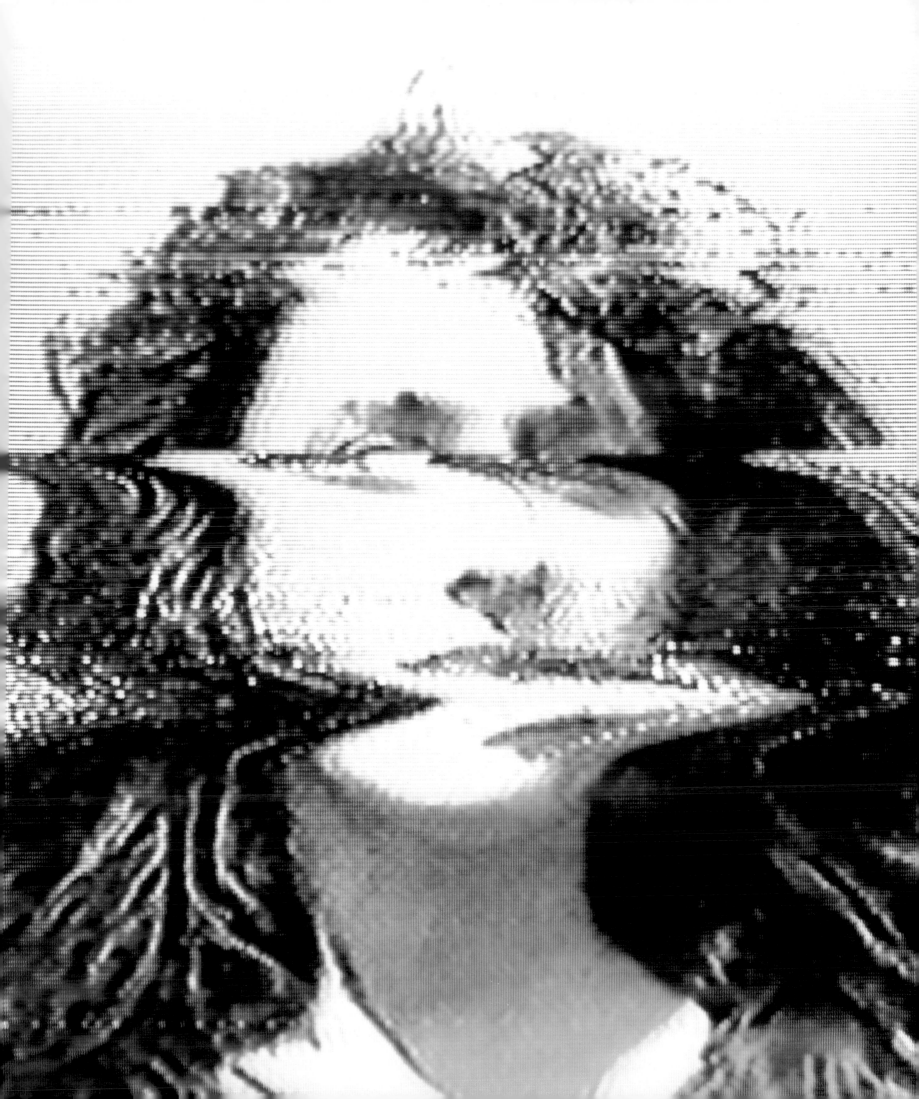

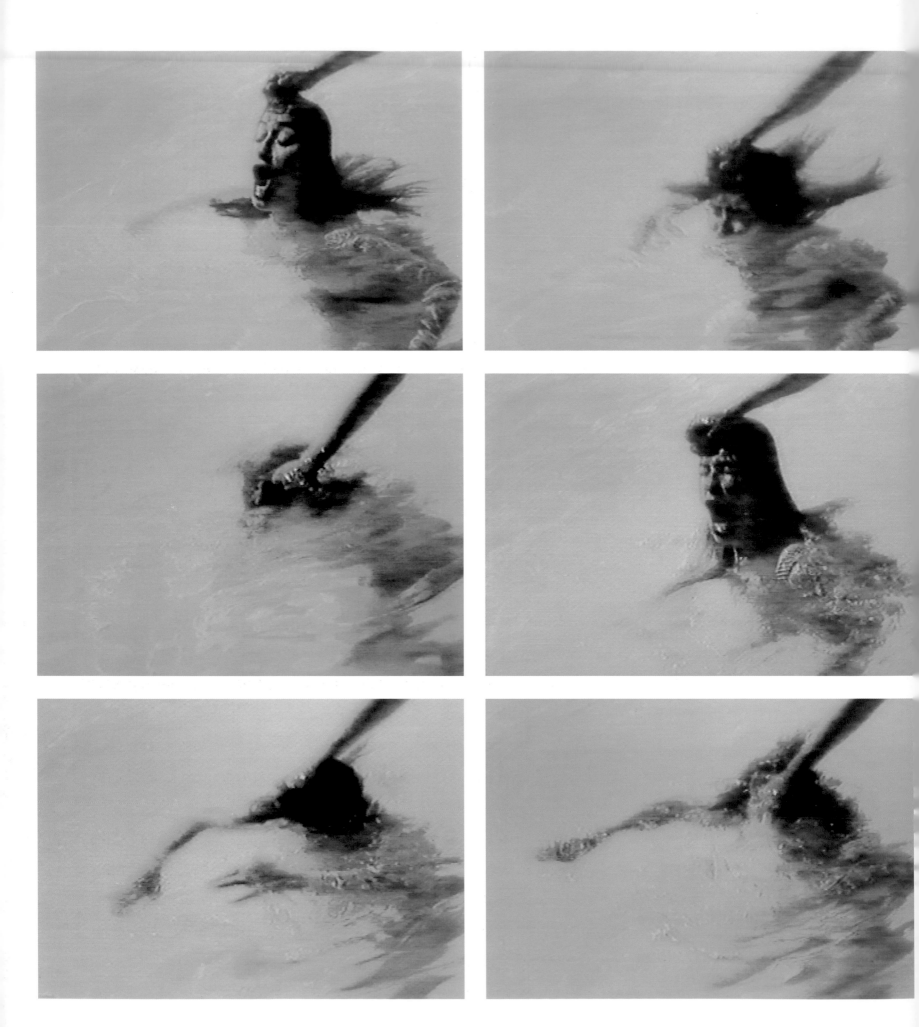

(Entlastungen) Pipilottis Fehler
([Absolutions] Pipilotti's
Mistakes), from the 'Submerging
Series'
1988
Video stills
12 min., colour, sound

Rist adds to her charting of bodily imperfections an experimentation with a wide array of failures that can occur in the process of producing audio-visual images. The aberrations, distortions and disturbances in the field of vision, which introduce a narrative about her protagonist's psychosomatic malfunctions, are the result of self-consciously undermining the prescribed rhythm necessary for clearly stabilized audio-visual impulses that produce recognizable graphic images and sounds.

A heuristically fruitful analogy structures this introductory sequence as follows: representations of a body that disturbs our preconceptions of normal stability (explicitly staged, passionate attitudes which break with regular behaviour, even while this aberrant body is fragmented and shown disconnected) are knotted together with audio-visual images that celebrate a symphony of mechanical errors. While these clearly readable audio-visual representations require that everything outside the dictated rhythm must be stabilized, the faults invoked by the title ('absolution') foreground situations either of excess, or conversely which fall short; that is, when the rhythm of regularity is vexed from too much or too little impulse. At the same time, however, this excessive display of imperfection does find relief, namely in the balance of image and sound: the percussion instruments rhythmically structure the fragmentation of the face. The silence spliced into this aggressive sound has its counterpoint in moments of blackness on screen. Rist's thematic and structural celebration of disturbances is a performance of boundary blurrings so radical that one can hardly see any single image clearly, as one can not clearly discern what the voice is saying. It is hard for the spectator to distinguish unequivocally the auditory from the visual aspects of representation; the overall impression is one of extreme fluidity. This undermines any desire to draw a clear boundary between the feminine body (as object of the gaze) and its spectator. Rather, it opens the question as to whether this body is human or nothing other than a mechanical creature, media-produced.

Interrogating the costs of a system of normative rules and what intervening against these codes might bring, Rist's work can be read in tandem with the resilient history of the language of hysteria, as both a medical and an aesthetic concept. The hysteric's excessive language – her fits of bodily incapacitation, her hallucinations, her histrionics, her double consciousness – serves as a mode of address to an audience. The message behind this aberrant behaviour is her unencompassible discontent with the symbolic codes that

constrain her, forcing her to accept a clear gendered identity when she would prefer to conceive of herself along more fluid lines. The hysteric's body, contorted with unsatisfied desire, seeking to relieve itself of the rigid laws of normalcy, follows one of Sigmund Freud's seminal discoveries regarding the hysteric's body language. Namely, the hysteric has recourse to speaking her distress through her body when symbolic language fails.[3] The fruitless scaling of the wooden fence in Rist's video can be seen as the bodily enactment of the phrase 'I am unable to surmount the obstacles that I am confronted with.' Jumping into the pool and the hand submerging her under water, could, in turn, be read as broadcasting 'I always find myself returning to an unpleasant situation', or 'Someone keeps forcing me to delve into parts of myself I don't want to confront', or 'Someone keeps forcing me to rely on my own resources when all I want is to place myself in their hands.' Finally, the fainting spells can be interpreted as an exaggerated performance of her vulnerability and disempowerment, not least because the German word for fainting, *Ohnmacht*, literally means 'without power'. On one hand the message is a radical sense of abandonment, what novelist Ingeborg Bachmann called *Todesarten* (modes of death), the daily, incapacitating injuries inflicted upon us by others. In one of the fainting scenes, the woman in the red dress actually places an index finger to her brow, as though saluting or shooting herself, before falling to the ground. On the other hand, the hysteric's aberrant body language always requires an audience. She trusts that she will be seen and heard. In this sense, also, the title heralds the counterdirectional rhetorical gesture: a utopic element underwrites Rist's embellished enactment of somatic aberrations. Namely, a belief that something will change if the pain is a self-consciously distorted and a self-referential, audio-visual performance of imperfection.

Because the hysteric believes in the very law of progress which so frustratingly eludes her, the performance of discontent is always directed at the very cultural laws that constrain her. Or put another way, she radically interrogates the very codifications she requires to emerge as a gendered subject. Rist has recourse to precisely this figure of thought in the latter part of the video, where the voice-over keeps listing rules, accompanied by the beating of a metronome. A child's voice responds by repeating phrases such as 'All the things I must learn', 'This is the world, this is correct', 'Everything is exactly where I left it.' However, in reiterating these commands, the child follows its own rhythm

(Entlastungen) Piplottis Fehler
([Absolutions] Pipilotti's
Mistakes) from the 'Heads Series'
1988
Video still
12 min., colour, sound

rather than adopting a prescribed beat. The images accompanying this auditory schooling show urban settings regulating movement through space – pedestrian zebra crossings, a red traffic signal. Soon an adult voice takes over the role-call of rules while we are shown images of the city from inside a moving vehicle. Our sense of the familiar is disturbed, however, by virtue of the camera angle, which renders the horizontal lines of the urban landscape either as vertical or completely upside down, or which captures the young woman either carrying enormous bright flowers into the grey city or standing next to a brick building which, as the camera moves upward, completely dwarfs her.

As the voice-over shifts from the protagonist, who has fully internalized the symbolic codes dictated to her (and concomitantly admonishes herself: 'I warn you, here

and there, and here and there'), to a female voice, we discover that what is at stake in this performance is the subject's self-design of a viable identity, relieved of its faults. We are presented with a string of oppositions – 'you are big and small, weak and strong, crazy and normal, good and bad, heavy and light, sick and healthy', and called upon to ask ourselves whether she fits into the framings – the squares and rectangles that, superimposed on the visual track, give structure to the urban landscape. By evoking these oppositions only to perform their untenability, Pipilotti Rist once again reiterates one of the seminal issues raised by the language of hysteria, namely a refusal to accept clear-cut representations of the self. By leaving the questions raised by the voice-over unanswered, she emphasizes that both positions are masquerades. Pipilotti Rist has explained: *'The holy-unholy subject of*

gender has taken hold of the unconscious in a particularly powerful manner. For this reason I am convinced that we will be able to approach the wounds, the festering kernels that have been stored there, only with the force of the visual, the figurative, and sounds. "Different" images can help bring about resilient change far more readily than verbal pamphlets. The language of images finds a more direct access to the unconscious, where prejudices slumber; it coins us far more strongly than words.' One could call this project of intervention a productive reformulation of the hysteric's crisis with symbolic language, for its aim is to record the aberrant language of the body so as to renegotiate the terms of the very symbolic code that constrains it. Rather than representing feminine malaise as a loss of language (with its corresponding loss of power) by performing difference Pipilotti Rist celebrates the

malfunction of a language regulated by normative laws.

One of the most perturbing aspects of the language of hysteria is that it is ruled by the belief in perfection and plenitude, even while it insists on highlighting the dissatisfaction with any given situation. As the feminine voice-over of *(Absolutions) Pipilotti's Mistakes* explains at the end: 'Actually I want to say that life is beautiful. Look at these colours, look at the amusing television programme. Look at the cosmos. But my pain has blinded me. The sun is setting. Soon I will no longer be cheerful. I hate all ideas of the ideal, which doesn't exist.' The scene that emerges is of the protagonist in her repeated effort to get out of the pool. Colour turns to black and white, and with it the voice-over shifts to a new key: 'I say, shit exists. Yes, evil exists, yes the non-ideal exists, yes, yes, yes … ' With this fundamentally ambivalent statement that affirms the existence of antagonism and difference, a radical disintegration of all images sets in. Yet the last word we hear is an emphatic 'yes', marking the acceptance of imperfection, of things being out of place, of constant struggle. Loosing the sharp contrasts and the clear rhythms, fully embracing the blurring of boundaries between oppositions, prove to be fitting performances of difference. As Rist has argued emphatically, a sense of human progress subtends all her work to such a degree that her interest is in producing works that exhibit an affirmative attitude towards the cultural presuppositions they seek to dismantle. Rather than formulating what displeases her in the stereotypes reproduced by the media, she exerts all her strength in materializing Utopias in an audio-visual mode: 'In so doing I use the slap in the face, which I receive when I contemplate the sluggish state of affairs as an impetus for the most self-assured and gracious mode of attack.'[4]

(Entlastungen) Pipilottis Fehler
([Absolutions] Pipilotti's
Mistakes), from the 'Individual
Series'
1988
Video stills
12 min., colour, sound

1 See Judith Butler, *The Psychic Life of Power: Theories in Subjection*, Stanford University Press, California, 1997.

2 See Georges Didi-Huberman, *Invention de l'hystérie: Charcot et l'iconographie de la Salpêtrière*, Macula, Paris, 1982, as well as Elisabeth Bronfen, *The Knotted Subject: Hysteria and its Discontents*, Princeton University Press, 1998, for a discussion of the vicissitudes of cultural representations of hysteria. For the recourse modern artists have had to the language of hysteria see *Die verletzte Diva. Hysterie, Körper, Technik in der Kunst des 20. Jahrhunderts*, ed. Silvia Eiblmayr, Dirk Snauwaert, Ulrich Wilmes and Matthias Winzen, Oktagon, Munich, 2000.

3 See Sigmund Freud, 'Studies in Hysteria' (1893–95), *The Standard Edition of the Complete Psychological Works of Sigmund Freud*, ed. J. Strachey with Anna Freud, 24 Vols., Hogarth Press, London, 1953–64.

4 Quotes are taken from *Alle wollen von allen benutzt werden, das ist gut so, Himalaya*, a compilation of Pipilotti Rist's first two books with additional pages, Kunsthalle Zurich; Musées de Paris, 1999.

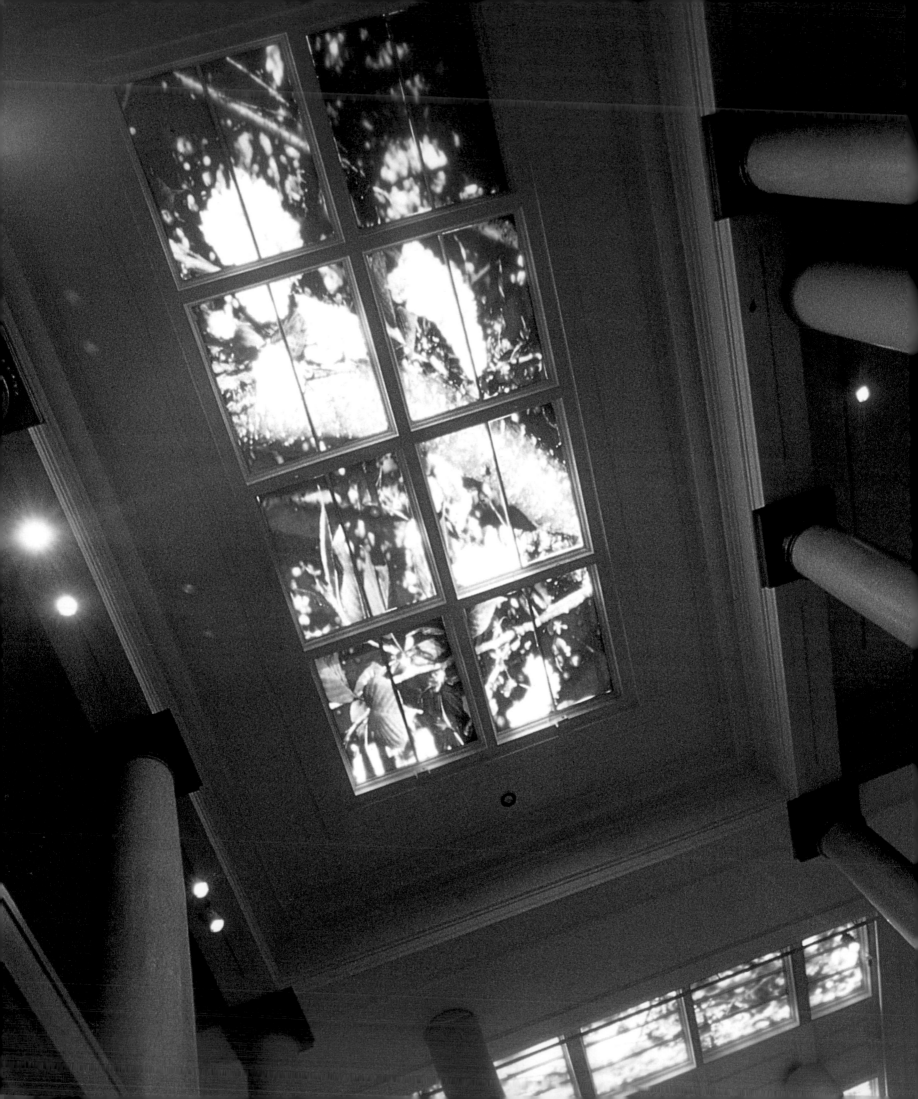

Contents

Interview I rist, you rist, she rists, he rists, we rist, you rist, they rist, tourist. Hans Ulrich Obrist in Conversation with **Pipilotti Rist, page 6.** Survey Peggy Phelan Opening Up Spaces within Spaces, The Expansive Art of Pipilotti Rist, page 32. Focus Elisabeth Bronfen (Entlastungen) Pipilottis Fehler (Absolutions: Pipilotti's Mistakes), page 78.

Artist's Choice Anne Sexton Barefoot, 1969, **page 94.** Richard

Brautigan The Irrevocable Sadness of Her Thank You, 1980, **page 98.**

Artist's Writings

Pipilotti Rist Innocent Collection c. 1988, ongoing, page 104. Title 1983, page 106. Prelude Morserne Freundlichkeiten 1983, page 110. Am Rett around the World, Interviews with Curators, Research Team, page 126. Ever Is Over All 1997, page 130. Monologue in Car (Suburb Brain), 1999, page 132. A Dream, 1995, page 136. Our Planet is Full of Joy (Our Planet Is Full of Joy), page 138. Chronology page 144 & Bibliography Comparative Selected Exhibitions, Bibliography, List of Illustrated Works, page 160.

Regenfrau (Rainwoman) **(I Am
Called a Plant)**
1999
Video still

Loving me with my shoes off
means loving my long brown legs,
sweet dears, as good as spoons;
and my feet, those two children
let out to play naked. Intricate nubs,
my toes. No longer bound.
And what's more, see toenails and
prehensile joints of joints and
all ten stages, root by root.
All spirited and wild, this little
piggy went to market and this little piggy
stayed. Long brown legs and long brown toes.
Further up, my darling, the woman
is calling her secrets, little houses,
little tongues that tell you.

There is no one else but us
in this house on the land spit.
The sea wears a bell in its navel.
And I'm your barefoot wench for a
whole week. Do you care for salami?
No. You'd rather not have a scotch?
No. You don't really drink. You do
drink me. The gulls kill fish,
crying out like three year-olds.
The surf's a narcotic, calling out,
I am, I am, I am
all night long. Barefoot,
I drum up and down your back.
In the morning I run from door to door
of the cabin playing *chase me*.

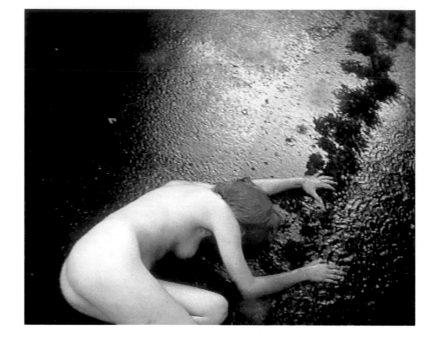

Regenfrau (Rainwoman) **(I Am
Called a Plant)**
1999
Video installation, sound
Kitchen cabinets and fixtures,
video projection, audio system
Installation, ARC, Musée d'Art
Moderne de la Ville de Paris
Collections , Stedelijk Museum
voor actuele Kunst, Ghent; Musée
des Beaux-Arts, Montreal
following pages, video stills from
installation

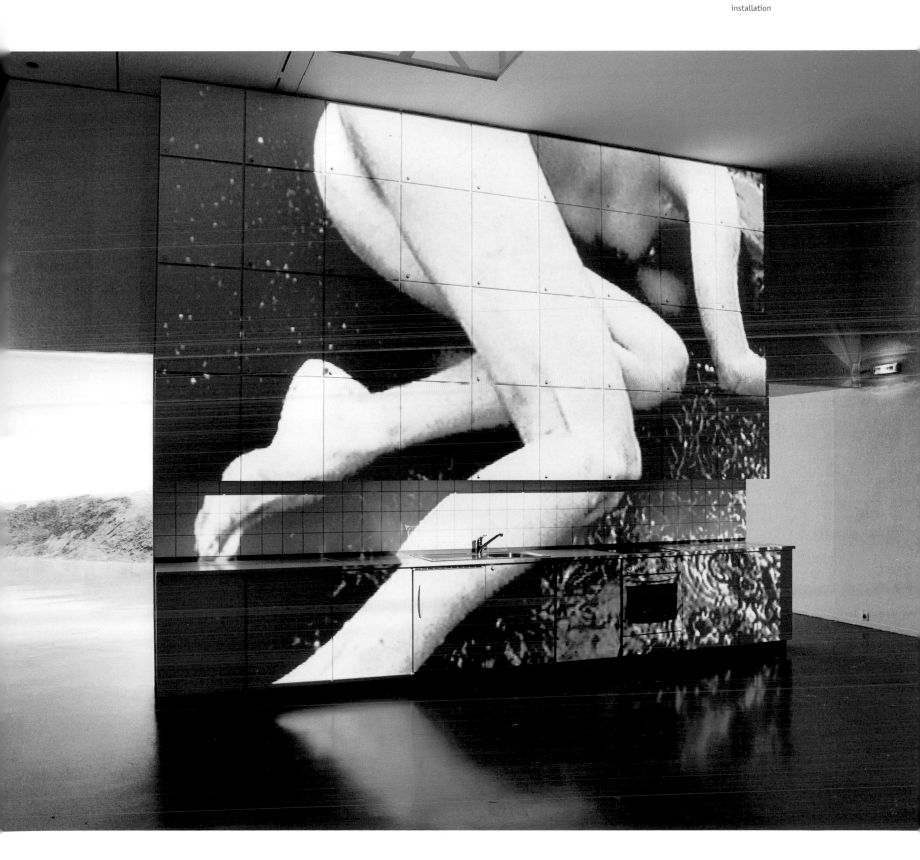

The Irrevocable Sadness of Her Thank You, 1980 **Richard Brautigan**

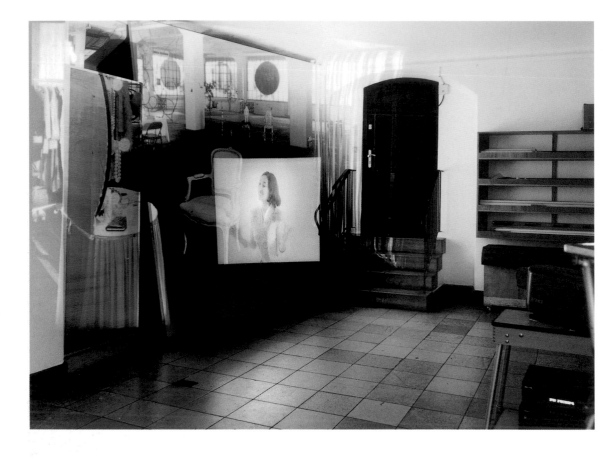

My Boy, My Horse, My Dog
1997
Video installation, sound with
Anders Guggisberg, interpreted by
Saadet Türköz
Video projection overlapped with
slide projection, audio system
Installation, Kunsthalle Nürnberg
Collection, Neues Museum,
Nürnberg
opposite, video still from footage

She won't escape. I won't let her escape. I don't want her lost forever because frankly I am one of the few people on this planet who gives a damn about her other than her friends and family if she has any.

I am the only American from a land of 218,000,000 Americans who cares about her. Nobody from the Soviet Union or China or Norway or France cares

… or the entire continent of Africa.

I was waiting at Harajuku Station for the Yamanote Line train to take me home to Shinjuku. The platform faced a lush green hillside: deep green grass with lots of bushes and trees, as always a pleasant sight here in Tokyo.

I didn't notice her waiting for the train on the platform with me, though I'm certain she was there, probably standing right beside me, and that's why I am writing this story.

The Yamamote train came.

It's green, too, but not lush, almost tropical like the hill beside the station. The train is sort of metallically worn out. The train is faded like an old man's dreams of long ago springs when he was perhaps even young and all he had in front of him is behind him now.

We got on the train.

All the seats were occupied and we had to stand and then I noticed her standing beside me because she was tall for a Japanese woman, maybe 5-7. She was wearing a simple white dress and there was a very calm, almost serene feeling of sadness about her.

Her height and sadness captured my attention and for the six or seven minutes that it takes to get to Shinjuku, she completely possessed my mind and now permanently occupies an important place there as these words bear witness.

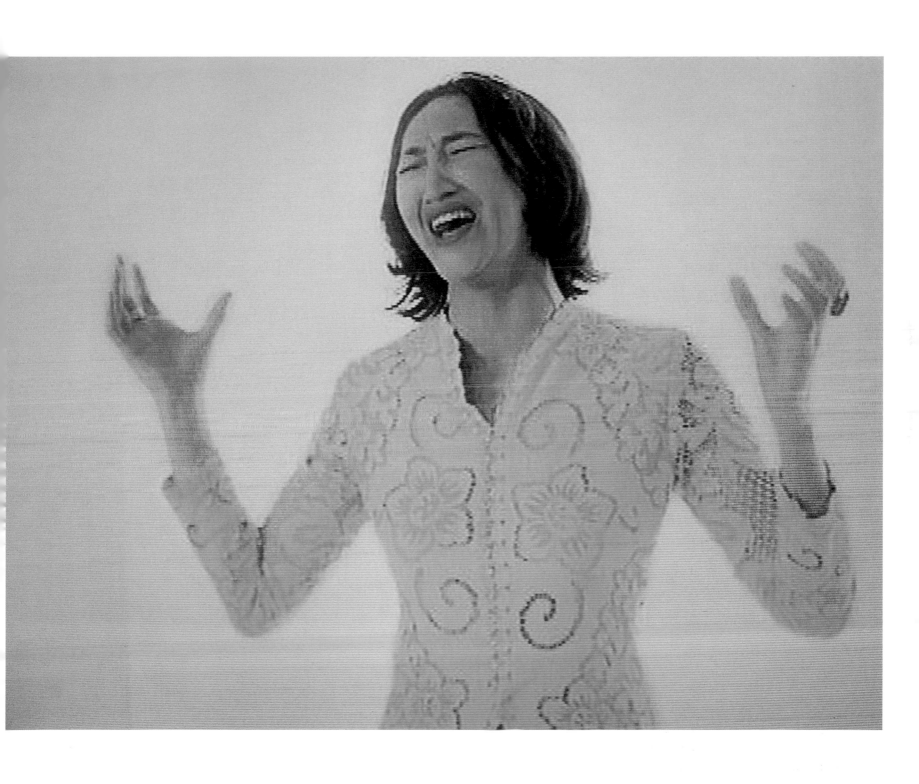

Untitled
1992
Video stills

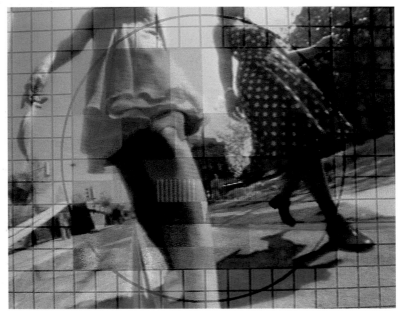

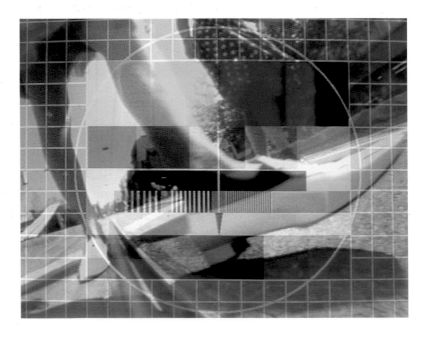

At the next stop a man sitting in front of me got up and the seat was vacant. I could feel her waiting for me to sit down, but I didn't. I just stood there waiting for her to sit down. There was no one else standing near us, so it was obvious that I was giving the seat to her.

I was thinking to her: *Please sit down. I want you to have the seat.* She continued standing beside me, staring at the empty seat.

I was just about to point at the seat and say in Japanese 'dozo' which means please, when a man sitting next to the empty seat slid over, taking it and then offering her his seat and she sat down in his seat, but she turned to me as she sat down and said 'thank you' to me in English. All of this took maybe twenty seconds from the time the seat in front of me was vacated and the woman was sitting down in the seat next to it.

This complicated little life ballet movement started my mind ringing like a sunken bell at the bottom of the Pacific Ocean during a great earthquake tearing cracks in the ocean floor, starting a tidal wave headed toward the nearest shore, maybe thousands of miles away: India.

The bell was ringing with the irrevocable sadness of her thank you. I had never heard two words spoken so sadly before. Though the earthquake of their first utterance is gone now, I am still in the power of its hundreds of aftershocks.

Thank you, thank you, thank you, thank you, thank you, thank you, thank you, thank you, after shocking over and over again in my mind, *thank you, thank you, thank you, thank you, thank you, thank you, thank you, thank you.*

I watched her sitting there for the few minutes until Shinjuku Station. She took out a book and started reading it. I couldn't tell what kind of book it was. I don't know if it was philosophy or a cheap romance. I have no idea of the quality of her intelligence, but her reading the book gave me the opportunity to look at her openly without making her feel uncomfortable.

She never looked up from the book.

She was wearing a simple white dress, which I think was not very expensive. I don't think that it cost very much money at all. The design was starkly plain and the material was modest in thread count and quality. The dress was not fashionably plain. It was really plain.

She was wearing very cheap, white plastic shoes that looked as if they had come from the bargain bin of a shoe store.

She was wearing faded pink socks. They made me feel sad. I had never looked at a pair of socks before and felt sad, but these socks made me feel very sad, though that sadness was only 1,000,000th the sadness of her thank you. Those socks were the happiest day of my entire life compared to her thank you.

The only jewellery she was wearing was a little red plastic ring. It looked like something you'd get in a box of Cracker Jacks.

She had to have had a purse to take the book out of because she wasn't carrying the book when she sat down and there were no pockets in her dress, but I can't remember anything about the purse. Perhaps, this was all that I could take.

Every living system has its limits.

Her purse was beyond the limits of my life.

About her age and appearance, as I said earlier, she was about 5-7, tall for a Japanese woman, and she was young and sad. She could have been anywhere between 18 and 32. It's hard to tell a Japanese woman's age.

She was young and sad, going to where I will never know, still sitting there on the train, reading a book when I got off at Shinjuku Station, with her thank you like a ghost forever ringing in my mind.

...blown romanticis
you, fallen in lo
 slowmotion
ike a trap to'me
gether in pairs
s the ideal nucle
on for economi
 cowse in a
u react mot

Contents

Interview I rist, you rist, she rists, he rists, we rist, you rist, they rist, tourist: **Hans Ulrich Obrist** in Conversation with **Pipilotti Rist**, page 6. Survey Peggy Phelan Opening Up Spaces within Spaces: The Expansive Art of Pipilotti Rist, page 32. Focus Elisabeth Bronfen (Entlastungen) Pipilottis Fehler ([Absolutions] Pipilotti's Mistakes), page 78. Artist's Choice Anne Sexton Barefoot, 1969, page 94. Richard Brautigan The Irrevocable Sadness of Her Thank You, 1980, page 98. **Artist's Writings Pipilotti Rist** Innocent Collection, 1988–ongoing, **page 104**. Title, 1989, **page 106**. Preface to *Nam June Paik: Jardin Illuminé,* 1993, **page 110**. 'I Am Half-aware of the World': Interview with Christoph Doswald, 1994, **page 116**. Two Untitled Poems, 1996, **page 130**. Monologue in Car (Suburb Brain), 1999, **page 132**. A Dream, 1999, **page 136**. One Day – Friday, 6 August 2000, 2000, **page 138**. Chronology page 144 & Production Credits, Bibliography, List of Illustrations, **page 158**.

Innocent Collection

1988–ongoing

Artist's collection of white,
translucent or blank objects

Title 1989

above, **Meine Stube** (My Living Room)
1985–86
Slide photograph

opposite, **Mein Schlafzimmer** (My Bedroom)
1985–86
Slide photograph

I know that when I press PLAY, the tape begins to spin. It spins to the right or the left, depending on which side of the equipment I stand. If I were a man I'd make porn films, but, as a twenty-seven-year-old human mouse, I can turn myself on or get turned on, just like that. Then I can go a step further: my hand reaches into my bra, I adopt the bra position. My hand is self-motivated. All I can say is how good it feels. So, on we go.

I want to be a bodybuilder, so come on, let's have lunch together today. Come on, let's have lunch together tomorrow. In fact today, 5 July, 1989, I ate out in the street at Lindenbergstrasse 23 in front of the Hirscheneck resturant. Which means I picked at two bits of squid off the plate of my friend, Fränzi Franztanz (170 cm). Sitting to my right was Jazzy (180 cm), who recently has been shaking off all her groundless fears. To her right was Muda (160 cm), who has taught me so much. We don't just eat together, we work together too. She knows what REW means, and lots of other things. Teresa (170 cm) was sitting by the wall, at a proper table so that she could put her curried chicken salad on it. As far as I remember she didn't have any bread with it. After we paid we went to the bar upstairs and played music. We made up a new song. Teresa added a sixteenth part, and I pressed REC on the sequencer. It was a bossa nova; it's our Betty Bosso Song.

It's best to work with friends (and Samir says so too). You can admit to your one own incompetence in proportion to your physical hindrances. I mean, after all, what can two unemployed, female technicians, who don't entirely get along, accomplish anyway?

Kunst, the German word for art, does indeed come from *können,* which means 'to be able': 'to be able' to master life (and the problems that one poses for oneself) with eyes wide open. Problems (that also pose themselves) are the spice of life (I'm quoting Muda here, although she claims otherwise.)

My eyes (turquoise blue) are two blood-powered cameras. The more openly and relentlessly I look into other people's eyes, the more brilliant the picture. My smile keeps what I have seen together with the rest of my body, which weighs 52 kilos. The stranger the objects I see, the longer I stare at them (the recording time), the greater the bonus I get. The 'tape' with all the information stored on it (the information that goes to make up the picture) is my knee, my colon and my heart. My work is more important to me than love, *I guess.* It goes up the left side of my body, and then straight back down on the right.

Our eyes, as we all know, are too slow to follow the sequence of fifty video images per second; but, we can feel it. I love the nervousness of video, because my own

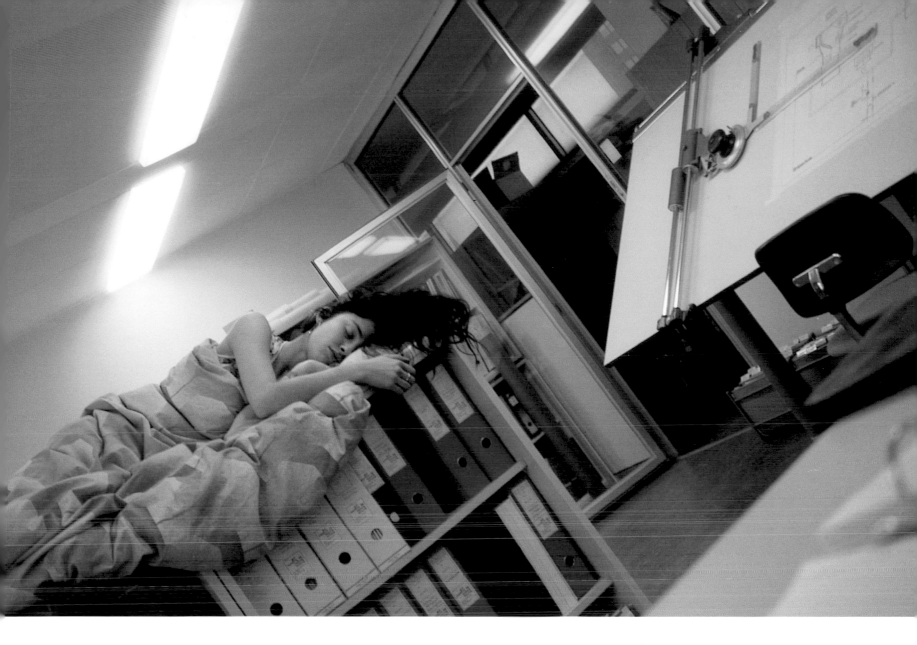

nervousness seems so tiny in comparison.

The snow eats the surface of the picture. Come and give me a kiss.

The sun rises in the east (clever!) and in the west it roller-skates down behind the mountain. *Turn on* – 1, 2, 3, 4, 5, 6, 7, 8, 9, 10, 11, 12, 13, 14 – *turn off*. Tomorrow I collect the black bed linen I've ordered. What's the use of a video artist who never takes a shower? Unlike me, Jesus had a Sony Watchman, but it fell into the water off the Copenhagen docks. Then his girlfriend gave him another one.

Since the consumer of a steady stream of pictures is forced to spend time recording with the producer, ideally she ought to like her own voice. Hopefully the videaste speaks in the vocal register that best suits her larynx and her person. But even if she shouts, there should still be an element of lightness.

During sex I find it difficult to whisper things or even to mumble anything, although when I was with Thomas, my first real lover, I loved whispering (in Swiss-German), 'I see endless hills flying right down to the bottom of the ocean'. It was very sexy; we were everywhere, under a tree, under a table, under a white cloth made up of lots of white bits of fabric sewn together. Always without coitus. With the tongue-creatures that came along after him a lot got in the way of talking in bed. Thomas is now a workaholic art director in advertising (Coca Cola, coffee, silk pajamas, luxury foods). I'll doubtless find something to say again. The worst that can happen is they cut off the power. The power-god knows that two roses can't consume one another. But there's always that need to take the camera right into the heart of a blooming flower,

and then into the very cells of the petals, and into the molecular structures of the cells, and on into the great nothingness. An American once did something like that; I think his name was Eams.

I steal V8 cassettes from Migros, the supermarket, although their cultural sponsorship section would benefit from a cameraman, a camera operated by a human being. Why use Betacam and not film? Whether it's Migros or the Coop, they all want the same thing, although the lighting in each is very different: in one it's bluish, in the other, greenish.

I work with video images that come out of improperly synchronized sequences, with shifts in the synchronization, when the image information is too fast or too slow. What does the video machine (or the player, the recorder, the time base corrector or the camera) show on the monitor if I ask too much or too little of it?

I'm interested in the pictures that result when the RGB (red-green-blue) signal is out of sync – for instance if the three colour tubes are shifted, or the different signal values are over-modulated. What chance images and rhythms does a video instrument use to save itself from overload? I'm interested in feedback and generation losses, like colour noise and bleeds. In my experiments with video it becomes clear to me how very much these supposedly faulty, chance images are like the pictures in my own subconscious. I call these pictures which don't match up with the dictates of the 'good', average images of the subconscious of the video machine.

These 'poor' pictures are related to those that shoot out from some unknown place when I'm looking at reality; they muddle with what I'm seeing. They are like the pictures in your head when you're falling asleep, when you close your eyes tight or when you're dreaming, either by day or by night. It's as though my own subconscious had materialized in the subconscious of the machine. The faulty images reveal what is otherwise concealed. These are the pictures that the industry technicians are so horrified by, or that they simply ignore. But there are lots of other people working with botched material. By doing so we pay homage – behind our ordinary machines, found all over the world by now – to the dead inventors who created these tools.

Making videos, whether experimental or poetic, means doing family therapy; the television is a family member, so to speak. If my work is intense, honest and good, then its therapeutic function is also my social relevance. Do you believe in antenatal conditioning?

'Titel', *Cinema: Film und die Künste*, Vol. 35, Verlag Stroemfeld / Roter Stern, Basel/Frankfurt, 1989, pp. 121–27.

Translated from German by Fiona Elliott.

<div style="text-align: right">

Life and Work
1986–2000
Collage of objects from the artist's
file, 'Life and Work'
Dimensions variable

</div>

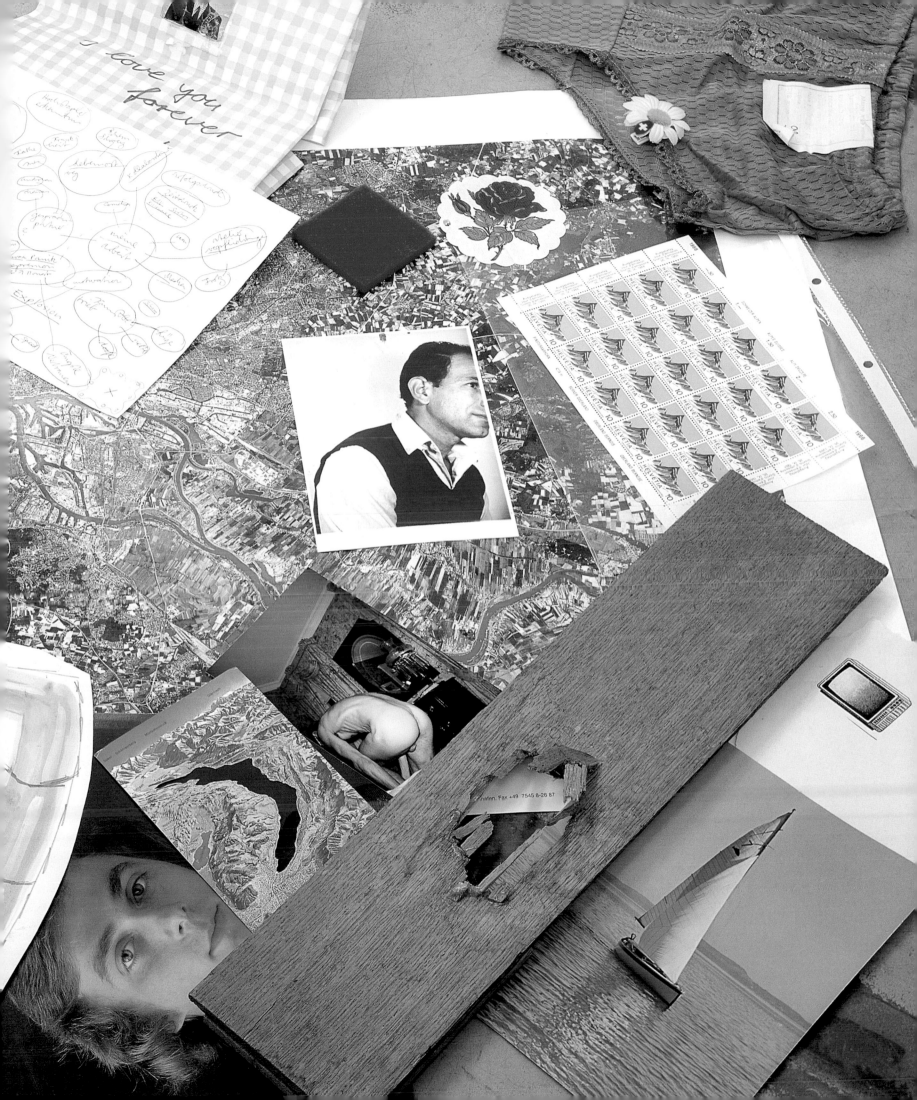

Here is the Korean bed of moss
Over there is Mount Harakiri
There's the nailfile factory
Further right the American bungalow
Snow climbs up the pane
Some parents' home or other
There's a frozen lake

In the twilight I fly through a street with my backpack propeller at a height of twenty-five metres. I can see into all the houses. Here four people sit down to eat. There a child crawls on a red carpet. Further left three adults discuss the arrangement of pictures in a catalogue. Over there a couple kiss under a bluish light. Someone tinkers with a model ship. Most have the television on. I quicken my flight. Sweet Mr Paik is seated behind me on the luggage rack. Our eyes are blood-fuelled cameras. Once more we are enthused by our multifarious lives. We digest impressions directly, or, at a pinch, register them on magnetic tape. I behold our organic muddy world and simultaneously remember, way back in the part of the brain for my right visual field, the strange design of our neighbour's television set and the tree between our houses. It is funny; everyone has neighbours and everyone remembers their television sets and their backyards.

Nam June Paik is a wild dog. He sees a tree, pees on it and the tree lights up. The leaves become screens that gleam and flicker bewitchingly. He feeds them rhythmic picture sequences from the player; this is the chlorophyll dissolved in water. The electric cables, which only he can toss around so artfully, are the roots. As long as no one switches off the power, no problems arise. Those who wander along the trees and bushes need only surrender to the flood of cathode rays. Their retinas are massaged by fluorescent rain. Their own nervousness suddenly appears to be relatively minor. The garden's seasons change in nano-seconds. This is the way you prolong life. Salvation lies in repetition!

We buy ourselves a kilo of apples. Nam June Paik has eaten every video innovation. He has no fear of machines; machines are basically stupid. Over the decades he has lept full force into the cornucopia of video technology. Now he is the great Renaissance artist of video with his twenty-seven trained assistants. In the beginning he flitted around the world with the first portable video equipment. He was a merry Fluxus artist and coaxed strange tunes out of the world. In black-

Monitorblüten (Monitor Blossoms)
1998
Video installation, silent
3 small black-and-white monitors, video images which depict entering the museum and overtaking the visitor on the stairs
Installation, Musée des Beaux-Arts, Montreal, 2000

and-white documentary photos we see him working with an innocent, child-like, earnest smile. One just *has* to kiss him. Because we live in such a nostalgia-heavy era, Paik is sentimentally blessed and can get away with anything. He plays on video keyboards or with digital effects as on a 'colour piano' (Paul Klee's dream). Without any respect for technology he rides into the sunset. This is cool, and makes him the role model for the video girls. He is our media grandfather who can do anything. Sometimes video history, as short and (supposedly) unencumbered as it is, seems under threat of being trampled by his giant shoes. With his video installations he has monopolized for decades a huge field of formal possibilities within the theme of 'a box with life in it' by exhausting virginal variations on 'the screen, the poetic lamp'. Others video artists must smother, capitulate or bypass him through content. Is this healthy?

Paik's new hardware battles remain just as imposing as ever because, as far as energetics goes, he does not allow them to slip from his small delicate hands. A

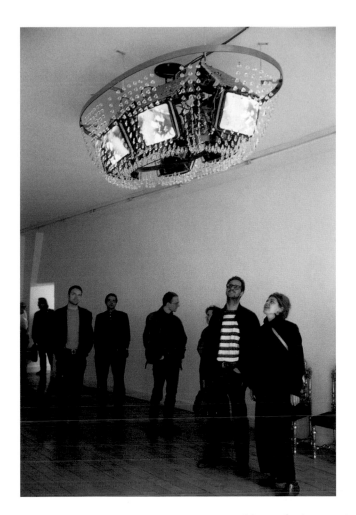

TV-Lüster (TV Chandelier)
1993
Video installation
6 monitors, suspended steel construction, audio system, chandelier crystals
Installation, Galerie Stampa, Basel
Collection, Swiss Confederation, Berne; permanently installed Kunstmuseum, St. Gallen

video artist keeps account of about fifty-four cables; Paik a great deal more. We quietly fly across the cabled suburbs. The world in front of, behind, or between the window and TV is the biggest video installation imaginable. It is all just a question of point of view. Video is the synthesis of music, language, painting, movement, mangy mean pictures, time, sexuality, lighting, action and technology. This is lucky for TV viewers and video artists. They love video, they love it with all its disadvantages, like the poor resolution of the image, reduced to 560 × 720 dots. They love it because of its disadvantages. It kick-starts our imagination and, behind our eyeballs, turns into an orgy of sensation and imagination. The monitor is the glowing easel where pictures are painted on the glass from behind.

The screen is a magic lamp. The machine throws pictures at us that we recognize from behind our eyelids: pictures from the moments in our unconscious when we are half-awake, euphoric, nostalgic or nervous. Through formal manipulation (colour-staining, digital distortion, layered perforation) and hyper-speed we lure the subconscious out of the machines and hold a mirror to our own subconscious.

We now change places. Mr Paik takes over the steering wheel and I take my seat on the luggage rack. Soon it is dark. Turn on the power:

Fear is a butcher
I am a reptile
Come, bountiful spirit, impregnate me
Nature gave me hands
I give them back to her
Come, bountiful spirit, impregnate me

Preface to *Nam June Paik: Jardin Illuminé*, Galerie Hauser & Wirth, Zurich, 1993. Translated from German by Jeanne Haunschild.

Nam June Paik
Video Funnel
1975/77
3-channel video, 90 monitors, steel structure
Installation, 'Von hier aus', Messegelände, Halle 13, Dusseldorf, 1984

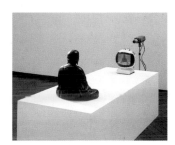

Nam June Paik
TV Buddha
1974
Bronze sculpture, monitor, video camera

Himalaya's Sister's Living Room
2000
Video installation, sound
7 video projections, furniture,
wallpaper, audio system
Installation, Luhring Augustine
Gallery, New York
Collection Hirshhorn Museum and
Sculpture Garden, Washington, DC

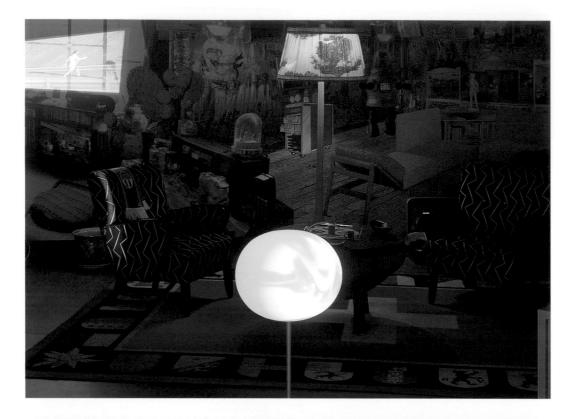

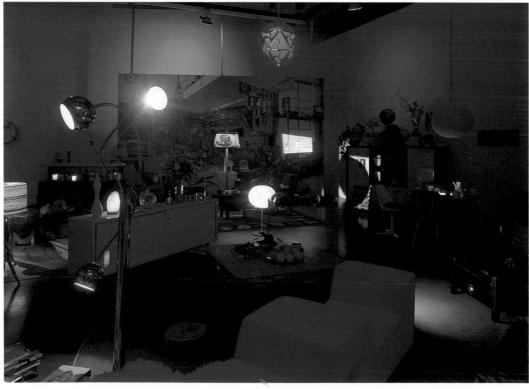

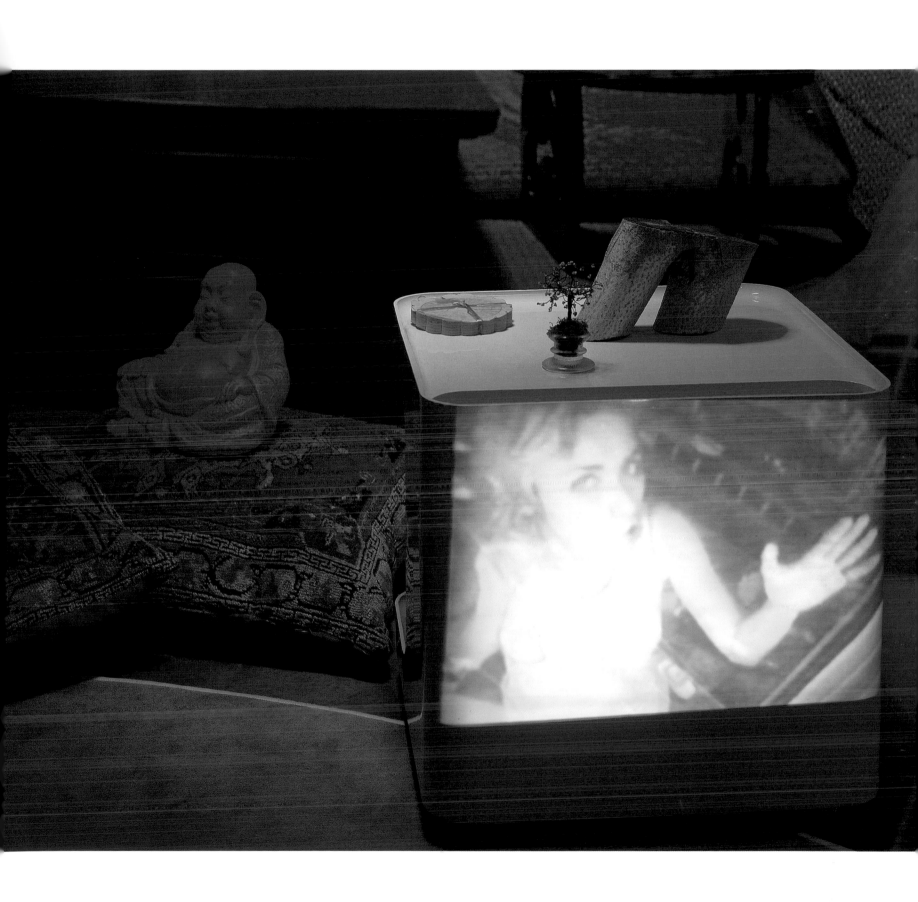

'I Am Half-aware of the World': Interview with Christoph Doswald
1994

Zu Deinem Tische treten wir (We
Step to Your Table)
1994/2000
Ilfochrome video still, glass,
polystyrene
120 × 160 cm

Doswald You generally present an 'overstated' female body by using a wide-angle lens and dressing yourself up. Sometimes that body seems to be a burden to its owner.

Rist **The ambivalence probably comes from the notion that the mind is more important than the body. It's taken me years to realize how idiotic that distinction is.**

Doswald This codependence between body and mind can be overcome, at least temporarily, by using drugs.

Rist **True, I've tried a lot of drugs, played with the body, but you pay an extremely high price emotionally when you try to dodge physical limitations by taking drugs.**

Doswald The extreme physicality of your videos is striking, as is the alienation of the images through the use of psychedelic colours. Does this aesthetic approach have anything to do with your experiences on drugs?

Rist **I'm sure they've influenced my consciousness and heightened my perceptions. But we can see and experience only what is inherent in and around the world around us. For example, when you close your eyes you see the aftereffect of objects in crazy colours. One reason I concentrate on inner images is because our society has a weak psyche that focuses on externals and concrete things, on colours and perceptions that are produced on the retina in collaboration with the brain. If we had to process every single optical signal, even the subconscious ones, we would be overwhelmed.**

Doswald Reduced perception as self-protection?

Rist **Exactly! That's what happens to the body, too. If we responded to every signal our body sends, tried to register every slightest bit of tension, we couldn't function anymore.**

Doswald Aren't people basically afraid of being subjected to involuntary perceptions?

Rist **Right. But the question is, to what extent do you refuse to perceive without sinking too deeply in your own shit?**

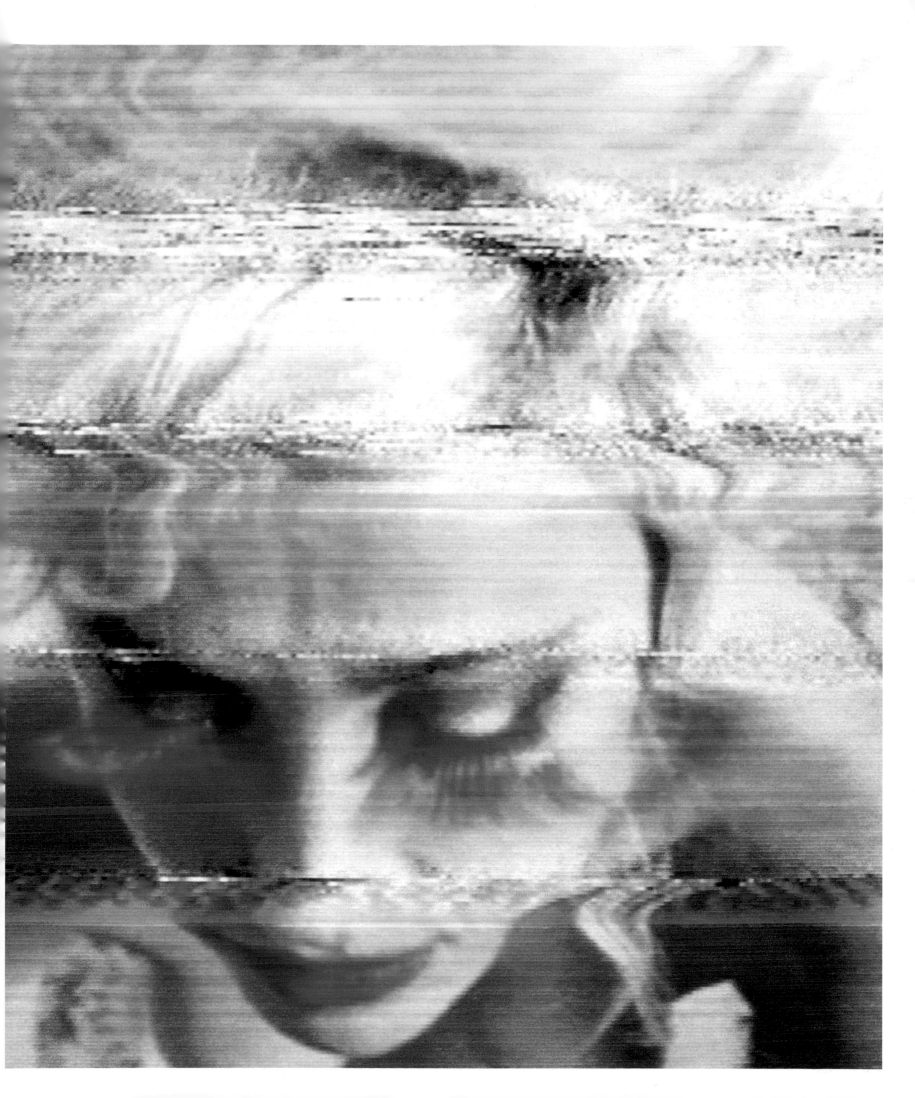

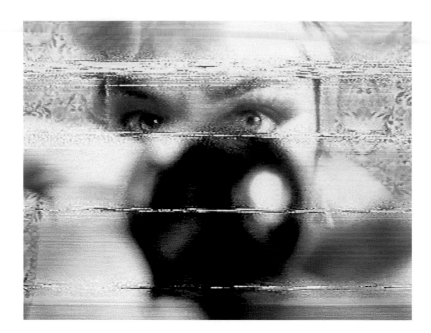

Sonne der Gerechtigkeit (Sun of
Justice)
1999
Ilfochrome video still, glass,
polystyrene
120 × 160 cm

Feuerwerk Televisione Lipsticky
(Firework Television Lipsticky)
1994/2000
Video still

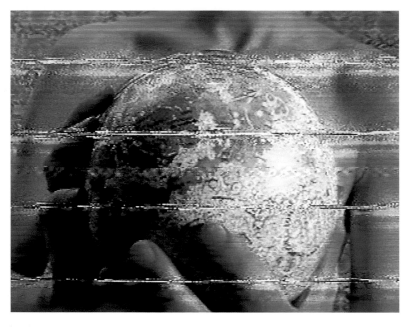

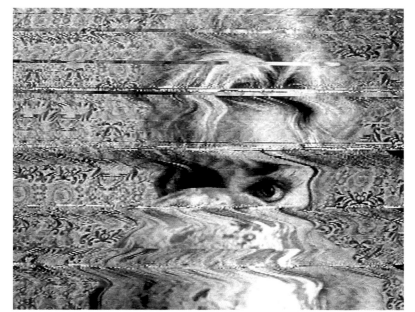

above, **Mitten wir im Leben sind**
(In the Middle of Life, We Are)
1999
Ilfochrome video still, glass,
polystyrene
120 × 160 cm

above, right, **Feuerwerk
Televisione Lipsticky** (Firework
Television Lipsticky)
1994/2000
Video still

right, **Ich will Dich lieben, Meine
Stärke** (I Wanna Love You, My
Strength) (detail)
1999
Ilfochrome video still, glass,
polystyrene
120 × 160 cm

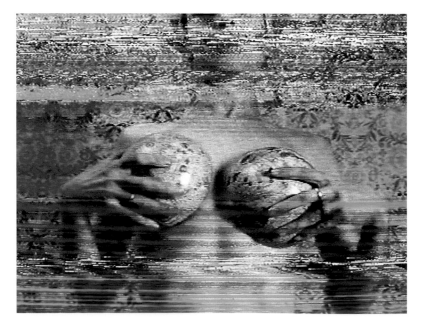

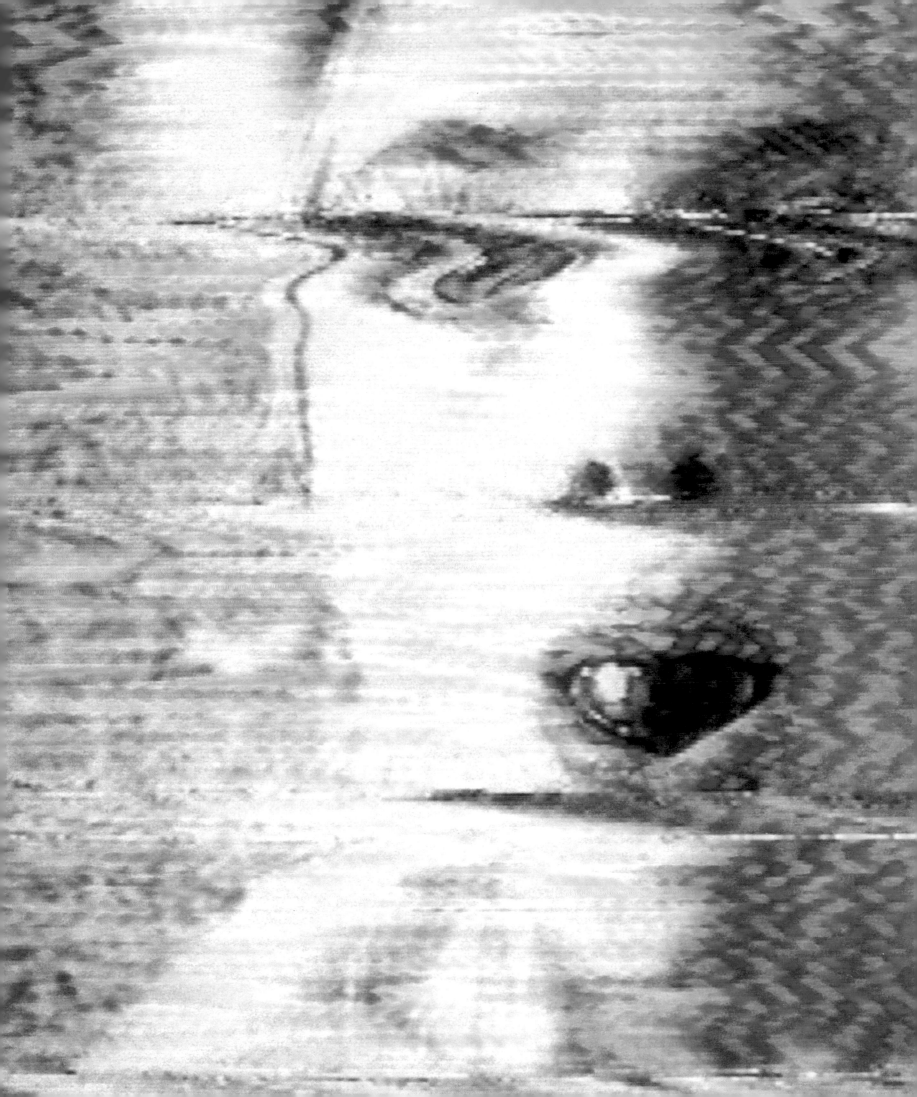

Doswald Some say you are Switzerland's token woman artist. Your work is often misconstrued as illustrating 'women power', from television shows on menstruation to your cropping up among the best-dressed women in Switzerland list. Your work, although very specific, has an extremely broad appeal.

Rist **Is that bad? I don't see it as being misrepresented. I'd worked on the subject of menstruation before the TV program and besides, clothes and jewellery are constituents of our feminine culture, and I'm proud of them. If I had to choose between my sex, this side of femininity would be one of the many reasons I prefer to be a woman. Just look at men: they have a pitiable spectrum of self-image at their disposal.**

Doswald I think that this reception of your work is also related to the lack of models for women, on the one hand, an immense increase in the need for an attractive visualized femininity.

Rist **That's true, but that need has always been there. Being a woman is the fate of 50 percent of the human race.**

Doswald If you could choose ...

Rist **' ... if I were a lad, it wouldn't be half as bad ... ' – well, actually I never wanted to be a girl. Then when I became a woman physically, I found the whole thing pretty astonishing. I observed myself as if examining some unknown animal species through a magnifying glass.**

Doswald Your artistic rendition of the female world has attracted critical attention from two angles: the art world on one side, the women's movement on the other. Who is your work for?

Rist **For ordinary folks and other nice people. I admit it bothers me that gender has become such a dominant factor in the perception of my work. First and foremost, I make art, that's the main thing. The trouble is that a work of art inevitably meets with different reactions from men or women. But I don't pay any attention to the viewer's gender in the conception of my work.**

Doswald It would be silly if a male artist dealt with the issue of being a man in his work. You have intentionally chosen to present your gender by using female emblems like handbags and bras.

Rist **When I begin with a work my own experiences are always the starting point. If the work is good, then it is automatically socially relevant as well. I admit, however, that I deliberately divide the world in two at times.**

I don't have preconceived theories that I then put into practice. My method tends to work the other way around: I stagger around in the dark in my work. I always want to surprise myself. It's only later that I analyze it in a larger context.

Doswald Does that mean, in contrast to many of your colleagues, that you don't like to talk about your work?

Rist **Yes, but it's also good when I'm forced to articulate myself.**

Doswald What does that mean exactly?

Rist I collect a huge amount of material and then get acquainted with this pack of images. That's the hardest part of the job. I have to find, among all these pictures, the ones I was actually looking for from the start. It is a conscious back-and-forth between what I want and what chance offers me. It's a slow process that produces a lot of unused pictures.

Doswald Yet your videos make a very compact, almost hermetic impression.

Rist That selection and manipulation of the images is a long, drawn-out process. I try one thing, then I reject it and look for new images. Video doesn't have this immediacy, this direct effect on mood, as does music or painting. An image has to go through a number of 'filters' before I decide whether it's any good.

Doswald But in manipulating or digitalizing the images they become painterly.

Rist I see videos as paintings behind glass that move. For example, in one video *(Entlastungen) Pipilottis Fehler*, *([Absolutions] Pipilotti's Mistakes*, 1988), I subjected the images to all kinds of interference: I played them too quickly for two simultaneously activated recorders, then put the pictures through a time base corrector that evens out irregularities. That was only one of twenty-five kinds of disturbance that I experimented with on the tape. Asking too much or too little of the machines resulted in pictures that I was thoroughly familiar with, my inner pictures – my psychosomatic symptoms. This technique is similar to painting where expressiveness or tackiness comes closer to the truth than a perfectly sharp, slick representation.

Doswald Truth? Is that what motivates your work?

Rist Yes, truth in the sense of honesty.

Doswald Collective or subjective?

Rist I mean shared perception.

Doswald You're active in an art world inhabited largely by men. What has your experience been as a woman in this subculture?

Rist **Creatively I work with so-called feminine methods. For planning and organizing I copy a lot from what men do. Sometimes I could die of shame when I sit in meetings and have to play games, but that's the price I have to pay. When a woman wants to get a project going she has to use methods that go against her nature. Women do not like to admit that they are using men's strategies because they're afraid that by doing so, they are no longer sexually attractive and they have to suppress their feelings.**

Doswald As an artist do you have more freedom in this respect than, say, a secretary, for example?

Rist **I operate in a protected area, in a sense. But I don't think of myself exclusively as an artist. I was originally interested in pop music. I designed backdrops and stage sets for bands. When I started making videos, the art world claimed me for itself. That suited me fine because the art cosmos is a playground with practically no constraints.**

Doswald The art system has become permeable, public and interdisciplinary in recent years. Your work is a good illustration of this development.

Rist **That's right. I am also opposed to art being elitist and I don't see why it shouldn't be commercial. It's absurd. Even if the art world keeps denying it, the art market exists and functions according to the same laws as any other business.**

Doswald Do you see yourself more as a figure in popular culture or as an artist?

Rist **It is important to me to be comprehensible. My art shouldn't work only on an intellectual level; it should also provoke emotions, invoke strength and give pleasure. Nice goals, don't you think?**

Doswald Yes. A lot of people would testify to the entertainment value of your work.

Rist **That's the point of good art. If it wants to have an effect, then it has to abandon the circle of academic initiates. My individual, wild images have a greater impact than sociological agendas.**

Doswald Being criticized for being light doesn't bother you then?

Basler Blutraum (Basel Blood
Room)
1993–94
Video installation, sound
Video projection on ceiling, audio
system, red dress, silvery spheres,
various objects on the floor, silver
coloured text on the wall:
*Arrivederci Hans, das war der letzte
Tanz* ('Arrivederci Hans, that was
the last dance')
Installation, Helmhaus Zürich.
1994

Rist **You can't overrate humour. And if I can manage to be entertaining without denying
suffering, then my work is successful.**

Doswald Is that why sound accompanies your installations?

Rist **Television has contributed a great deal to our sense of isolation. I want to break
down that barrier. And it's important for viewers of my TV-like, sound-and-image
installations to appear in the monitors so that they can reconquer the space that
television took away from them.**

Doswald You often complicate access to the monitor. Viewers have to squat down in front
of a child's bed, look at the ceiling or squeeze into a low space if they want to see the videos.

Rist **I want to strip this dominating box of its conspicuous shape. I take it out of its
context and implant it elsewhere.**

Doswald You are recontextualizing one-dimensional patterns of reception – you've already
done that with the subject of menstrual blood, breaking a taboo by giving it an image.

Rist **I've been asked if I wanted to shock viewers with these pictures. That's ridiculous.
The idea is to get the blood out into the open, to show this red fluid, this marvellous
liquid, this flesh-clock. Society has the tendency to hide menstrual blood as if it were
dirty and diseased. I think a girl should shout for joy the first time she gets her period,
because it is a symbol of creative power, of life. Blood, our lifeblood: it's the cleanest
thing in the world.**

Doswald Blood can also be associated with life-threatening events like death and injury.

Rist **Blood outside of the body disturbs people. This abandonment of form is taboo; it
means that the human machine is not running as it should. Menstruation is a sign of
good health, but every conceivable thing is done to keep it out of sight, to make it
invisible. So it's never been possible to give menstrual blood positive associations. The
potentially positive conception of blood as a life force can only be transferred to
menstruation by bringing it out into the open, making it visible, as I do in my work.**

Blutclip (Bloodclip)
1993
Video stills
2 min. 30 sec., colour, sound by
Sophisticated Boom Boom

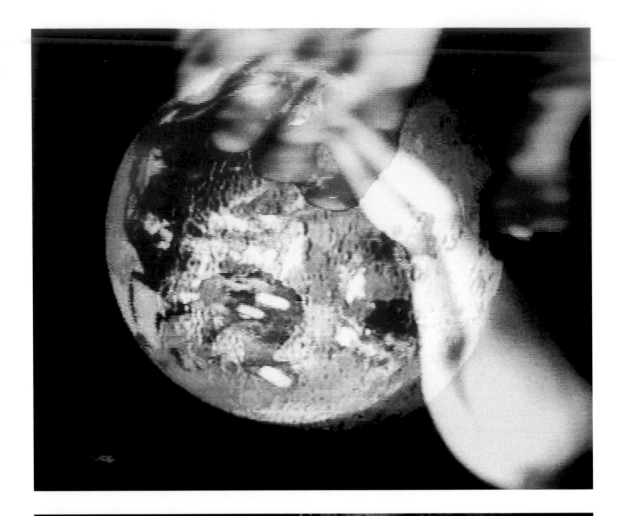

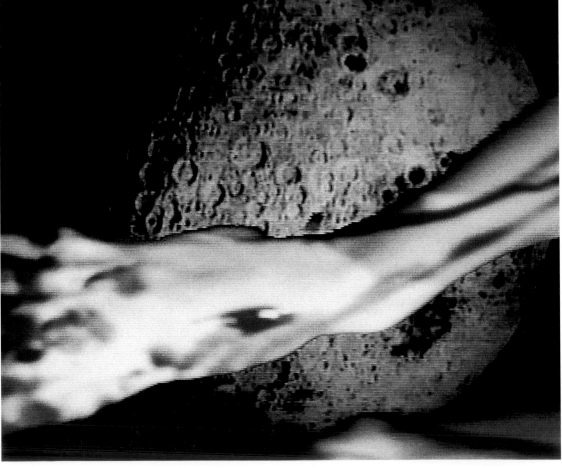

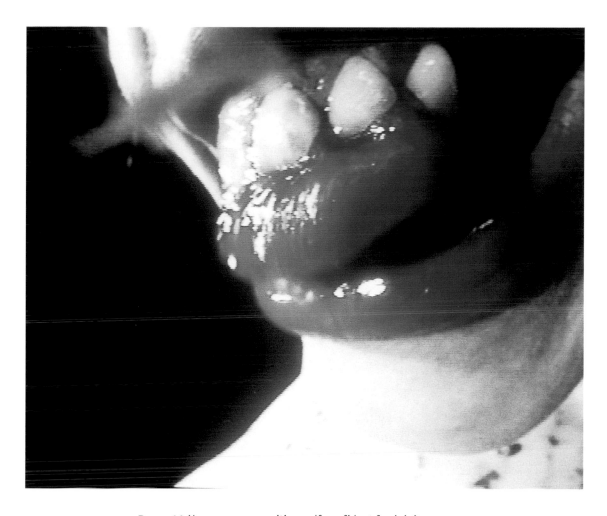

Doswald You espouse a positive, self-confident femininity

Rist **Of course. But I don't want to convey the feeling that only Pipilotti can do it; she's made it and is now showing others how. I'm always struggling with myself no matter what I do.**

Doswald So, it does have to do with an ambivalent relationship to your own body.

Rist **It's like a quest for the lost body. I observe myself analytically, I'm my own guinea pig.**

Doswald Do you practise any sports?

Rist **I dance. Today, for example, I danced through three MC Solaar pieces. I often dance with my brother in our living room at home. And today I came close to calling you and asking to go for a swim with me before our interview. I think from now on I'll have all my appointments at the swimming pool.**

'Ich halbiere bewusst die Welt, Pipilotti Rist im Gespräch mit Christoph Doswald', *Be Magazin*, No. 1, Künstlerhaus Bethanien, Berlin, 1994. Translated from German by Catherine Schelbert. Revised 2001.

Two Untitled Poems 1996

Atmospäre & Instinkt
(Atmosphere & Instinct)
1998
Video still
Video projection on the ground,
sound
Collection, Museum für Moderne
Kunst, Frankfurt; Musée d'art
contemporain, Villeurbanne (FRAC
Rhône-Alpes)

I'd like to be a policewoman, because of the uniform. I'd like to drill through our skulls and sew our brains together. While I still can, I stroll through the meadow, damp from melted snow. I squeeze my way through the smoking, chattering, frenzied crowd; outside, behind the discotheque, I lean against the wall. I could be anywhere, anybody. I am a physicist. I would like to have no fear.

There are different kinds of clouds: those I have seen, and those I imagine. The clouds I imagine (most clouds) I have never seen. The vast majority of clouds are those which others have seen or have imagined or will one day imagine.

Artist's contribution to the exhibition catalogue, 'Wild Walls', curated by Leontine Coelewij and Martijn van Nieuwenhuyzen. Stedelijk Museum, Amsterdam 1995. Revised 2001.

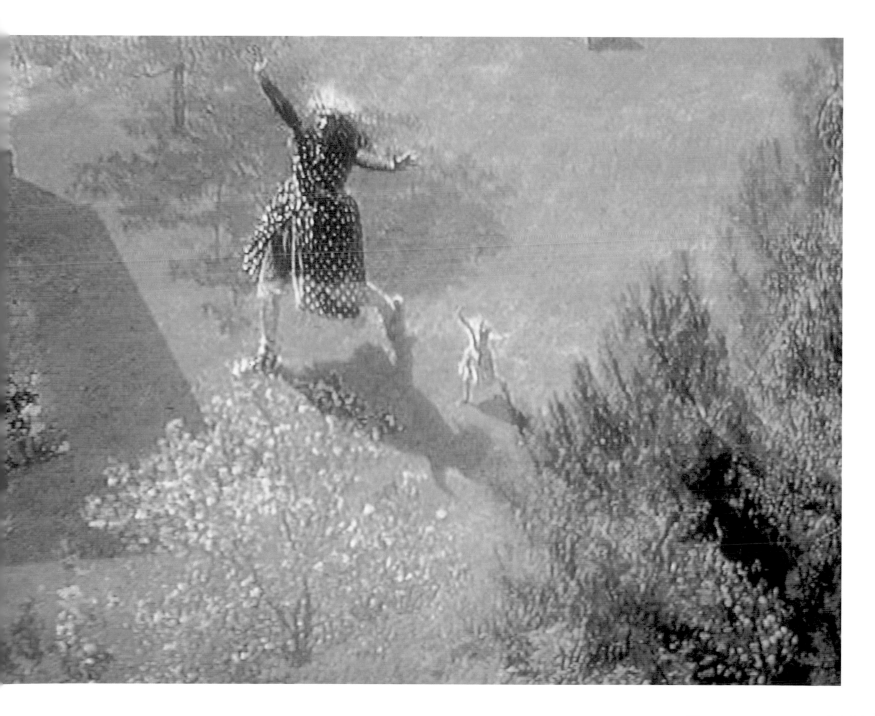

Monologue in Car (Suburb Brain) 1999

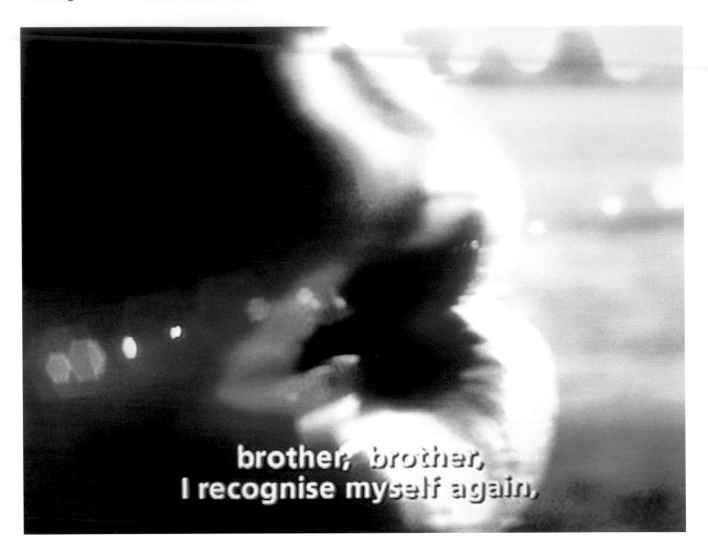

We lived in a flat-roofed house. Everyone had their own room. It was near the highway, and one could hear the cars especially at night. We were taught to look for Truth, Goodness and Beauty. The human being, aside from its animalistic facets, also possesses reason, intellect, responsibility, diplomacy, morals. Put this all together with a contented swing of the hip. Look, look at them sitting in front of the house; they have an orange bicycle and a pink one, too. Seeing with open eyes and looking with closed ones is difficult to reconcile. I find a Citroen nicer than a Mercedes. Sister, sister … brother, brother , I recognize myself again …

All this overblown romanticism … only you, in love, glancing in slow motion, seem like a trap to me. To rot together in pairs of two: this is the ideal nuclear constellation for economic desire. In a couple, you react most regularly, you know, have breakfast, sleep, relax, work.

I try to slot myself into nature's system, and when I'm not beautiful, then at least I'm still elegant. I have understood that we are part animal, but I don't understand it. The male seeks out a female – oh no, the other way round: the female seeks a male, who helps her (at least in the early years) to wean the youngsters. All that stuff, like strong, reputable shoulders. Once the female has the child, then everything's OK, she stays where she is and the male is rather polygamist.

I am a birch tree. My blood is boiling. What hurts you most when you think about your parents and their relationship? They never performed good love scenes. They never kissed.

Three thousand years of philosophical history, 150 years of psychological history. You mustn't think that you can once again reinvent the whole lot in just one afternoon. What do we want to do? Firstly, to redirect poetry back to metaphysics, physics and ethics. Back to these three, I mean back to metaphysics, and return theology to physics, logic – even logic – technology, epistemology and even psychology. Yes, even psychology belongs to physics. I mean psychology is also physics. Ethics is political.

My blood is boiling.
How would you react if your lover said she/he wanted to leave? Under which circumstances could you really, in any way, truthfully be able to answer such a question? And to whom?

There are three philodendrons: a huge maple, an ash, a birch tree. Should one end the relationship when it's at its best? Let's take a risk! Yes. Should one end the relationship at its best? Yes; no. I don't know.

Spoken text to *Vorstadthirn (Suburb Brain)*, 1999, video installation.

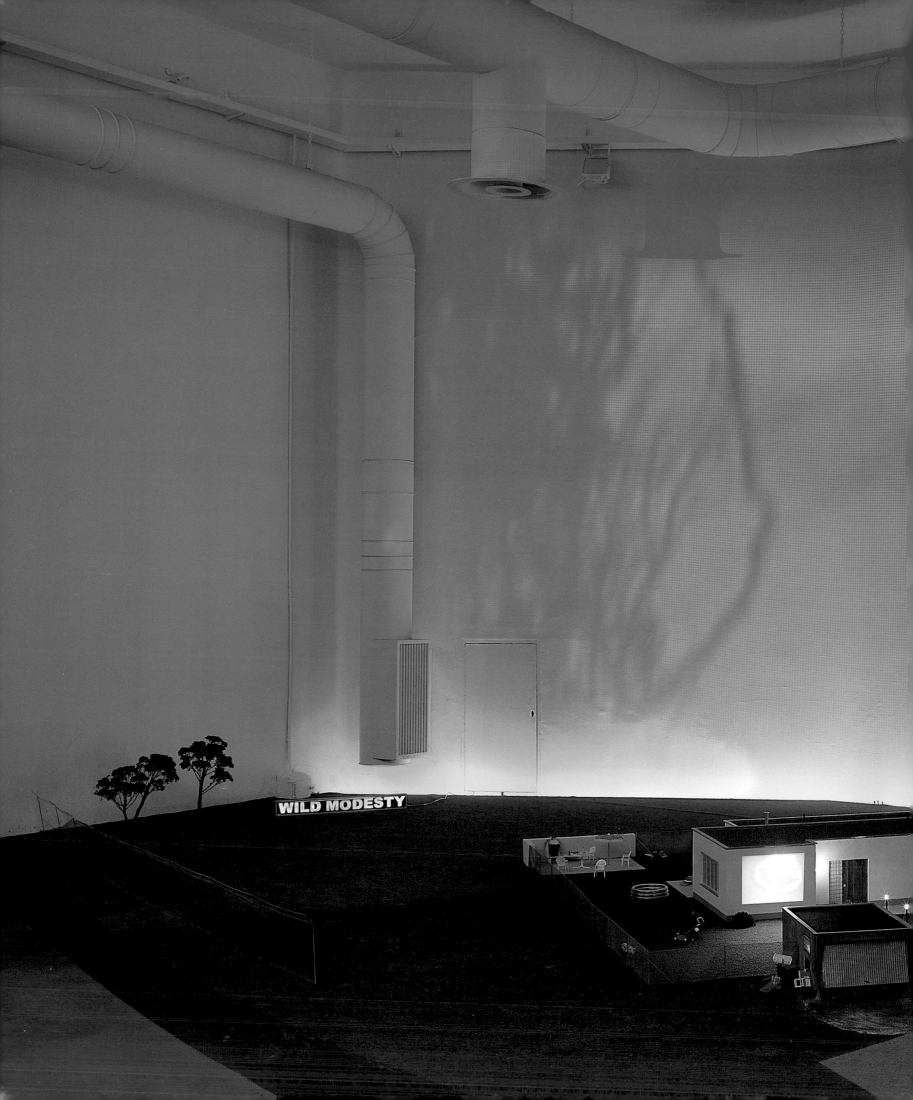

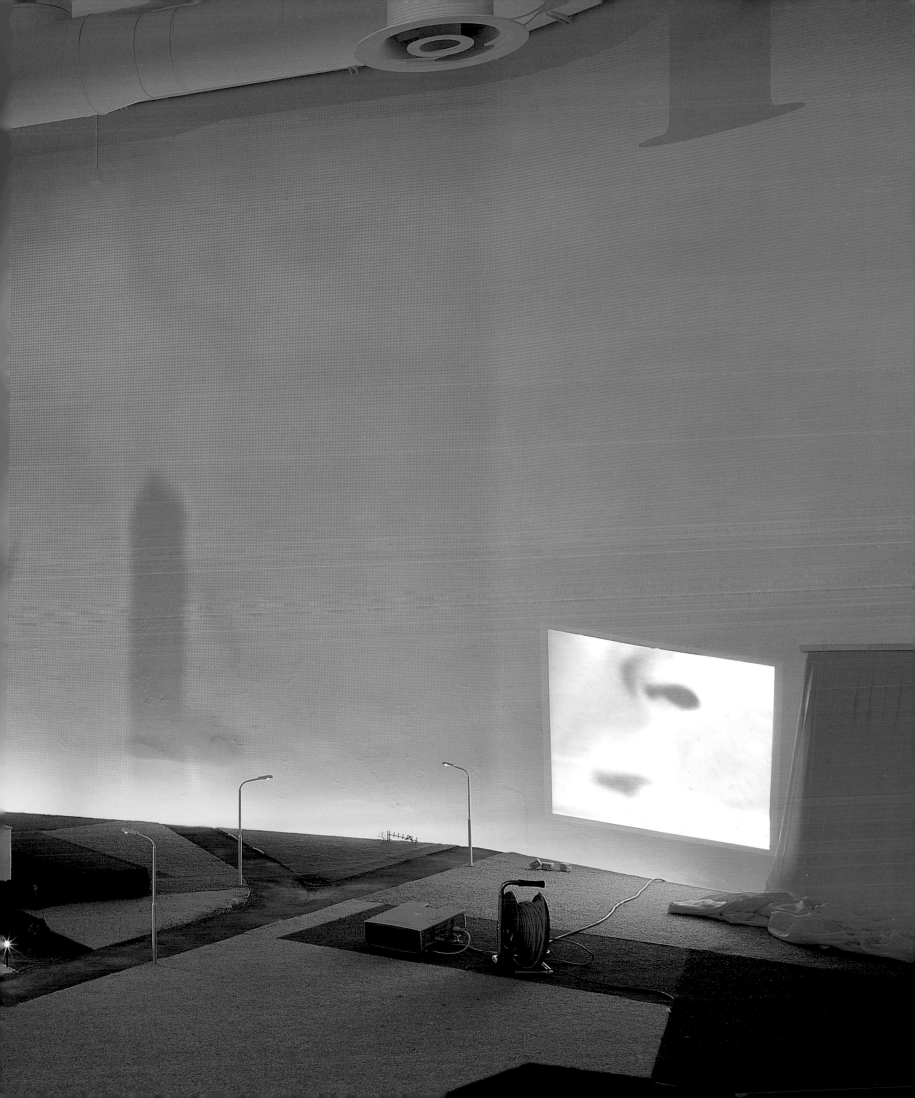

A Dream 1999

I dreamt I was an editor at a pornographic publishing house. The office was as large as a football stadium. It was like being in Tokyo, except none of my female colleagues smoked. The largest rooms were the toilets, which were twice the size of the office itself and fully decorated. Every day we published a book on a new sexual practice. Today's players wore a clitoris on each thumb, and poked them into their ears. When they were overcome by exhaustion, they prepared for bed. A buttercup seed popped out of a thumb and germinated in the earwax; a man's head exploded. A book exploded too. I escaped disguised as a bee.

The morning sun shone on the wet and juicy green field. I buzzed from one yellow flower to another in the midst of this brutal green and extreme blue. The newly milked milk was so hot it was steaming; a hurricane blew in the bucket, shaping the milk like a Louis XV curl, half a metre high. In the wood behind, a young girl bounced along in a truck on the bumpy riverbed. The heavy vehicle swerved away from the gravel; the girl just managed to push herself through the window slit.

I pulled her away from the riverbed and held her on my breast. Her mud-matted hair dirtied my stiff white shirt. The girl disappeared under my armpit until just her hands could be seen. The sun shone through her thick fingers, making them look orange.

Crying like a chained dog, I danced in a disco. It looked like our house. My tears shone in the coloured light. I was not ashamed or even frightened, and jumped around like a monkey. The soles of my feet slipped on the floor wet with tears, which made me dance even more quickly.

My body hovered horizontally and came to rest. From every direction my fellow dancers flew upwards and caressed me with their small cold hands, all over my body, consoling me. The salt water burned. After having cried long enough, I was free to choose a new identity. I thought I might become like you.

Sogni/Dreams, ed. Francesco Bonami and Hans Ulrich Obrist, project for the Fondazione Sandretto De Rebaudengo per l'Arte, Castelvecchi Arte, Venice, 1999.

I wake up in my mother's bedroom. I hear raindrops and the twittering of birds; her bed is empty and the cover is thrown back. My two five-year-old nephews are already breathing rasping breaths on their mattresses on the floor, their limbs wrapped up in bed-covers and pyjamas. I close my eyes again. Later one of them stands over me whispering: Mummy's in the Azores watching mother whales. The two slender-limbed boys hurl themselves under my blankets, against my back and my belly. They say I'm to call them my babies. Mama has brought buttery buns. The honey beckons. Jonathan refuses, despite the cold, to put a jacket on: nobody would be able to see the animals on his T-shirt from Australia.

I slide across wet concrete paving-stones to Dad in the house next door; Mama says he'd be hurt if I didn't. His flat is a museum to the tramp's way of life. Bins of recyclable materials he's collected, cork taps, mayonnaise and mustard tubes, spruce-tree branches, crystals and stones. The mushrooms he has collected are laid out in slices on the sofa and the floor to dry.

Back along wet blades of grass to Mama Anna, in the thirteen-room house. We are still printing out the plan for the house clearance and a list of the various collections we drew up yesterday. She and the two boys in their super-upholstered baby-seats drive me to the train. Mama is a good driver. We drive through the clouds and past a red Chevrolet surrounded by dripping bushes on wet, gleaming tar. Anna turns quickly, I remember the data: 1970, 160,000 km, 210 PS, price on request. Arriving at Sargans station, Jonathan refuses to get out of the car. We see a woman carrying a dog around her belly. The upper part of its rear end is shaved, and divided by an enormous line of stitches.

The two boys and my mother are like a single unit. In farewell, I press my face to the window and Damian walks along beside the departing train.

I sit down opposite Achmed, the tango singer; the windows are pale green and grey stripes. We greet one another. Because he was reading, I pretend to fiddle with my computer. When the trolley comes we ask for coffee and mineral water. For the rest of the journey Achmed tells me the story of his real/unreal wedding, and how the Lakeside Park in Zurich came to be set up in 1882, with major expropriations and the spending of twelve annual budgets by the borough for that single project: the people's lake-shore!

On Militärstrasse I stop at the lovely second-hand shop Bolero to fetch three trouser suits, romper-suit style, one in American flag material, one in lace and one in dark blue jersey. I paid for them yesterday. I like the crazy woman who runs the

clockwise from top left,
Mythenquai III; Mythenquai I;
Mythenquai V; Mythenquai IV;
Mythenquai II; Mythenquai VI;
Mythenquai VII
2000
Ilfochrome, glass, polystyrene
120 × 160 cm each

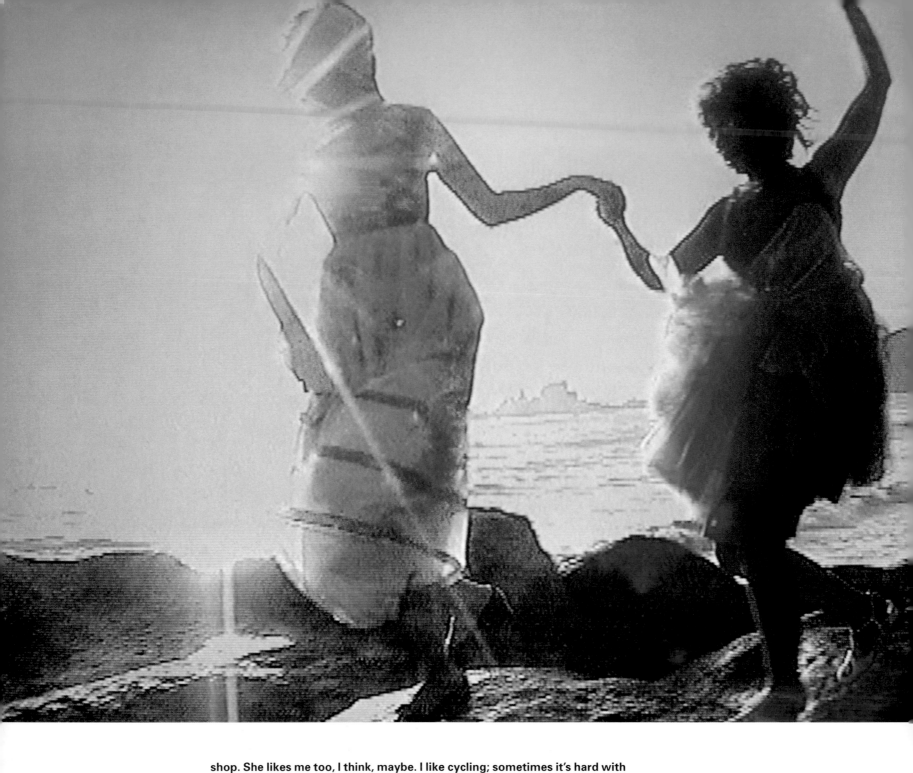

shop. She likes me too, I think, maybe. I like cycling; sometimes it's hard with luggage, but somehow it's always OK. If necessary I've also got a milk carrier. It's there, where the others are waiting because Adrian Bauer, the Mac wiz, is giving us (Cornelia, Davide, Claudia, Pius, Arthur, Rahel, Sushma and Tamara and me) the answers about all our questions about Netscape (glowing letters and cable catalogues). Now I know how to set up automatic responses, everything about the difference between text and HTML and how to add automatic addresses and poetry stuff on to your mail and so on. The decisions about how to put e-mails for particular projects into a special bin are still unresolved, but there are ways, even if they call for a high level of discipline.

I cycle to the dentist, journey time fifteen minutes, twenty-three seconds. He comes to the door in his jumper, tells me I'm an hour late. We go and get sweets from Sprüngli near the Opera, and sit down on the edge of Sechsilüten Square. I was right about the time; he had written it on the little card. I eat a very delicious Birewegge and Tomaz guzzles down two Visiteandine (the best of Sprüngli). We

Himalaya's Sister's Living Room
2000
Video still

put off tonight's dinner with our two friends until Thursday. We talk a bit about discotheques, their auditory and visual aspect. It hits me once again: I want to build the perfect disco.

I buy the sore-throat tablets that the chemist would use herself. I think the pain must have been intensified by all that boisterous singing with Mama and my nephews. The two pearls under my tongue are swollen.

In Rosenthal's ceramics shop on Bahnhofstrasse, with my broken nails, I order the discontinued model 2000 by esteemed designer Pietro Fornasetti: a collector's edition plate based on the models available Europe-wide, and also a butter-dish and two bowls from the 'Palladium' series. I wonder whether I should work here, then decide not to and turn southwest. By the Annex Collection window I bump into Theres and Martin. Theres and I admire the pieces made of velvet and silk, then we all drink an espresso with a glass of water. I'm very hyper and act the part of the happy woman taking a break from creative work (always goes down well). We talk about a vicar we all know, about houses and gardens, about their wonderful house with its old trees, now divided up for them, Martin's mother and their daughter Tutu. Just before the shops shut, Balz, my cheeky man and I, chat on the phone about whether or not he should go to the organic store.

At Stauffacherplatz I meet Gabi, a nurse. Backlit we talk about lots of things, like the idea that broccoli's supposed to be good for preventing cancer, about the division of childcare between fathers and mothers, and her son's hare-lip operation.

Unusually, I cycle back to the studio, paying attention to the highway code. My beautiful sister Tamara with her sweet-tempered bum is still there e-mailing feverishly away on one of the free computers. She's happy; she knows a lot and yet she's still naïve. I write down the day so far and then leave our beloved 300 m² studio with Tamara. Somebody on the combox is asking about onions and stock. Tamara quickly replies for me while I sit on the edge of the shop window and write an urgent e-message to regal Jacqueline: 'its sooo wonderful, the holznach-t-room, thatd b great, mamas driving me, when u + i meet?'

We go on walking, talk about my brother's plan to open a cultural restaurant, and the fact that he asked me yesterday if I'd design it. We beam and shiver. At the front door she gives me the ingredients for master-chef, lovely Balz, who mixes it up while I chill on the beautiful duvet with the motif 'misprints and leaping dolphins' (made by/a gift from Tamara), stretch out my limbs, run my fingers

along my ribs and open them. Balz's companion Olaf and his brother Martin walk up the stairs to the fifteenth floor, where the meal is almost ready.

It tastes fantastic: saffron risotto, broccoli onions – break fever break fever. We joke that we're being invited into High Society the following day, and tease each other about the possible reasons. In the clothes-room the four of us swap clothes. We have to enter it today so that it doesn't look too new tomorrow. Balz takes my flowery trousers, the salmon-coloured leather coat and his gay see-through shirt, size Extra Small; I think he looks sweet. Martin gets a present from my brother of the white trouser suit, which was too big for him. Olaf hangs up my suit, which fits him, and doesn't come with me to the Rohstofflager concert hall where the electric artist Richard A. James/Aphex Twin and the people from his Rephlex label are playing.

For the first time in my life I go to the – admittedly lovely – industrial zone of Oerlikon, made up of the thighs formed by the railway line and the road to Dällikon (where the sacred Sharp projectors are imported and distributed). We like the zone, but can't agree on the very modern red park cottage. The Roths harbour a slight suspicion of fascism.

We're much too late and that's still too early. Michael, whom I owe an email reaction to his CD, let the three of us in with another four people who thought he was talking to them. So we only had to wait fifteen minutes. The music by the DJ with the long dark hair is funny, the next one's too loud, but there are ear-plugs available at the cloakroom. My hero doesn't come on until 4.30 a.m., he's supposed to have been sitting stoned under the DJ's desk so I had to dance and think about the people dancing peacefully down there. I chat with someone called Mark Bernecker, son of the teacher Mr Bernecker, my mother's colleague, and go on reflecting about the spectacle presented to me. I think once again how I want to build the perfect disco. It has to be nice and sparkling and have perfect acoustics everywhere. How could I do that?

Martin drives us home, we get to sit in the back. I develop the knee-thumb game (and millions of other games) with Balz. Sex is a game too: sun, be swallowed up. Balz is groaning already; that's my favourite music. Sleep. Let the fathers be in the North. Sleep. That was my first Friday in August, 2000.
P.S. The Chevrolet Camaro consumed 14 litres of petrol per 100 km, cost about 8,000 Swiss francs. Unfortunately it's too much of an environmental hazard for me.

Previously unpublished

Himalaya's Sister's Living Room
2000
Video still

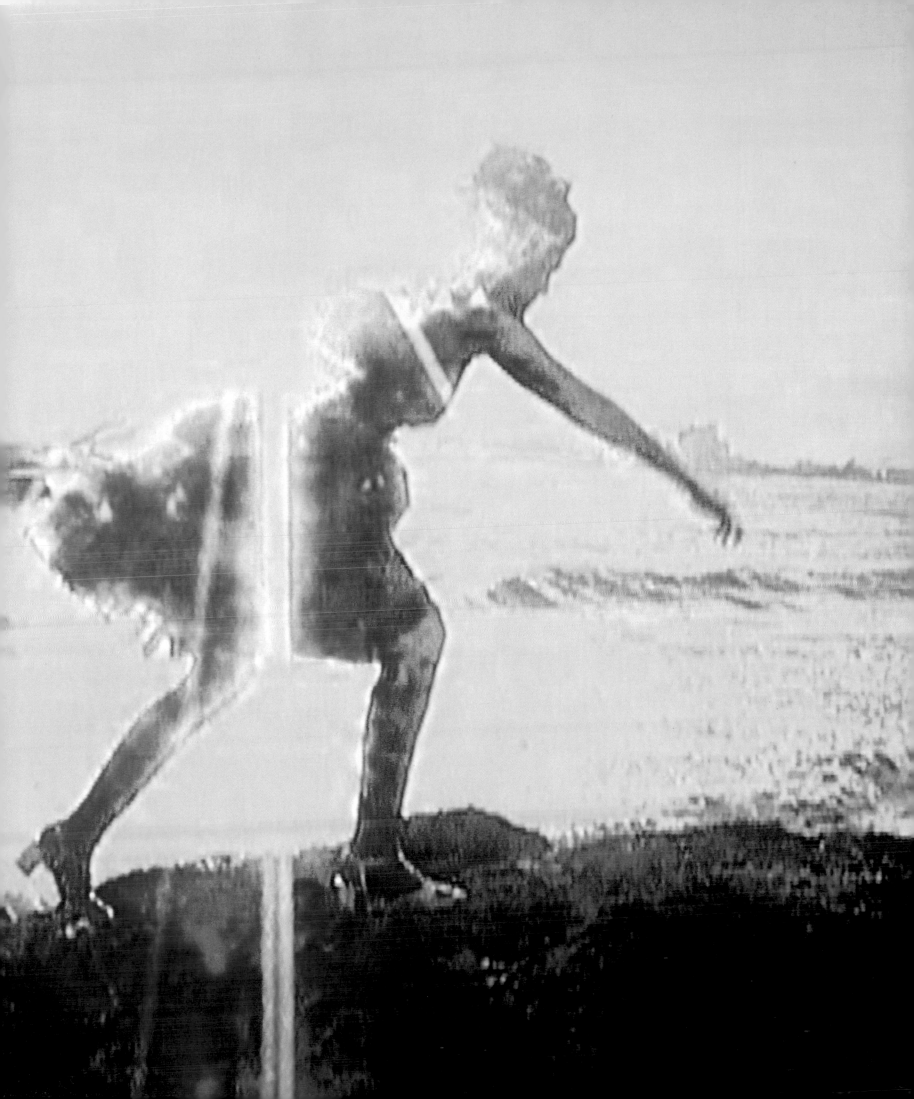

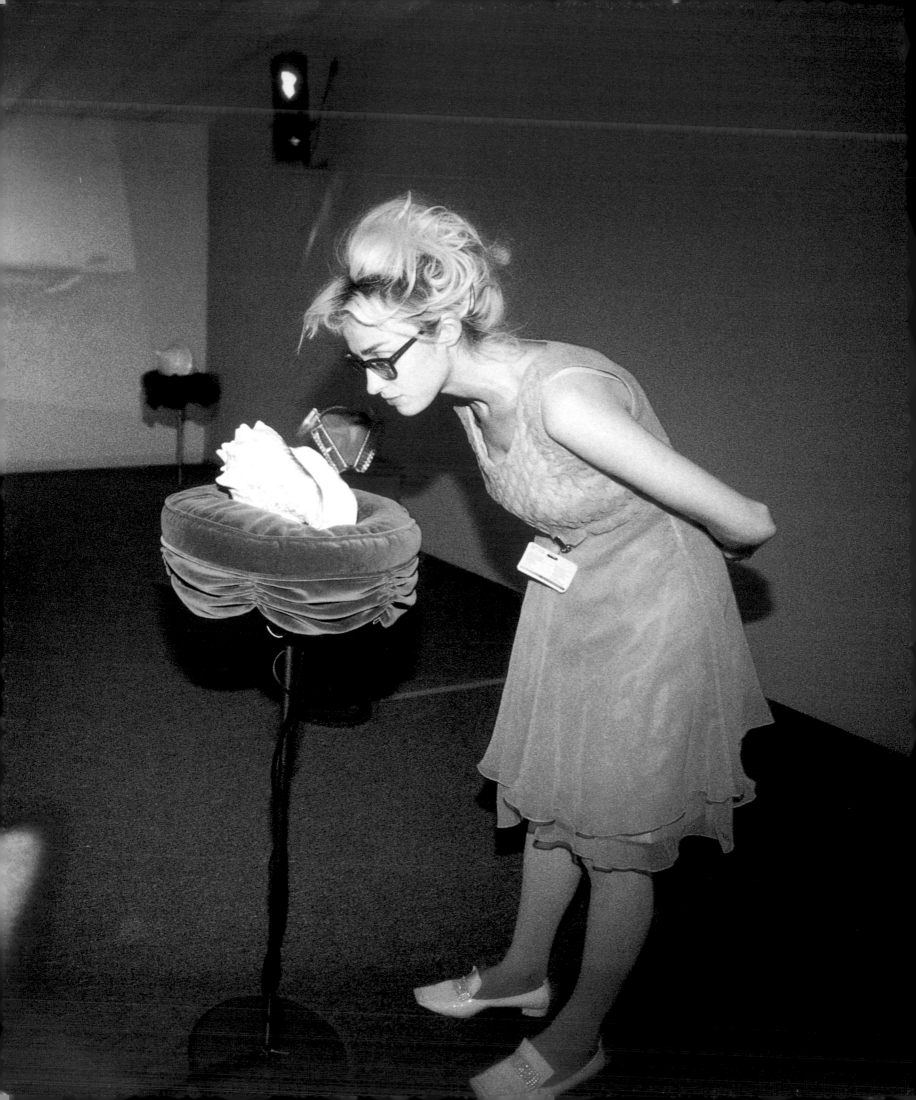

ontents

Interview Trist, you rist, she rists, he rists, we rist, you rist, they rist, tourist. Hans Ulrich Obrist in Conversation with Pipilotti Rist. page 6. **Survey** Peggy Phelan 'Opening Up Spaces within Spaces: The Expansive Art of Pipilotti Rist. page 32. **Focus** Elisabeth Bronfen (Entlastungen) Pipilottis Fehler (Absolutions) Pipilotti's Mistakes) page 78. **Artist's Choice** Anne Sexton Barefoot, 1969, page 94. Richard Brautigan 'The Irrevocable Sadness of Her Thank You, 1980, page 98. **Artist's Writings** Pipilotti Rist Innocent Collection, 1988 - ongoing, page 104. Title, 1989, page 106. Preface to Nam June Paik, Jardin Illimine, 1993, page 110. 'I Am Half-aware of the World' Interview with Christoph Doswald, 1994, page 116. Two Untitled Poems, 1996, page 130. Monologue in Car (Suburb Brain), 1999, page 132. A Dream, 1999, page 136. One Day – Friday, 6 August 2000, 2000, page 138. **Chronology** page 144 & Production Credits, Bibliography, List of Illustrations, **page 158.**

Selected exhibitions and projects
1982–90

1982–86
Studies Commercial Art, Illustration and Photography
Institute of Applied Arts, Vienna

1984
'Bank für Mond & Scheine',
Galeria Prottore/Stauraum, Vienna (solo)

1985
'Über & unter Wasser',
Kupferdruckwerkstatt Bregenz, Bregenz (group)

1986–88
Studies Audio Visual Communications (Video), School
of Design, Basel

1987
Screening, Solothurner Film- und Videotage

Screening, Film- und Videotage, Basel

Receives award, Film- und Videotage, Basel

1988
'UMBRUCH 1978–88',
Kunsthalle, St. Gallen (group)

Screening, '34. Westdeutsche Kurzfilmtage',
Oberhausen

Screening, 'London Film Festival'

Screening, 'Feminale', Cologne

Receives award, 'Feminale', Cologne

1989
'Die Tempodrosslerin saust' (with Muda Mathis),
Kunsthalle, St. Gallen (solo)

'We Can't Art Bar' (with Lori Hersberger),
Basel (group)

'Basler Künstlerinnen und Künstler',
Kunsthalle, Basel (group)

Screening, 'Viper', Lucerne

Receives award, 'Viper', Lucerne

Screening, 'Bielefelder Avantgarde-Filmtage'

Screening, 'Femme Totale', Dortmund

Screening, 'Filmtage Osnabrück'

1990
Screening, 'Festival Int. de Film et Video de Femmes',
Montreal

Screening, 'Cinevideo', Karlsruhe

Screening, 'Sound Basis Visual Art Festival', Warsaw

Lecture, University of Zurich

Installation view, 'Bank für Mond & Scheine', Galeria
Prottore/Stauraum, Vienna

Selected articles and interviews
1982–90

Invitation card, 'Bank für Mond & Scheine', Galeria Prottore/Stauraum,
Vienna

1989
Lerch, Liliane, 'Rist & Mathis: Künstlerfrauenpaare',
Kunstforum International, Ruppichteroth, April–May

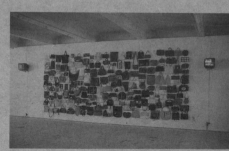

Installation view, 'Die Tempodrosslerin saust' (with Muda Mathis),
Kunsthalle, St. Gallen

Selected exhibitions and projects
1991–93

1991
'MIT HERTZ',
Kulturzentrum Kammgarn, Schaffhausen, toured to
'Une séléction de MIT HERTZ', **Centre d'art
contemporain**, Fribourg (group)
Cat. *Mit Hertz*, Kulturzentrum Kammgarn,
Schaffhausen; Centre d'art contemporain, Fribourg,
texts Yegya Arman, Christine Hunold, et al.

'Chamer Räume Kunst an Ort',
Forum Junge Kunst Zug, Cham (group)
Cat. *Chamer Räume Kunst an Ort*, Forum Junge Kunst
Zug, Cham, texts Pipilotti Rist, Anna Winteler, et al.

Receives award, Eidgenössisches Kunststipendium

1992
'Nett, dass Du mich begleitest durch die Kanalisation',
Galerie Walcheturm, Zurich (solo)

Shedhalle, Zurich (group)
Cat. *M. Shirai, J. Bollande, S. Gertsch, M. Huber, P. Rist*,
Shedhalle Zurich, text Harm Lux

'Fragmenti Intervalli Interfaci: Paradigmi della
Frammentazione nell'Arte Svizzera',
Leonardi V-idea, Genoa (group)
Cat. *Frammenti Interfacce Intervalli: Paradigmi della
Frammentazione nell'Arte Svizzera*, Museo d'arte
contemporanea di Villa Croce, Genoa, text Viana Conti

'Simone Berger, Pipilotti Rist, Francis Traunig',
Kunsthalle Palazzo, Liestal (group)
Cat. *Pipilotti Rist, Francis Traunig*, Kunsthalle Palazzo,
Liestal, text Hedy Graber

'The Metapher of Light/Poliset',
Centro Video Arte, Ferrara (group)
Cat. *The Metapher of Light/Poliset*, Comune di Ferrara,
Padiglione d'Arte Contemporanea, Gallerie Civiche
d'Arte Moderna Palazzo die Diamanti, Centro Video
Arte, Ferrara, text Lola Bonora

Receives award, 'Zürcher Filmpreis', Zurich

Invitation card, 'Nett, dass Du mich begleitest durch die
Kanalisation', Galerie Walcheturm, Zurich

1993
'Schwester des Stroms',
Galerie Stampa, Basel (solo)

Record cover, **Les Reines Prochaines**, *Lob Ehre Ruhm Dank*,
BOY Records, 1993

'Transitt: New Art from Switzerland',
**Museet for Samtidskunst – The National Museum of
Contemporary Art**, Oslo (group)

'Aperto 93',
XLV Venice Biennale (group)
Cat. *XLV Venice Biennale*, Edizioni La Biennale di
Venezia, texts Francesco Bonami, Roberto Pinto, et al.
Cat. *Aperto 93*, Giancarlo Politi Editore, Milan, texts
Achile Bonito Oliva, Léone von Oppenheim, et al.

Selected articles and interviews
1991–93

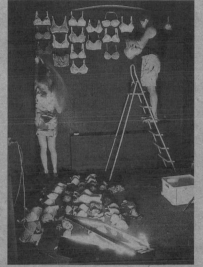

Ssss I to VII (1991–92), in progress, Forum Junge Kunst
Zug, Cham, *l. to r.*, Pipilotti Rist, Franzi Madörin

1992
Reich, Anne, 'Pipilotti Rist: Der Reiz des Unsauberen –
Ein Interview', *Kunst-Bulletin*, No. 12, Zurich

3 Köpfe (3 heads), 1992, in progress

Kalt, Jörg, 'Schwester des Stroms', *Da Magazin*, No. 7,
Zurich, February

1993
Jolles, Claudia, 'Pipilotti Rist: Galerie Stampa, Basel',
Artforum, No. 3, New York
Kempker, Birgit, 'Blut ist der Schuh', *Basler Zeitung-
Magazin*, No. 24, Basel, April
Mack, Gerhard, 'Die Bilder im Kopf beim Schmusen',
Turicum, Stäfa, August–September

Brockmann, Jan, 'Transitt: Ny kunst fra Sveits / New
Art from Switzerland, Museet for Samtidskunst –
National Museum of Contemporary Art, Oslo', *Terskel /
Threshold*, No. 10, Museet for Samtidskunst, Oslo

'A la recherche du temps présent',
Kunsthaus, Glarus (group)

Receives award, Förderungspreis der Jubiläumstiftung
der Schweizerischen Bankgesellschaft SBG

Receives award, Eidgenössisches Kunststipendium

1994
'5 installations vidéo',
Musée d'art et d'histoire, Geneva (solo)

'I'm Not the Girl Who Misses Much – Ausgeschlafen,
frisch gebadet und hochmotiviert',
Kunstmuseum, St. Gallen; **Kunstverein**, Hamburg;
Neue Galerie am Landesmuseum Joanneum, Graz
(solo)
Artist's book, *Pipilotti Rist (167 cm): I'm Not the Girl
Who Misses Much*, Oktagon, Stuttgart, texts Konrad
Bitterli, Jacqueline Burckhardt, Bice Curiger,
Christoph Doswald, et al.

22 Biennial of São Paulo (group)
Cat. *22 Biennial of São Paulo*, Fundação de São Paulo,
texts Nelson Aguilar, et al.
Cat. *Hannah Villiger / Pipilotti Rist*, Max Wechsler,
Baden

'Use Your Allusion: Recent Video Art',
Museum of Contemporary Art, Chicago (group)

'Steirischer Herbst '94: 100 Umkleidekabinen. Ein
ambulantes Kunstprojekt',
Badeanstalt, Graz (group)
Cat. *Steirischer Herbst '94: 100 Umkleidekabinen*,
Steirischer Herbst, Graz, text Paolo Bianchi

'Oh Boy, It's a Girl! Feminismen in der Kunst',
Kunstraum, Vienna; **Kunstverein**, Munich (group)
Cat. *Oh Boy, It's a Girl! Feminismen in der Kunst*,
Kunstverein München, Munich, texts Hedwig
Saxenhuber, Astrid Wege, et al.

'hauttief',
Helmhaus, Zurich (group)
Cat. *hauttief*, Helmhaus, Zurich, texts Marie-Louise
Lienhard, et al.

'Suture - Phantasmen der Vollkommenheit',
Kunstverein, Salzburg (group)
Cat. *Suture - Phantasmen der Vollkommenheit*,
Kunstverein, Salzburg, texts Silvia Eiblmayr, et al.

Galerie Akinci, Amsterdam (group)

Screening, 'No Man's Land',
Palazzo delle Esposizioni, Rome
Cat. *No Man's Land: Nomadismo tra le Culture in*

Das elektrische Skelettchen (erinnert sich) (The Little
Electric Skeleton [Remembers]), 1993, installation
Kunsthaus, Glarus

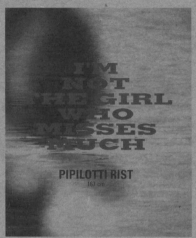

Book cover, *Pipilotti Rist (167 cm): I'm Not the Girl
Misses Much*, Oktagon, Stuttgart, 1994. Designed by Thomas
Rhyner

Zwez , Annelise, 'Pipilotti Rist: Das Wissen am Gefühl
Abzwacken', *Artis*, Berne, December–January

1994

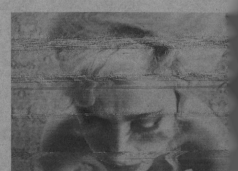

Invitation card, 'I'm Not the Girl Who Misses Much – Ausgeschlafen, frise
gebadet und hochmotiviert', Kunstmuseum, St. Gallen

Eine Spitze in den Westen – ein Blick in den Osten (bzw. N-S) (A Peak
into the West – A Look into the East), 1992–99, 22 Biennial of São Paulo,
with Hannah Villiger and Herzog & DeMeuron

Geerling, Let, 'Uit het handtasje: Over de metamorfose
van de videokunst', *Metropolis M*, Utrecht, February
Lux, Harm, 'Pipilotti Rist: Nirwana im Rosengarten',
Metropolis M, Utrecht, February

Svizzera, Palazzo delle Esposizioni, Rome, text Ester De Miro D'Ajeta

Screening, 'Minima Media: Medienbiennale Leipzig'
Cat. *Minima Media: Medienbiennale Leipzig*, Handbuch zur Medienbiennale Leipzig, text Dieter Daniels

Screening, 'New Media Logia', **Soros Centre for Contemporary Arts**, Moscow

Screening, **Institute of Contemporary Arts**, Perth

Lecture, **Kunstakademie**, Oslo

Receives award, Manor-Kunstpreis, St. Gallen

Receives award, Prix d'art contemporain de la Banque Cantonale Geneva

1995
'De kop van de kat is jarig en zijn poortjes vieren feest',
Galerie Akinci, Amsterdam (solo)

Galerie Franck & Schulte, Berlin (solo)

'A Night at the Show',
Fields Zurich, Zurich (group)

'Femininmasculin – Le sexe de l'art, X/Y',
Centre Georges Pompidou, Paris (group)
Cat. *Femininmasculin – Le sexe de l'art, X/Y*, Centre Georges Pompidou, Paris, texts Stéphanie Moisdon, Nicolas Trembley, Christine Van Assche, et al.

'Wild Walls',
Stedelijk Museum, Amsterdam (group)
Cat. *Wild Walls*, Stedelijk Museum, Amsterdam, texts Leontine Coelewij, Martijn Nieuwenhuyzen, et al.
Performance, **Stedelijk Museum**, Amsterdam

'How Is Everything',
Landesmuseum, Innsbruck; **Kunstbunker**, Nürnberg; **Wiener Secession**, Vienna (group)

'Video Visions Cairo',
Cairo University (group)
Cat. *Visions Video Cairo*, Cairo University, texts Jacqueline Burckhardt, Bice Curiger, Mayssoon Mahfouz, Werner Scheurer

'Body Smart',
Oratorio di San Rocco, Padua (group)
Cat. *Body Smart*, Oratorio di San Rocco, Padova, text Annamaria Sandonà

'Zeichen & Wunder: Niko Pirosmani (1862–1918) und die Kunst der Gegenwart',
Kunsthaus, Zurich (group)
Cat. *Zeichen und Wunder: Niko Pirosmani (1862–1918) und die Kunst der Gegenwart*, Kunsthaus Zurich; Centro

Doswald, Christoph, Rist, Pipilotti, 'Ich halbiere bewusst die Welt: Pipilotti Rist im Gespräch mit Christoph Doswald', *Be Magazin*, No. 1, Künstlerhaus Bethanien, Berlin
Doswald, Christoph, 'Pip-Up', *neue bildende kunst*, No. 5, Berlin, October

1995
Hays, K. Michael, 'Het ontstaan van ideologische gladheid', *de Architect*, Amsterdam, December

Babias, Marius, 'Pipilotti Langstrumpf, Angewandte Frauenkultur', *Zitti*, No. 22, Berlin

Special Swiss stamp commemorating 100 years of film, from the Electronic Media section

Artist's pages, *Wild Walls*, Stedelijk Museum, Amsterdam, 1995

Galego de Arte Contempèoranea, Santiago de
Compostela, Ostfildern-Ruit bei Stuttgart, text Bice
Curiger

'Beyond Switzerland',
Museum of Art, Hong Kong (group)

Screening, 'Naughty Girls', **Zaal de Unie & Nederland
Filmmuseum**, Rotterdam

Lecture, Vorführung, Kunstschule Hertsogen Bosch,
The Netherlands

1996
'The Social Life of Roses. Or Why I'm Never Sad' (with
Samir),
Kunstmuseum, Solothurn; **Kunsthalle**, Baden-Baden
(solo)

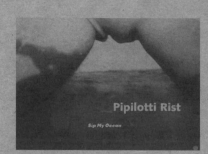

Pipilotti Rist
Sip My Ocean

Museum of Contemporary Art, Chicago (solo)
Cat. *Pipilotti Rist: Sip My Ocean*, Museum of
Contemporary Art, Chicago, text Dominic Molon

'Shooting Divas',
Centre d'Art Contemporain, Geneva (solo)

'Slept in, Had a Bath, Highly Motivated',
Chisenhale Gallery, London (solo)

'Zwischen Hodler und Nelkenmaler',
Kunsthaus, Zurich (group)

'The Scream',
Arken Museum of Modern Art, Ishoj (group)
Cat. *The Scream*, Arken Museum of Modern Art, Ishoj,
texts Kim Levin, Jorunn Veiteberg, et al.

'I'm Your Problem',
Kunsthaus Mürz und Kunsthaus Galerie,
Mürzzuschlag (group)
Cat. *I'm Your Problem*, Kunsthaus Mürz und Kunsthaus
Galerie, Mürzzuschlag, texts Johanna Hofleitner,
Otmar Dychlik, et al.

'Electronic Undercurrents',
Statens Museum for Kunst, Copenhagen (group)
Cat. *Electronic Undercurrents*, Statens Museum for
Kunst, Copenhagen, Marianne Øckenholt, et al.

'Mirades (sobre el Museu)',
Museo d'Arte Contemporanea, Barcelona (group)
Cat. *Mirades (sobre el Museu)*, Museo d'Arte
Contemporanea, Barcelona, text Maria Antonia Perello

'Nach Weimar',
Neues Museum Weimar, Weimar (group)
Cat. *Nach Weimar*, Kunstsammlungen zu Weimar, texts
Klaus Biesenbach, Hans Ulrich Obrist, Niklaus
Schafhausen, et al.

'Push-ups',
Athens Fine Arts School, Athens (group)
Cat. *Push-ups*, Ministry of Culture, Athens, text Emily
Tsingou

PIPILOTTI RIST

SLEPT IN, HAD A BATH,
HIGHLY MOTIVATED

20 APRIL – 26 MAY
Preview 19 April, 6.30 – 8.30pm

Supported by Pro Helvetia (Swiss Arts Council), Union Bank of Switzerland and Eric Franck

1996
Gerstner, Ulrich, ' ... Or Why I'm Never Sad, Pipilotti
Rist und Samir in Baden-Baden', *Neue Zürcher Zeitung*,
Zurich, 29 November
Tietenberg, Annette, 'Ein typisches Fernsehkind;
Video-Queen: Pipilotti Rist in der Kunsthalle Baden-
Baden', *Frankfurter Allgemeine Zeitung*, Frankfurt, 19
December

Spinelli, Claudia, 'Shooting Divas. Ein Projekt von
Pipilotti Rist', *Kunst-Bulletin*, No. 9, Zurich, September

Williams, Gilda, 'Pipilotti Rist: Chisenhale Gallery,
London', *Art Monthly*, London, June

SHOOTING DIVAS
Pipilotti Rist

Artist's edition, T-shirt, Chisenhale Gallery, London. Model: Tom Rist

Selected exhibitions and projects
1996–97

'NowHere',
Louisiana Museum for Modern Art, Humlebaek
(group)
Cat. *NowHere*, Louisiana Museum for Modern Art,
Humlebaek, texts Iwona Blazwick, Anneli Fuchs, Lars
Grambye, et al.

Screening, 'Inside the Visible', **Institute of
Contemporary Art**, Boston

Screening, 'Fuzzy Logic', **Institute of Contemporary
Art**, Boston

Screening, 'Auto reverse 2', **Magazin**, Grenoble

Lecture, **Museum of Contemporary Art**, Chicago

Receives award, DAAD Stipendium, Berlin

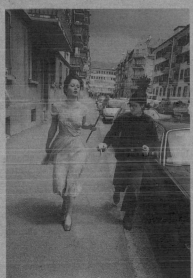

Ever Is Over All, 1997, in progress, Zurich, *l. to r.*, Silvana
Ceschi, Pipilotti Rist

1997
'The Social Life of Roses. Or Why I'm Never Sad' (with
Samir),
Villa Stuck München, Munich; **Stedelijk Museum Het
Domeijn Sittard**, Sittard, The Netherlands (solo)

'Kunst ... Arbeit: Aus des Sammlung Südwest LB',
Südwest LB, Stuttgart (group)
Cat. *Kunst ... Arbeit: Aus des Sammlung Südwest LB*, ed.
Stephan Schmidt-Wulffen, Ostfildern bei Stuttgart,
texts Melitta Kliege, Stephan Schmidt-Wulffen, et al.

'On Life, Beauty, Translations and Other Difficulties',
5th International Istanbul Biennale (group)
Cat. *5th International Istanbul Biennial. On Life,
Beauty, Translations and Other Difficulties*, Istanbul
Foundation for Culture and Arts, Istanbul, texts Rosa
Martinez, et al.

Selected articles and interviews
1996–97

Anderson, Laurie; Rist, Pipilotti, 'Laurie Anderson and
Pipilotti Rist Meet Up in the Lobby of a Hotel in Berlin
on September 9, 1996', *Parkett*, No. 48, Zurich
Babias, Marius, 'Pipilotti Rist', *frieze*, No. 27, London,
March–April
Babias, Marius, 'Risikofaktor Rist; Wenn Träume wie
sterbende Fische zucken', *Parkett*, No. 48, Zurich
Colombo, Paolo, 'Shooting Divas', *Parkett*, No. 48,
Zurich
Curiger, Bice, 'Pipilotti Rist, Yoghurt on Skin – Velvet
on TV', *Jahresbericht des Kunsthauses*, Zurich
Janus, Elisabeth, 'Pipilotti Rist', *Artforum*, No. 10, New
York, Summer
Spector, Nancy, 'The Mechanics of Fluids', *Parkett*, No.
48, Zurich
Sprecher, Margrit, 'Pipilotti Rist', *Geo Special*, No. 2,
Hamburg, April
Stange, Raimar, 'Raimar Stange über Pipilotti Rist',
artist Kunstmagazin, Bremen, February
Ursprung, Philip. 'Pipilotti Rist's Fliegendes Zimmer',
Parkett, No. 48, Zurich
de Brugerolle, Marie, 'Pipilotti Rist', *Documents sur
l'art*, No. 8, Paris

1997
Luyckx, Filip, 'The Social Life of Roses or Why I'm Never
Sad', *Sint-Lukasgalerij*, No. 3, Brussels, January, 1998
Smallenburg, Sandra, 'De wereld is nu eenmaal zo
gekleurd', *NRC Handelsblad*, Rotterdam, 10 November
Ter Borg, Lucette, 'Tinkelend lokt aards visioen
Pipilotti Rist', *de Volkskrant*, Amsterdam, 4 December
Zwez, Annelise, 'Grossmut begatte mich: The Social
Life of Roses', *Artis*, No. 2, Stuttgart

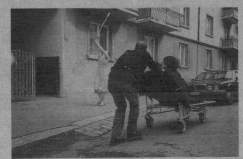

Ever Is Over All, 1997, in progress, Zurich, *l. to r.*, Silvana Ceschi, Anders
Guggisberg, Pipilotti Rist

Kontova, Helena, 'Biennale di Istanbul', *Flash Art
Italia*, No. 207, Milan, December

Selected exhibitions and projects
1997

'Screen, Surface & Narrative Space',
MuuTen Museum of Contemporary Art, Helsinki
(group)

'Nonchalance d'attitudes',
Centre Pasqu'art Biel, Switzerland (group)
Cat. *Nonchalance d'attitudes*, Centre Pasqu'art Biel,
Switzerland, texts Christoph Doswald, et al.

'time out',
Kunsthalle, Nürnberg (group)
Cat. *time out*, Renta Preis, Nürnberg, texts Stephan
Schmidt-Wulffen

'Unmapping the Earth',
Kwangju Biennale, Korea (group)
Cat. *Kwangju Biennale: Unmapping the Earth*,
Speed/Water, Kwangju, texts Harald Szeemann, et al.

Receives award, Kwangju Biennale Award

'4e Biennale de Lyon',
L'autre, Lyon (group)
Cat. *4e biennale de lyon d'art contemporain. L'autre*,
Réunion des Musées Nationaux, Lyon, texts Harald
Szeemann, et al.

'Future Present Past',
XLVII Venice Biennale (group)
Cat. *Passato, Presente, Futuro: La Biennale di Venezia.
XLVII Esposizione Internazionale d'Arte*, Martellago,
Venice, texts Germano Celant, et al.

SOME KIND OF HEAVEN

Receives award, Premio 2000, Venice Biennale

'Rooms with a View: Environments for Video',
Solomon R. Guggenheim Museum, SoHo, New York
(group)

'Epicenter Ljubljana',
Moderna galerija, Ljubljana (group)
Cat. *Epicenter*, Moderna galerija, Ljubljana, texts Mika
Briski, Harald Szeemann

'Some Kind of Heaven/Ein Stück vom Himmel',
Corner House, Manchester; **John Hansard Gallery**,
Southampton; **South London Gallery**, London;
Kunsthalle, Nürnberg (group)
Cat. *Some Kind of Heaven/Ein Stück vom Himmel*,
Kunsthalle Nürnberg; South London Gallery, London,
text Sadie Coles

Lecture, 'Women and the Art of Multimedia', **National
Museum of Women in the Art**, Washington, DC

Screening, 'Sixth New York Video Festival', **Lincoln
Center**, New York

Screening and lecture, Progetto Giovani, Milan

Receives award, Renta Preis der Kunsthalle Nürnberg

Selected articles and interviews
1997

Ahtila, Eija-Liisa, 'Screen Surface & Narrative Space',
muu magazine, No. 1, Helsinki, Fall

Kontova, Helena, 'Kwangju Biennale', *Flash Art*, Milan,
January–February, 1998

Rian, Jeff, 'Biennale de Lyon', *Flash Art*, Milan, October

Smith, Roberta, 'A Channel-Surfing Experience with
Beanbag Chairs and Gym', *New York Times*, 25 April
Smith, Roberta, 'Another Venice Biennale Shuffles to
Life', *New York Times*, 16 June
Ter Braak, Lex, 'Biënnale van Venetä', *Metropolis M*,
Vol. 18, No. 4, Utrecht, August–September
Thea, Carolee, 'The Venice Biennale 47th International
Art Exhibition', *Sculpture*, Washington, DC, November

Walsh, Maria, 'Some Kind of Heaven', *Art Monthly*,
London, July–August

Sonna, Birgit, 'Aschenbrödel als Videoprinzessin',
Süddeutsche Zeitung, Munich, 24 April

Selected exhibitions and projects
1997–98

1998
SITE Santa Fe, New Mexico (solo)

Wadsworth Atheneum, Hartford, Connecticut (solo)

'Remake of the Weekend in Berlin',
Nationalgalerie im Hamburger Bahnhof Berlin,
Museum für Gegenwart, Berlin (solo)
Artist's book, *Remake of the Weekend*, with CD, *We
Can't*, Oktagon, Cologne, texts Britta Schmitz, Gerald
Matt, Alessandra Galasso, Bernhard Bürgi

Remake of the Weekend, in progress, Gran Canaria, 1998, *l.
to r.*, Inger Nilson, Anders Guggisberg, Saadet Türkös

'Remake of the Weekend (auf österreichisch)',
Kunsthalle, Vienna (solo)

'Realities',
Ydessa Hendeles Art Foundation, Toronto (group)

'Global Vision: New Art from the 90s',
Deste Foundation, Athens (group)
Cat. *Global Vision: New Art from the 90s*, Deste
Foundation, Athens, text Katerina Gregos

'Freie Sicht aufs Mittelmeer. Junge Schweizer Kunst
mit Gästen und Gastmahl',
Kunsthaus, Zurich; **Kunsthalle Schirn**, Frankfurt
(group)
Cat. *Freie Sicht aufs Mittelmeer. Junge Schweizer Kunst
mit Gästen und Gastmahl*, Kunsthaus Zurich; Schirn
Kunsthalle Frankfurt, text Bice Curiger

'Divas',
Western Front Center of the Arts, Vancouver (group)

'Shoot at the Chaos',
Wacoal – Spiral Art Centre, Tokyo (group)
Cat. *Shoot at the Chaos*, Wacoal – Spiral Art Centre,

Selected articles and interviews
1997–98

Sirmans, Franklin, 'The Unbearable Lightness of
Whiteness', *Flash Art*, Milan, October
Saltz, Jerry, 'Merry-Go-Round', *Flash Art*, Milan,
October
Hannula, Mika, 'Sweet and Tender Hooligan', *Siksi*, Vol.
12, No. 1, Stockholm, Spring

1998

Clewing, Ulrich, 'Always-ultra Pipi-Pose', *die
tageszeitung*, Berlin, 14–15 May
Czöppan, Gabi, 'Knick in der Pupille', *Focus*, No.12,
Munich, 16 March
Erdmann Ziegler, Ulf, 'Rist Factor', *Art in America*, New
York, June
Fiedler, Tanja, 'Schneewittchen ist tot, aber der Sex
lebt', *Berliner Morgenpost*, Berlin, 13 March
Schäfer, Andreas, 'Wir wollen tanzen, tanzen, tanzen',
Berliner Zeitung, Berlin, 5 October
Tietenberg, Annette, 'Der Videoclip als Seelenstrip',
Frankfurter Allgemeine Zeitung, Frankfurt, 28 April

Bonik, Manuel, 'Vom Nachtdienst in das Wochenende',
Der Standard, Vienna, 19 June
Dumreicher-Ivanceanu, Alexander, 'Ever Is Over All:
Pipilotti Rist und ihre Wochenendkathedrale zu Wien',
(Blimp) Film Magazine, No. 39, Graz
Frehner, Matthias, 'Achtung! Rote Lippen schnappen!',
Neue Zürcher Zeitung, Zürich, 21–22 March
Hübner, Jakob, 'videogames', *Stadtzeitung für Wien*,
No. 26, Vienna
Mittringer, Markus, 'Neulich im Paisley-Park', *Der
Standard*, Vienna, 26 June
Pacher, Jeannette, 'Lieblich aufmuckend', *Forum für
Feministische Gangarten*, No. 25, Vienna, 26 August
Vachtova, Ludmila, 'Trunken, himbeerrot', *Die
Weltwoche*, Zurich, 19 March

Cameron, Dan, 'The New Melting Pot', *Flash Art*, Milan,
October
Dault, Gary Michael, 'Chasing Truth through the
Looking Glass', *Globe and Mail*, Toronto, 6 June
Glueck, Grace, 'Contemporary Works Intended to
Provoke', *New York Times*, 17 July

Hirsch, Antonia, 'Pipilotti Rist', *Front*, Vancouver,
September–October

Invitation card, 'Remake of the Weekend in Berlin', Nationalgalerie im
Hamburger Bahnhof Berlin, Museum für Gegenwart, Berlin

Selected exhibitions and projects
1000

Tokyo, texts Shimizu Toshio, et al.

'Strange Days: Gregory Crewdson, Tracey Moffatt,
Pipilotti Rist, Kara Walker',
Art Gallery of New South Wales, Sydney (group)
Cat. *Strange Days: Gregory Crewdson, Tracey Moffatt,
Pipilotti Rist, Kara Walker*, Art Gallery of New South
Wales, Sydney, text Wayne Tunnicliffe

'Hugo Boss Prize',
Solomon R. Guggenheim Museum, SoHo, New York
(group)
Cat. *Award Giving in the Visual Arts: The Hugo Boss Prize
1998*, Solomon R. Guggenheim Museum, New York,
texts Nancy Spector, et al.

'Berlin/Berlin: Berlin Biennale',
Kunstwerke Berlin (group)
Cat. *Berlin/Berlin: Berlin Biennale*, Ostfildern-Ruit,
Stuttgart, texts Klaus Biesenbach, Hans Ulrich Obrist,
et al.

'Aids Welten: Zwischen Resignation und Hoffnung',
Centre d'art contemporain, Geneva (group)

Television broadcast, 'ARKIPELAG – Stockholm
European Capital of Culture', Swedish National
Television, Stockholm

'ARKIPELAG – Stockholm European Capital of Culture',
Seehistorisches Museum, Stockholm (group)

'The King Is Not the Queen: The Mind Against the Eye in
Contemporary Film and Video',
organized by ARKIPELAG – Stockholm European Capital
of Culture
Nordic Museum, Stockholm (group)

Lecture, **Tate Gallery**, London

Screening, Witte de With Centre for Contemporary Art,
Lowlands, Rotterdam

Selected articles and interviews
1998

Cunningham, Daniel Mudie, 'Strange Days: The 4th
Guinness Contemporary Art Project', *Sydney Star
Observer*, 11 June
Mendelssohn, Joanna, 'Nobody Told Me There'd Be
Days Like These', *The Australian*, Sydney, 5 June
Smee, Sebastian, 'The Whole World Is Wild at Heart',
Sydney Morning Herald Metro, 22–28 May

Saltz, Jerry, 'Who's the Boss?', *Time Out*, New York,
9–16 July
Schjeldahl, Peter, 'Bonjour Ristesse', *Village Voice*, New
York, 11 August
Turner, Jonathan, 'Pipi Goes to Video', *ARTnews*, New
York, November
Schjeldahl, Peter, 'The Art World Beauty Contest', *New
Yorker*, 1 November, 1999
Seabrook, John, 'Nobrow Culture: Why It's Become So
Hard To Know What You Like', *New Yorker*, 20
September, 1999

Bonik, Manuel, 'Die Bildstörerin', *Deutsche Vogue*, No.
2, Munich, February
Buchmann, Sabeth, 'Produktivitätssysteme. Zu den
Arbeiten von Pipilotti Rist', *Texte zur Kunst*, No. 32,
Cologne, December
Haye, Christian, 'The Girl Who Fell to Earth', *frieze*, No.
38, London, March–April
Heartney, Eleanor, 'The Return of the Red-Brick
Alternative', *Art in America*, January
Hierholzer, Michael, 'Blütenträume aus dem Stoff der
Uniformen', *Frankfurter Allgemeine Zeitung*, Frankfurt,
14 June
Obrist, Hans Ulrich, 'Pipilotti Rist', *cream:
contemporary art in culture*, Phaidon Press, London
Obrist, Hans Ulrich, 'Rist for the Mill', *Artforum*, New
York, April

Menü

KUNSTHAUS ZÜRICH

CREDIT SUISSE | PRIVATE BANKING

Selected exhibitions and projects
1999

1999
Receives award, Wolfgang Hahn Preis, Museum Ludwig, Cologne

'Wolfgang Hahn Preis',
Museum Ludwig, Cologne (solo)
Cat. *Pipilotti Rist: Wolfgang Hahn Preis*, Festschrift, Cologne, texts Michelle Nicol, et al.

'Remake of the Weekend (French)',
Musée d'Art Moderne de la Ville de Paris; 'Remake of the Weekend à la Zurichoise', **Kunsthalle**, Zurich (solo)
Artist's book, *Pipilotti Rist (50kg): Himalaya*, Oktagon, Cologne, texts Konrad Bitterli, Bice Curiger, Jacqueline Burckhardt, et al.

Fundação Serralves, Porto (solo)

'Das XX. Jahrhundert: Ein Jahrhundert Kunst in Deutschland',
Neue Nationalgalerie, Berlin (group)
Cat. *Das XX. Jahrhundert: Ein Jahrhundert Kunst in Deutschland*, Staatliche Museen zu Berlin-Preussischer Kulturbesitz und Nicolaische Verlagsbuchhandlung Beuermann GmbH, Berlin, texts Peter Schuster, et al.

'dAPERTutto',
48th Biennale Venice (group)
Cat. *Biennale di Venezia: dAPERTutto*, Marsilio, Venice, texts Harald Szeemann, et al.

Exhibition opening, 'Pipilotti Rist', Fundação Serralves, Porto, *l. to r.*, Vicente Todolí, Pipilotti Rist

Selected articles and interviews
1999

1999

Boyer, Charles-Arthur, 'Pipilotti Rist', *Art Press*, No. 248, Paris, July–August
Crex, Armel, 'Art, prothèses et puces', *Valeurs de l'Art*, Paris, September–October
Descombes, Mireille, 'Pipilotti Twists Again', *L'Hebdo*, Lausanne, 4 February
Frehner, Matthias, 'Nichts ist definitiv und immer alles möglich, Wohnexperimente: Pipilotti Rist in der Kunsthalle Zürich', *Neue Zürcher Zeitung*, Zurich, 23 January
Frei, Klaus, 'Das soziale Engagement der Künstler testen', *Zürcher Unterländer*, Dielsdorf, 18 December
Hubschmid, Christian, 'Un après-midi à la zurichoise', *Neue Zürcher Zeitung*, Zurich, 25 January
Janus, Elizabeth, 'Pipilotti Rist, Kunsthalle Zürich', *Artforum*, No. 8, New York, April
Lebovici, Elisabeth, 'Pipilotti Rist par nature pop', *Libération*, Paris, 24 May
Lequeux, Emmanuelle, 'Pupille de la passion', *aden Le Mondo*, No. 73, Paris, 21–27 May
Lux, Harm, 'L'Ospitalità di Pipilotti Rist', *Flash Art*, No. 215, Milan, April–May
Lux, Harm, 'Pipilotti Rist: A Cosmos in Her Own Right', *Flash Art*, Vol. 32, No. 207, Milan, Summer
Luyckx, Filip, 'Pipilotti Rist', *Sint Ludasgalerij Drussel*, Brussels, September
Mack, Gerhard, 'Wenn die Bilder Trauer zeigen', *St. Galler Tagblatt*, St. Gallen, 23 January
Malinaud, Sandrine, 'Dame Pipilotti Rist', *art actuel*, No. 2, Paris, May–June
Maurer, Simon, 'Die Emanzipation der Müdigkeit', *Tages Anzeiger*, Zurich, 17 February
Nuridsany, Michel, 'Pipilotti Rist, 50 kg', *Le Figaro*, Paris, 27 April
Réqnier, Philippe, 'Pipilotti Rist à Paris, du musée à l'appartement', *Le Journal des Arts*, No. 82, Paris, May

Sardo, Delfim, 'O programa do Fim-de-Semana', *ArteIbérica*, No. 22, Lisbon, March
Vidal, Carlos, 'El videoarte como flujo de placeres', *Lapiz*, Vol. 18, No. 153, Madrid
Vidal, Carlos, 'O fluir livre das imagens luminosas', *A Capital*, Madrid, 13 February

Cover, artist's book, *Pipilotti Rist (50kg): Himalaya*, Oktagon, Cologne, design Thomas Rhyner

Remake of the Weekend (French), in progress, Musée d'Art Moderne de la Ville de Paris

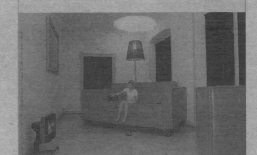

'video cult/ures: multimediale Installationen der 90er
Jahre',
ZKM Karlsruhe, Karlsruhe (group)
Cat. *video cult/ures: multimediale Installationen der
90er Jahre*, Museum für Neue Kunst-ZKM Karlsruhe, Du
Mont, Cologne, texts Ursula Frohne, et al.

'Beauty Now: Evolving Esthetics and Contemporary
Art',
Hirshhorn Museum and Sculpture Garden,
Smithsonian Institution, Washington, DC, toured to
Hans der Kunst, Munich (group)
Cat. *Regarding Beauty: A View of the Late Twentieth
Century*, Hirshhorn Museum and Sculpture Garden,
Smithsonian Institution, Washington, DC, text Neal
Benezra, Olga Viso

'The Passion and the Waves',
6th International Istanbul Biennial (group)
Cat. *6th International Istanbul Biennial*, Kültür ve
Sanat Vakfi, Istanbul, texts Paolo Colombo, et al.

'Blown Away: 6th Caribbean Biennial',
San Martin (group)

'Vision of the Body in Fashion',
Metropolitan Museum of Modern Art, Tokyo;
National Museum of Modern Art, Kyoto (group)
Cat. *Vision of the Body in Fashion*, National Museum of
Modern Art, Kyoto, text Shinji Kohmoto

'Looking for a Place',
3rd SITE Santa Fe Biennial (group)
Cat. *Looking for a Place: 3rd SITE Santa Fe Biennial*,
Santa Fe, 2000, texts Louis Grachos, Rosa Martinez, et
al.

Screening, **Moderna Museet**, Stockholm

2000
Musée des Beaux-Arts, Montreal (solo)

Attias, Laurie, 'Pipilotti Rist', *frieze*, No. 49, London,
November–December
Bilstein, Johannes; Trübenbach, Ursula; Winzen,
Matthias (ed.), *Macht und Fürsorge. Das Bild der Mutter
in der zeitgenössischen Kunst und Wissenschaft*,
Oktagon, Cologne
Blase, Christoph, 'Pipilotti Rist', *Art at the Turn of the
Millennium. Ausblick auf das Jahrtausend*, Taschen,
Cologne
Curiger, Bice, 'Ein Zimmer mit erhöhter
Körpertemperatur', *Tages-Anzeiger*, Zurich, 28
December
Köppel, Roger, 'Wie in einem Irrenhaus', *Das Magazin*,
No. 43, Zurich, 30 October–5 November
Pühringer, Alexander, 'Ich bin nichts
Aussergewöhnliches', *noëma art journal*, No. 51,
Vienna, May–June
Williams, Eliza, 'Pipilotti Rist', *zoo*, No. 3, London,
October

2000
Allen, Jennifer, 'Pipilotti Rist. Dans la peau de l'image',
Parachute, Montreal, April–June
Whyte, Murray, 'Wicked Gamine', *National Post*,
Montreal, 10 May

Artist's edition, **L'honneur de Pipilotti rougit**, 2000, design Thomas
Rhyner

Selected exhibitions and projects
2000–01

'Open My Glade',
organized by the Public Art Fund, New York,
Times Square, New York (solo)
Website, <www.squaretimes.net>, texts Roxanna
Marcocci, Akiko Miyake, et al.

Luhring Augustine, New York (solo)

Devleeshal, Middleburgh (solo)

'Agents of Change: 12th Biennale of Sydney',
Sydney (group)
Cat. *Agents of Change: 12th Biennale of Sydney*,
Biennale of Sydney, texts Nick Waterlow, Fumio Nanjo,
Louise Neri, Hetti Perkins, Sir Nicholas Serota, Robert
Storr, Harald Szeemann, et al.

'Norma Lilienthal und Astrid Blütenstaub', (with Grill
5: Käthe Walser, Annemarie Bucher, Eva Keller)
Landesgartenschau, Singen (group)

'Exorcism/Aesthetic/Terrorism',
Museum Boijmans van Beuningen, Rotterdam (group)
Cat. *Exorcism/Aesthetic/Terrorism*, Museum Boijmans
van Beuningen, Rotterdam, texts Chris Dercon, et al.

'Over the Edges',
Stedelijk Museum voor Actuele Kunst, Ghent (group)
Cat. *Over the Edges*, Stedelijk Museum voor Actuele
Kunst, Ghent, texts Jan Hoet, Giacinto Di Pietrantonio

Lecture, **Institute of Contemporary Arts**, London

Lecture, **Accademia di architettura di Mendrisio**,
Mendrisio

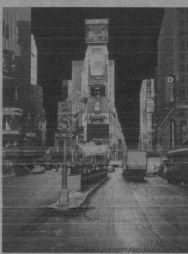

Invitation cards, 'Open My Glade', Times Square, New York.
Design: Thomas Rhyner

2001
Galerie Hauser & Wirth, Zurich (solo)

'Show a Leg',
Tramway, Glasgow (solo)

Centraalmuseum, Utrecht (solo)

Museo de arte contemporanea Reina Sofia, Madrid
(solo)

Yokohama Triennale,
Yokohama (group)

'Szenenwechsel XX',
Museum für Moderne Kunst, Frankfurt (group)

'Confidences',
Casino Luxembourg, Luxembourg (group)

Selected articles and interviews
2000–01

Bronfen, Elisabeth, 'Times Square oder Hat die Polizei
die Nacht besiegt?', *Basler Zeitung*, Basel, 28 April

Conley, Kevin, 'Lady Video', *New Yorker*, 8 May
Stevens, Mark, 'It's All in the Rist', *New York*, New York,
8 May
Wilson-Goldie, Karen, 'Peep Show Video', *Black Book*,
New York, Spring

Website, <www.squaretimes.net>, designed by Trix Barmettler

Karcher, Eva, 'Ich habe einen Traum', *Die Zeit*,
Hamburg, 20 January

Bibliography

Allen, Jennifer, 'Pipilotti Rist. Dans la peau de l'image', *Parachute*, Montreal, April–June, 2000

Anderson, Laurie; Rist, Pipilotti, 'Laurie Anderson and Pipilotti Rist Meet Up in the Lobby of a Hotel in Berlin on September 9, 1996', *Parkett*, No. 48, Zurich, 1996

Attias, Laurie, 'Pipilotti Rist', *frieze*, No. 49, London, November–December, 1999

Babias, Marius, 'Pipilotti Langstrumpf, Angewandte Frauenkultur', *Zitti*, No. 22, Berlin, 1995

Babias, Marius, 'Pipilotti Rist', *frieze*, No. 27, London, March–April, 1996

Babias, Marius, 'Risikofaktor Rist; Wenn Träume wie sterbende Fische zucken', *Parkett*, No. 48, Zurich, 1996

Bitterli, Konrad; et al., *Pipilotti Rist (167 cm): I'm Not the Girl Who Misses Much*, Oktagon, Stuttgart, 1993

Bitterli, Konrad; et al., *Pipilotti Rist (50kg): Himalaya*, Oktagon, Cologne, 1999

Blase, Christoph, 'Pipilotti Rist', *Art at the Turn of the Millennium. Ausblick auf das Jahrtausend*, Taschen, Cologne, 1999

Bonik, Manuel, 'Die Bildstörerin', *Deutsche Vogue*, No. 2, Munich, February, 1998

Bonik, Manuel, 'Vom Nachtdienst in das Wochenende', *Der Standard*, Vienna, 19 June, 1998

Boyer, Charles-Arthur, 'Pipilotti Rist', *Art Press*, No. 248, Paris, July–August, 1999

Bronfen, Elisabeth, 'Times Square oder Hat die Polizei die Nacht besiegt?', *Basler Zeitung*, Basel, 28 April, 2000

Buchmann, Sabeth, 'Produktivitätssysteme. Zu den Arbeiten von Pipilotti Rist', *Texte zur Kunst*, No. 32, Cologne, December, 1998

Burckhardt, Jacqueline; et al., *Pipilotti Rist (167 cm): I'm Not the Girl Who Misses Much*, Oktagon, Stuttgart, 1993

Burckhardt, Jacqueline; et al., *Pipilotti Rist (50kg): Himalaya*, Oktagon, Cologne, 1999

Bürgi, Bernhard; et al., *Remake of the Weekend*, Oktagon, Cologne, 1998

Clewing, Ulrich, 'Always-ultra Pipi-Pose', *die tageszeitung*, Berlin, 14–15 May, 1998

Colombo, Paolo, 'Shooting Divas', *Parkett*, No. 48, Zurich, 1996

Conley, Kevin, 'Lady Video', *New Yorker*, 8 May, 2000

Crex, Armel, 'Art, prothèses et puces', *Valeurs.de l'Art*, Paris, September–October, 1999

Curiger, Bice; et al., *Pipilotti Rist (167 cm): I'm Not the Girl Who Misses Much*, Oktagon, Stuttgart, 1993

Curiger, Bice, 'Pipilotti Rist, Yoghurt on Skin – Velvet on TV', *Jahresbericht des Kunsthauses*, Zurich, 1996

Curiger, Bice; et al., *Pipilotti Rist (50kg): Himalaya*, Oktagon, Cologne, 1999

Curiger, Brice, 'Ein Zimmer mit erhöhter Körpertemperatur', *Tages-Anzeiger*, Zurich, 28 December, 1999

Czöppan, Gabi, 'Knick in der Pupille', *Focus*, No.12, Munich, 16 March, 1998

de Brugerolle, Marie, 'Pipilotti Rist', *Documents sur l'art*, No. 8, Paris, 1996

Doswald, Christoph; et al., *Pipilotti Rist (167 cm): I'm Not the Girl Who Misses Much*, Oktagon, Stuttgart, 1993

Doswald, Christoph; Rist, Pililotti, 'Ich halbiere bewusst die Welt, Pipilotti Rist im Gespräch mit Christoph Doswald', *Be Magazin*, No. 1, Künstlerhaus Bethanien, Berlin, 1994

Doswald, Christoph, 'Pip-Up', *neue bildende kunst*, No. 5, Berlin, October, 1994

Dumreicher-Ivanceanu, Alexander, 'Ever Is Over All: Pipilotti Rist und ihre Wochenendkathedrale zu Wien', *(Blimp) Film Magazine*, No. 39, Graz, 1998

Erdmann Ziegler, Ulf, 'Rist Factor', *Art in America*, New York, June, 1998

Frehner, Matthias, 'Achtung! Rote Lippen schnappen!', *Neue Zürcher Zeitung*, Zurich, 21–22 March, 1998

Frehner, Matthias, 'Nichts ist definitiv und immer alles möglich, Wohnexperimente: Pipilotti Rist in der Kunsthalle Zürich', *Neue Zürcher Zeitung*, Zurich, 23 January, 1999

Frei, Klaus, 'Das soziale Engagement der Künstler testen', *Zürcher Unterlander*, Dielsdorf, 18 December, 1999

Galasso, Alessandra; et al., *Remake of the Weekend*, Oktagon, Cologne, 1998

Gerstner, Ulrich, ' ... Or Why I'm Never Sad, Pipilotti Rist und Samir in Baden-Baden', *Neue Zürcher Zeitung*, Zurich, 29 November, 1996

Hannula, Mika, 'Sweet and Tender Hooligan', *Siksi*, Stockholm, Spring, 1997

Haye, Christian, 'The Girl Who Fell to Earth', *frieze*, No. 38, London, March–April, 1998

Hays, K. Michael, 'Het ontstaan van ideologische gladheid', *de Architect*, Amsterdam, December, 1995

Heartney, Eleanor, 'The Return of the Red-Brick Alternative', *Art in America*, January, 1998

Hierholzer, Michael, 'Blütenträume aus dem Stoff der Uniformen', *Frankfurter Allgemeine Zeitung*, Frankfurt, 14 June, 1998

Hubschmid, Christian, 'Un après-midi à la zurichoise', *Neue Zürcher Zeitung*, Zurich, 25 January, 1999

Hunold, Christine, *Mit Hertz*, Kulturzentrum Kammgarn, Schaffhausen; Centre d'art contemporain, Fribourg, 1991

Janus, Elisabeth, 'Pipilotti Rist', *Artforum*, No. 10, New York, Summer, 1996

Janus, Elizabeth, 'Pipilotti Rist, Kunsthalle Zürich', *Artforum*, No. 8, New York, April, 1999

Jolles, Claudia, 'Pipilotti Rist: Galerie Stampa, Basel', *Artforum*, No. 3, New York, 1993

Kalt, Jörg, 'Schwester des Stroms', *Dan Magazin*, No. 7, Zurich, February, 1992

Kempker, Birgit, 'Blut ist der Schuh', *Basler Zeitung-Magazin*, No. 24, Basel, April, 1993

Köppel, Roger, 'Wie in einem Irrenhaus', *Das Magazin*, No. 43, Zurich, 30 October–5 November, 1999

Lebovici, Elisabeth, 'Pipilotti Rist par nature pop', *Libération*, Paris, 24 May, 1999

Lequeux, Emmanuelle, 'Pupille de la passion', *aden Le Monde*, No. 73, Paris, 21–27 May, 1999

Lerch, Liliane, 'Rist & Mathis: Künstlerfrauenpaare', *Kunstforum International*, Ruppichteroth, April–May, 1989

Lux, Harm, 'Pipilotti Rist: Nirwana im Rosengarten', *Metropolis M*, Utrecht, February, 1994

Lux, Harm, 'L'Ospitalità di Pipilotti Rist', *Flash Art*, No. 215, Milan, April–May, 1999

Lux, Harm, 'Pipilotti Rist: A Cosmos in Her Own Right', *Flash Art*, Vol. 32, No. 207, Milan, Summer, 1999

Luyckx, Filip, 'The Social Life of Roses or Why I'm Never Sad', *Sint-Lukasgalerij*, No. 3, Brussels, January, 1998

Luyckx, Filip, 'Pipilotti Rist', *Sint-Ludasgalerij Brussel*, Brussels, September, 1999

Mack, Gerhard, 'Die Bilder im Kopf beim Schmusen', *Turicum*, Stäfa, August–September, 1993

Mack, Gerhard, 'Wenn die Bilder Trauer zeigen', *St. Galler Tagblatt*, St. Gallen, 23 January, 1999

Malinaud, Sandrine, 'Dame Pipilotti Rist', *art actuel*, No. 2, Paris, May–June, 1999

Matt, Gerald; et al., *Remake of the Weekend*, Oktagon, Cologne, 1998

Mittringer, Markus, 'Neulich im Paisley-Park', *Der Standard*, Vienna, 26 June, 1998

Molon, Dominic, *Pipilotti Rist: Sip My Ocean*, Museum of Contemporary Art, Chicago, 1996

Nuridsany, Michel, 'Pipilotti Rist, 50 kg', *Le Figaro*, Paris, 27 April, 1999

Obrist, Hans Ulrich, 'Pipilotti Rist', *cream: contemporary art in culture*, Phaidon Press, London, 1998

Obrist, Hans Ulrich, 'Rist for the Mill', *Artforum*, New York, April, 1998

Pacher, Jeannette, 'Lieblich aufmuckend', *Forum für Feministische Gangarten*, No. 25, Vienna, 26 August, 1998

Pühringer, Alexander, 'Ich bin nichts Aussergewöhnliches', *no'ma art journal*, No. 51, Vienna, May–June, 1999

Reich, Anne, 'Pipilotti Rist: Der Reiz des Unsauberen - Ein Interview', *Kunst-Bulletin*, No. 12, Zurich, 1991

Rist, Pipilotti; et al., *Pipilotti Rist (167 cm): I'm Not the Girl Who Misses Much*, Oktagon, Stuttgart, 1993

Rist, Pipilotti; Anderson, Laurie, 'Laurie Anderson and Pipilotti Rist Meet Up in the Lobby of a Hotel in Berlin on September 9, 1996', *Parkett*, No. 48, Zurich, 1996

Rist, Pipilotti; et al., *Remake of the Weekend*, Oktagon, Cologne, 1998

Rist, Pipilotti; et al., *Pipilotti Rist (50kg): Himalaya*, Oktagon, Cologne, 1999

Régnier, Philippe, 'Pipilotti Rist à Paris, du musée à l'appartement', *Le Journal des Arts*, No. 82, Paris, May, 1999

Saltz, Jerry, 'Merry-Go-Round', *Flash Art*, Milan, October, 1997

Schmitz, Britta; et al., *Remake of the Weekend*, Oktagon, Cologne, 1998

Schäfer, Andreas, 'Wir wollen tanzen, tanzen, tanzen', *Berliner Zeitung*, Berlin, 5 October, 1998

Sirmans, Franklin, 'The Unbearable Lightness of Whiteness', *Flash Art*, Milan, October, 1997

Smallenburg, Sandra, 'De wereld is nu eenmaal zo gekleurd', *NRC Handelsblad*, Rotterdam, 10 November, 1997

Spector, Nancy, 'The Mechanics of Fluids', *Parkett*, No. 48, Zurich, 1996

Spinelli, Claudia, 'Shooting Divas. Ein Projekt von Pipilotti Rist', *Kunst-Bulletin*, No. 9, Zurich, September, 1996

Sprecher, Margrit, 'Pipilotti Rist', *Geo Special*, No. 2, Hamburg, April, 1996

Stange, Raimar, 'Raimar Stange über Pipilotti Rist', *artist Kunstmagazin*, Bremen, February, 1996

Stevens, Mark, 'It's All in the Rist', *New York*, 8 May, 2000

Ter Borg, Lucette, 'Tinkelend lokt aards visioen Pipilotti Rist', *de Volkskrant*, Amsterdam, 4 December, 1997

Tietenberg, Annette, 'Ein typisches Fernsehkind; Video-Queen: Pipilotti Rist in der Kunsthalle Baden-Baden', *Frankfurter Allgemeine Zeitung*, Frankfurt, 19 December, 1996

Tietenberg, Annette, 'Der Videoclip als Seelenstrip', *Frankfurter Allgemeine Zeitung*, Frankfurt, 28 April, 1998

Ursprung, Philip, 'Pipilotti Rist's Fliegendes Zimmer', *Parkett*, No. 48, Zurich, 1996

Vachtova, Ludmila, 'Trunken, himbeerrot', *Die Weltwoche*, Zurich, 19 March, 1998

Vidal, Carlos, 'El videoarte como flujo de placeres', *Lapiz*, Vol. 18, No. 153, Madrid, 1999

Vidal, Carlos, 'O fluir livre das imagens luminosas', *A Capital*, Madrid, 13 February, 1999

Williams, Eliza, 'Pipilotti Rist', *zoo*, No. 3, London, October, 1999

Williams, Gilda, 'Pipilotti Rist: Chisenhale Gallery, London', *Art Monthly*, London, June, 1996

Wilson-Goldie, Karen, 'Peep Show Video', *Black Book*, New York, Spring, 2000

Zwez, Annelise, 'Pipilotti Rist: Das Wissen am Gefühl Abzwacken', *Artis*, Berne, December–January, 1993

Zwez, Annelise, 'Grossmut begatte mich: The Social Life of Roses', *Artis*, No. 2, Stuttgart, 1997

Disco, 1985
Concept and realization: Pipilotti
Rist and T.omi Scheiderbauer
X-rays: Walter Rist

I'm Not the Girl Who Misses Much, 1986
Single channel video tape
Directing, editing, camera, cast, sound: Pipilotti Rist
Sound: *Happiness is a Warm Gun* by John Lennon/Paul McCartney

Sexy Sad 1, 1987
Single channel video tape
Directing, editing, camera: Pipilotti Rist
Cast and sound: Lori Hersberger
Piano: Fréderique Rickenbacher

(Entlastungen) Pipilottis Fehler ([Absolutions] Pipilotti's Mistakes), 1988
Single channel video tape
Directing, editing, camera, cast, sound: Pipilotti Rist
Sound parts: Hans Feigenwinter, Les Reines Prochaines
Camera Assistance: Lori Hersberger
Thanks to the School of Design, Basel, and Käthe Walser

Die Tempodrosslerin saust (The Tempo-throttler's Rushing), 1989
Single channel video tape
Directing, editing, cast, camera, sound: Muda Mathis and Pipilotti Rist
Sound, cast: Fränzi Madörin, Regina Florida Schmid, Teresa Alonso (Les Reines Prochaines)
Installation assistance: Luzia Stäubli, Claude Spiess
Thanks to Hip Mathis, Kunsthalle St. Gallen, Roli Frei, Rudolf Schawalder, François Malherbe, Anna Rist, Gaby Streiff

You Called Me Jacky, 1990
Single channel video tape
Directing, editing, camera, cast: Pipilotti Rist
Sound: Kevin Coyne

Als der Bruder meiner Mutter geboren wurde, duftete es nach wilden Birnenblüten vor dem braungebrannten Sims (When my mother's brother was born there was a fragrance of wild pear blossom outside the brown-burnt sill), 1992
Single channel video tape
Directing, editing, camera, sound: Pipilotti Rist
Guitar: Heinz Rohrer
Thanks to Neila, Yannik and Henry Rohrer, Anna Rist

Pickelporno (Pimple Porno), 1992
Single channel video tape
Directing, editing, sound, camera: Pipilotti Rist
Sound: Peter Bräker, Les Reines Prochaines
Editing assistance: Ronnie Wahli
Camera: Käthe Walser, Samir
Cast: Judith Bürgin, Sai Kijima and diverse body stunts

Eindrücke verdauen (Digesting Impressions), 1993
Video installation
Directing, editing: Pipilotti Rist
Thanks to Dr. Peter Liechti (endoscopy footage)

TV-Lüster (TV Chandelier), 1993
Video installation
Concept, editing, camera, cast: Pipilotti Rist
Sound: Felix Haug after Johann Sebastian Strauss
Construction: Stefan Urweider, Pius Tschumi
Construction assistance: Anna, Tamara and Andrea Rist, Käthe Walser
Thanks to Swarowski Austria and Stampa, Basel

Yoghurt on Skin – Velvet On TV, 1994
Video installation
Video: see credits for *Sip My Ocean* and *Blutclip*
Construction: Tamara Rist, Stefan Urweider, Samuel Löffel
Production assistance: Nadia Schneider
Technical upgrade: Hugo Schmid, Pius Tschumi
Upgrade production management: Pius Tschumi

Selbstlos im Lavabad (Selfless in the Bath of Lava), 1994
Video installation
Directing, editing, camera, cast: Pipilotti Rist
Sound: Peter Bräker

I'm a Victim of this Song, 1995
Single channel video tape
Directing, editing, sound, camera: Pipilotti Rist
Sound: Anders Guggisberg, cover version of the song *Wicked Game* by Chris Isaac
Camera: Pierre Mennel, Giorgio Zehnder

Fliegendes Zimmer (Flying Room), 1995
Video installation
Directing, editing, camera: Pipilotti Rist
Camera: Stefan Jung

Cast: Employees of UBS Buchs
Assistance: Anders Guggisberg, Nadia Schneider, Esther van Messel
Construction: Hugo Schmid, Stefan Urweider, Kali Perriard, Philipp Rüesch
Computer calculations: Patrik Ritz
Oil painting: Anders Guggisberg
Thanks to Dig it, Zürich, and Toni Schönenberger

Mutaflor, 1996
Video installation
Directing, editing, cast: Pipilotti Rist
Camera: Anders Guggisberg

Sip My Ocean, 1996
Video installation
Directing, editing, camera, cast, sound: Pipilotti Rist
Sound: Anders Guggisberg, cover version of the song *Wicked Game* by Chris Isaac
Camera and cast: Pierre Mennel
Production assistance: Nadia Schneider
See also credits *Pickelporno*, 1992

Shooting Divas, 1996
Video installation
Writing, directing, vocal, set design: Pipilotti Rist
Sound, recording, set design: Anders Guggisberg
Recording: Ruedi Gfeller
Editing: Mich Hertig
Camera: Karin Sudan
Cast, vocal: Pier Angela Compagnino, Danny-Aude Rossel, Monique Froidevaux, Marielle Pinsard, Ben Merlin, Laure Vouillamoz, Anna Luif with Noël Akchoté, Gerda and Kathrin Treml, Saadet Türköz, Sandra Nickl
Production assistance: Nadia Schneider
Set design and construction: Miriam Schlachter, Diego Zweifel, Tamara Rist
Thanks to the Centre d'art contemporain, Geneva: Zoe Stähli, Peter Stöckli

Ever Is Over All, 1997
Video installation
Directing, camera, vocal, costumes: Pipilotti Rist
Sound, requisites, travelling: Anders Guggisberg
Editing: Ian Mathys
Camera: Aufdi Aufdermauer
Cast: Silvana Ceschi, Gabrielle Hächler, Anna Rist, Tom Rist, Mich Hertig, Gian Wilhelm
Shooting assistance: Anahita Krzyzanowski

Iron flower: Martin Fischer
Best boys: Donner Trepp, Christian Davi, Attila Panzel
Fotos: Stefan Banz
Thanks to Manuela Wirth, Andreas Fuhrimann, Christoph Doswald, Urs Gerber, Anna Rist, Brigitte Hofer, Garage Giuseppe Cannizzo, Serge Nyffeler, Meret und Maxi Mars Matter, Gregor Meier
Special thanks to Galerie Hauser & Wirth, Zürich

Blauer Leibesbrief (Blue Bodily Letter), 1992/98
Video installation
Directing, editing, cast, sound: Pipilotti Rist
Camera: Samir

Blutraum (Blood Room), 1993/98
Video installation

Blutclip (Bloodclip), 1993
Single channel video tape
Directing, editing, cast, camera: Pipilotti Rist
Sound: Sophisticated Boom Boom
Soundmix installation: Felix Haug
Cast and assistance: Ursula Palla
Installation assistance: Tamara Rist
Thanks to Regula Bochsler and SF DRS

Atmosphäre & Instinkt (Atmosphere & Instinct), 1998
Video installation
Directing, editing, cast, vocal: Pipilotti Rist
Sound: Anders Guggisberg
Editing: Mich Hertig
Camera: Aufdi Aufdermauer, Mich Hertig
Production management: Cornelia Providoli
Installation assistance: Pius Tschumi
Thanks to Ursula Hauser, Helicopter Fuchs, Martina Egi

Achterbahn / das Tram ist noch nicht voll (Tram Route Eight / The Tram Is Not Crowded Yet), 1998
Installation
Concept and realization: Pipilotti Rist, Thomas Rhyner, Ian Krohn
Sound: Ruedi Gfeller
Inside photographs: Katharina Rippstein
Outside photographs: Paco Carrascosa
Production assistance: Bettina Coaz

Nichts (Nothing), 1999
Machine producing smoke-filled soap bubbles
Development: Pius Tschumi, Hildegard Spielhofer

Development and construction of the machine: Dimitri Westermann
Production management: Cornelia Providoli

Eine Spitze in den Westen – ein Blick in den Osten (A Peak into the West – A Look into the East), 1992/99
Video installation
Concept, video/sound: Pipilotti Rist
Construction: René Lang, Stefan Urweider, Andi Schrämmli
Construction upgrade: Dimitri Westermann
Upgrade production management: Pius Tschumi and Cornelia Providoli
Thanks to Shedhalle Zürich, Ursula Rist and Emanuel Tschumi

Himalaya Goldsteins Stube (Himalaya Goldstein's Living Room), 1999
Video installation
Directing, editing, camera, sound: Pipilotti Rist
Sound and camera: Anders Guggisberg
Editing assistance: Mich Hertig
Camera: Samir
Production assistance: Silke Schäfer
Cast: Saadet Türköz, Inger Nilsson, Aufdi Aufdermauer, Nadia Schneider
Make-up: Amber
Production management: Cornelia Providoli
Development and construction: Pius Tschumi, Davide Ciresa, Isa Nogara, Daniel Hunziker
Videotechnic: Aufdi Aufdermauer
Construction: Reto Lütscher, Käthe Walser, Kuno Nüssli, Martin Schnidrig, Remo Weber, Wolfgang Capellari, BOST Production Zürich, CKSoft (Cyril Kreyenbühl)
Pillow from Hansjörg Marti
Oil painting: Wolfgang Capellari
Design bar: Davide Ciresa
Design wall paper: Anders Guggisberg and Andres Lutz
Thanks to Kunsthalle, Zurich, and Musée d'Art Moderne de la Ville de Paris
For some videos see credits of: *Sip My Ocean* and *Vorstadthirn* (*Suburb Brain*)

Regenfrau (Rain Woman) **I Am Called a Plant**, 1999
Video installation
Directing, cast, editing: Pipilotti Rist
Installation design and construction: Pius Tschumi

Assistance: Daniel R. Hunziker
Editing assistance: Mich Hertig
Camera: Aufdi Aufdermauer
Sound: Anders Guggisberg
Production management: Cornelia Providoli

Extremitäten (weich, weich) [Extremities (Smooth, Smooth)], 1999
Video installation
Writing, directing, camera, cast, vocal: Pipilotti Rist
Camera, cast, sound: Anders Guggisberg
Editing: Mich Hertig
Production management and cast: Cornelia Providoli
Requisites: Tamara Rist
Installation management and construction: Pius Tschumi
Technic: Dimitri Westermann

Vorstadthirn (Suburb Brain), 1999
Video installation
Writing, directing, camera, cast, Guitar: Pipilotti Rist
Sound and camera: Anders Guggisberg
Editing: Mich Hertig
Camera: Pierre Mennel
Light: André Pinkus
Cast: Esther, Moritz und Maria Eppstein, Mauro Arnold, Beatrice, Fidel and Max Aeberli, Boni Koller, Regula, Ruedi, Tim, Noah and Salome Bechtler, Ursula, David, Andreas, Yves and Marcel Göldi Rist; Charlotte, Emily, Miriam and Eberhard von Körber
Shooting assistance: Maria Monika Ender, Victor Escobar
Production management: Cornelia Providoli
Installation design, construction: Davide Ciresa, Pius Tschumi
Video technic: Aufdi Aufdermauer
Thanks to Luzia Schmid

I Couldn't Agree with You More, 1999
Video installation
Directing, editing, camera: Pipilotti Rist
Sound: Anders Guggisberg
Editing: Mich Hertig
Camera ('forest' 16 mm): Beni Kempf
Cast: Tom Rist, Anders Guggisberg, Olivia Oeschger, Silvana Ceschi, Balz's Jaguar
Shooting assistance: Mich Hertig, Maria Monika Ender
Installation assistance: Pius Tschumi
Production management: Cornelia Providoli

Open My Glade, 2000
Video installation
Directing, editing, cast: Pipilotti
Rist
Editing assistance: Mich Hertig
Camera: Filip Zumbrunn
Production management: Cornelia
Providoli
Production assistance: Arthur
Miranda
Homepage: Trix Barmettler Grafic
Design: Thomas Rhyner
Commissioned by Public Art Fund
NY for Times Square, New York

Himalaya's Sister's Living Room,
2000
Video installation
Credits see *Himalaya Goldstein's
Living Room*.
Additional installation
construction and production
management: Davide Ciresa
Additonal cast: Cornelia Providoli,
Anders Guggisberg
Additional camera: Filip Zumbrunn
Thanks to Luhring Augustine
Gallery, New York, Felix Kaufmann,
Michele Maccarone

Closet Circuit, 2000
Installation
Development: Pius Tschumi,
Dimitri Westermann
Production management: Cornelia
Providoli

Das Zimmer (The Room),
1994/2000
Video installation
Concept: Pipilotti Rist
Construction: Urs Grob @ Stahl &
Traum, Tamara Rist
Electronic: Marc Ofner, technical
upgrade: Hugo Schmid, Bild & Ton,
Dimitri Westermann
Videos: see credits all single
channel tapes
Thanks to Kunstmuseum St. Gallen

I Never Taught in Buffalo, 2000
Wallpaper
Concept and footage: Pipilotti Rist
Production: Beat Zgraggen and
Irène Gattiker @ Gazebo
Production management: Pius
Tschumi and Cornelia Providoli
Assistance: Arthur Miranda

Hello Goodbye, 2000
Video installation
Photography and concept:
Pipilotti Rist
Assistance: Davide Ciresa
Construction: Davide Ciresa, Pius
Tschumi, Daniel R. Hunziker

Monitorblüten (Monitor
Blossoms), 1998/2000
Video installation

Concept, editing, camera: Pipilotti
Rist
Camera site specific: Aufdi
Aufdermauer, Pius Tschumi
Installation assistance: Tamara
Rist, Bettina Coaz, Cornelia
Providoli, Michelle Maccarone

Technical manuals: Pius Tschumi,
Sushma Banz and Davide Ciresa
until 2000, from 2001 ART IN
SPACE Käthe Walser and Monika
Schori

Public Collections
Swiss Confederation Berne
Museum of Contemporary Art,
Chicago
Museum Ludwig, Cologne
Louisiana Museum, Humlebaek,
Denmark
Museum für Moderne Kunst,
Frankfurt
Musée d'art et d'histoire , Geneva
Stedelijk Museum voor actuelle
Kunst, Ghent
Museum of Contemporary Art, Los
Angeles
De Vleeshal, Middleburgh, The
Netherlands
Musée des Beaux-Arts, Montreal
Bayerische
Staatsgemäldesammlungen,
Munich
The Museum of Modern Art, New
York
Solomon R. Guggenheim Museum,
New York
Neues Museum, Nürnberg
Kunstmuseum, St. Gallen
Musée d'art contemporain,
Villeurbanne (FRAC Rhône-Alpes)
Hirshhorn Museum and Sculpture
Garden, Washington, DC
Kunstsammlungen zu Weimar,
Neues Museum Weimar
Sammlung der Stadt, Zurich
Kunsthaus, Zurich

List of Comparative Images
page 72, **Vito Acconci**
Adaptation Study (Blindfolded
Catching)

page 39, **Laurie Anderson**
Stories from the Nerve Bible

page 35, **Matthew Barney**
Drawing Restraint 7
Walker Arts Center, Minneapolis,
Minnesota

page 42, **Berwick Street Film
Collective**, including **Mary Kelly**
Nightcleaners

page 84, **Louise Bourgeois**
Arch of Hysteria

page 84, **Jean-Martin Charcot**
Attitudes Passionelles, Extase

page 12, **Vera Chytilova**
Daisies

page 20, **Maureen Connor**
The Sixth Sense

page 35, **Stan Douglas**
Hors-champs

page 72, **Valie Export** (with Peter
Weibel)
Tapp und Tastkino (Touch Cinema)

page 59, **Victor Fleming**
The Wizard of Oz

page 23, **Felix Gonzalez-Torres**
Untitled

page 34, **Douglas Gordon**
Twenty-four Hour Psycho

page 34, **Susan Hiller**
Belshazzar's Feast

page 12, **Joan Jonas**
Vertical Roll

page 36, **Pippi Långstrump** (Pippi
Longstocking)

page 44, **John Lennon**

page 84, **Annette Messager**
Voluntary Tortures (detail)
FRAC Rhônes-Alpes, France

page 59, **Claude Monet**
Poppies, near Argenteuil
Musée d'Orsay, Paris

page 16, **Yoko Ono**
Do It Yourself Dance Piece (Swim in
Your Sleep)

page 35, **Tony Oursler**
Angerotic

page 113, **Nam June Paik**
TV Funnel

page 113, **Nam June Paik**
TV Buddha

page 42, **Adrian Piper**
Catalysis III

page 42, **Cindy Sherman**
Untitled Film Still 7
The Museum of Modern Art, New
York

page 9, **Nedko Solakov**
On the Wing

page 39, **Andy Warhol**
The Chelsea Girls

page 72, **Andy Warhol**
Edie Screen Test

page 12, **John Waters**
Pink Flamingos

page 35, **Rachel Whiteread**
Ghost

List of Illustrated Works
page 22, **Achterbahn/das Tram ist
noch nicht voll** (Tram Route 8/The
Tram Is Not Crowded Yet), 1998
page 57, **Als der Bruder meiner
Mutter geboren wurde, duftete
es nach wilden Birnenblüten vor
dem braungebrannten Sims**
(When my mother's brother was
born there was a fragrance of wild
pear blossom outside the brown-
burnt sill), 1992
page 131, **Atmospäre & Instinkt**
(Atmosphere & Instinct), 1998
pages 126–27, **Basler Blutraum**
(Basel Blood Room), 1993–94
page 49, **Blauer Leibesbrief** (Blue
Bodily Letter), 1992/98
pages 128, 129, **Blutclip**
(Bloodclip), 1993
page 19, **Closet Circuit**, 2000
page 67, **Das Zimmer** (The Room),
1994/2000
page 41, **Die Tempodrosslerin
saust** (The Tempo-throttler's
Rushing), 1989
page 11, **Disco**, 1985
page 56, **Eindrücke Verdauen**
(Digesting Impressions), 1993
page 57, **Eine Spitze in den
Westen – ein Blick in den Osten**
(A Peak into the West – A Look into
the East), 1992/99
*pages 46, 78, 81, 82, 83, 85, 86,
89, 90, 121, 122, 123,*
(Entlastungen) Pipilottis Fehler
([Absolutions] Pipilotti's
Mistakes), 1988
pages 58, 59, 60, 61, **Ever Is Over
All**, 1997
page 70, **Extremitäten (weich,
weich)** (Extremities [Smooth,
Smooth]), 1999
page 118, 119, **Feuerwerk
Televisione Lipsticky** (Firework
Television Lipsticky), 1994/2000
page 37, **Fliegendes Zimmer**
(Flying room), 1995
page 66, **Grossmut begatte
mich/Search Wolken** (Magnamity
Mate with Me/Search Clouds),
1995
page 92, **Hello Goodbye**, 2000
pages 28, 29, 30–31, 32, **Himalaya
Goldsteins Stube** (Himalaya
Goldstein's Living Room), 1999
pages 114, 115, 140, 143,
Himalaya's Sister's Living Room,
2000
pages 20, 21, **I Couldn't Agree
with You More**, 1999
page 68–69, **I Never Taught in
Buffalo**, 2000
page 57, **I'm a Victim of this
Song**, 1995
pages 13, 14–15, 43, **I'm Not the
Girl Who Misses Much**, 1986
page 118, **Ich will Dich lieben,
Meine Stärke** (I Wanna Love You,
My Strength), 1999
pages 104, 105, **Innocent
Collection**, 1988–ongoing
page 40, **Japsen**, 1988
page 11, **Jeans**, 1984
page 109, **Life and Work**,
1986–2000
page 6, **Me As a Human Being**,
2000
page 107, **Mein Schlafzimmer** (My
Bedroom), 1985–86
page 106, **Meine Stube** (My Living
Room), 1985–86
page 118, **Mitten wir im Leben
sind** (In the Middle of Life, We
Are), 1999
page 111, **Monitorblüten** (Monitor
Blossoms), 1998
pages 52, 53, **Mutaflor**, 1996
pages 98, 99, **My Boy, My Horse,
My Dog**, 1997
page 139, **Mythenquai I**, 2000
page 139, **Mythenquai II**, 2000
page 139, **Mythenquai III**, 2000
page 139, **Mythenquai IV**, 2000
page 139, **Mythenquai V**, 2000
page 139, **Mythenquai VI**, 2000
page 139, **Mythenquai VII**, 2000
pages 18, 19, **Nichts** (Nothing),
1999
pages 24, 25, 27, **Open My Glade**,
2000
pages 50, 51, **Pickelporno** (Pimple
Porno), 1992
page 11, **Rahel kommt** (Rachel
Comes), 1984
pages 94, 95, 96, 97, **Regenfrau**
(Rainwoman) **(I Am Called a
Plant)**, 1999
pages 38, 74–75, 76, **Selbstlos im
Lavabad** (Selfless in the Bath of
Lava), 1994
page 48, **Sexy Sad 1**, 1987
page 73, **Shooting Divas**, 1996
pages 136, 137, **Sihlfeld**, 2000
pages 4, 62–63, 64, 65, **Sip My
Ocean**, 1996
page 118, **Sonne der
Gerechtigkeit** (Sun of Justice),
1999
page 11, **Tiroler Pickel** (Tirolese
Pimple), 1984
pages 112, 113, **TV-Lüster** (TV
Chandelier), 1993
page 100, **Untitled**, 1992
pages, 132, 133, 134–35,
Vorstadthirn (Suburb Brain),
1999
pages 54, 55, **Yoghurt on Skin –
Velvet on TV**, 1994
page 57, **You Called Me Jacky**,
1990
page 117, **Zu Deinem Tische
treten wir** (We Step to Your Table),
1994/2000